HY RYAN!

DRAW EVERYDAY...

I DO...

CAPTAIN
MACK
ZISTER

Mark Kistler's Draw Squad

Mark Kistler

A program developing positive, creative thinking for parents, teachers, high schoolers, children, plumbers, hang gliders, taxicab drivers, nurses, farmers, hot air balloonists, origami maniacs...

A Fireside Book

Published by Simon & Schuster Inc.
New York London Toronto Sydney Tokyo

Copyright © 1988 by Mark Kistler

A FIRESIDE BOOK
Published by Simon & Schuster Inc.
Simon & Schuster Building
Rockefeller Center
1230 Avenue of the Americas
New York, New York 10020

FIRESIDE and colophon are registered trademarks
of Simon & Schuster Inc.

Designed by Lynn Karpinski
Manufactured in the United States of America

10 9 8 7 6 5 4

Library of Congress Cataloging in Publication Data

ISBN 0-671-65694-5

Dedication

This book is dedicated to my mentor and friend, Bruce McIntyre, who is the "Einstein" of drawing education. His many years of dedication to teaching have reinforced my belief that teachers are society's true heroes.

Special Thanks

Over the past year many, many people have helped me make this book a reality. From planning to typesetting, these people have made the adventure tremendously fun and rewarding. Thank-you. Thank-you. Thank-you.

Art Teachers Contributing Ideas and Key Word Definitions:

Ron Adams, Seattle, WA
Vivienne Anderson, Albany, NY
Mona Brookes, Santa Monica, CA
James M. Clarke, Houston, TX
Sarah Clevenger, Fort Wayne, IN
Ms. D. Cosgro, Plattsburgh, NY
Jack Davis, Denton, TX
Tom DiPierro, Farmingville, NY
Cheryl Duffy, Fort Wayne, IN
Tina Farrel, Houston, TX
Margaret Hansen, San Ramon, CA
David R. Humphreys, Washington, DC
Lee Hutchins, Ophir, CA
Lola Johnson, Plattsburg, NY
Dorothy Kitaka, Fort Wayne, IN
Amy "Art" Krichko, Bitburg, West Germany
Ken Kraintz, Everett, WA
Sonja Manza, Tumwater, WA
Bruce McIntyre, Santa Ana, CA
Andrew E. Mills, Albany, NY
Henric Post, Albany, NY
Susan Russel, Everett, WA
Mike Schmid, Fort Wayne, IN
Ann Smith, Cypress, TX
John Steers, Corsham, Wiltshire, England
Tracy Stiffler, Rochester, NY
Hans van der Veen, Groningen, Holland
Leslie Wingfield, Magnolia, TX
Marybeth Wingfield, Magnolia, TX

Drawing By Contributing Draw Squaders

To all of the student Draw Squaders who contributed their drawings in this book, thank-you for your amazingly brilliant and wonderful art.

Production Crew

Artistic Typesetting & Graphics - Thanks a million, Mary

Edith Fine & Judith Josephson - Thank-you for introducing me to Carol Mann and prompting me to take on this project.

Gloria Formica - Draw Squad Suit Seamstress

Denise Gutierrez and Denise Karatsu - Great typesetting under pressure

Harley Hahn - Copy Editor

Kristopher Jeter - President, Mark Kistler Productions, my best friend, who holds all the pieces together.

W. Thomas Jeter III - Editing, production, and 1,000 hours a week.

Lynn Karpinski - Design and Editing

Magic Innovations - For stats and other camera work - Thank-you

Carol Mann - The most patient literary agent in the entire Western Hemisphere

Minuteman Press - Printing and staying open 'til late for paper and supplies - thank-you, Henry Schlichting

Debbie Petersen - Editing and typing

Thomas Priest Photography - Front cover photograph and endless patience

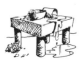

Media Support

David Allen, Albany, NY
Hal Clement, San Diego, CA
Ann Courier, Plattsburg, NY
Bob Edwards, Washington, DC
Bob McDougall, Albany, NY
Ken Morrison, Seattle, WA
Simon Pontin, Rochester, NY
Michael Stier, Baltimore, MD
Phil Urbina, Carlsbad, CA

And to the 200 or so other supportive reporters, thank-you for the great interviews.

Public Television Stations

A giant, humongous, enormous thank you to the 193 public television stations across the nation who have supported my dream and have aired my childrens' series, "The Secret City."

Enthusiam Maintenance Crew

Beau & Bunny
Binney and Smith, Inc.
Ray Bradbury
Quirt & Tammy Crawford
City Copy of San Diego
Debbie & Shawn
Denise & Colleen
Renee Eads
Joel & Marsha Gori
Ralph & Helen Harner
Donna & Ken Hayward
Hunt Art Materials Corporation
Ann King
Charles & Helen Kistler
Joyce Kistler
Karl "bro" Kistler
Mari Kistler
Steve & Tina Kistler
Melissa Layton
Beth Maniero
Sonja Manza
Maryland Public Television Crew
Tony Matthews & Michelle McCowen
Robert Neustadt
New York State Imagination Celebration
Earl Nightingale
Nike Shoes
John Price
Dan & Terri Roper
Greg Rudolph
Harry Schurch
Lee Iacocca's Secretary
Lee Soloman

Coffee Shops

Bombay Beach Club - Cass Sinclair, you're a 10
Denny's Restaurants - great coffee
Dooley McCluskey's - wonderful people
McDonald's - comfortable drawing tables
Thai Spoon - Danny Khaimarn/Thee Ravat
And to all the coffee shops up and down Interstate 5 thank you for
allowing me to sit for hours on end just so I could Draw! Draw! Draw!

Airlines

Alaska Airlines - incredible service
American Airlines - yummy omelet at 6:05
Delta Airlines - the best roasted almonds
MarkAir - cool name
PSA - I miss you
TWA - nice seats

WHAT'S INSIDE
(Contents)

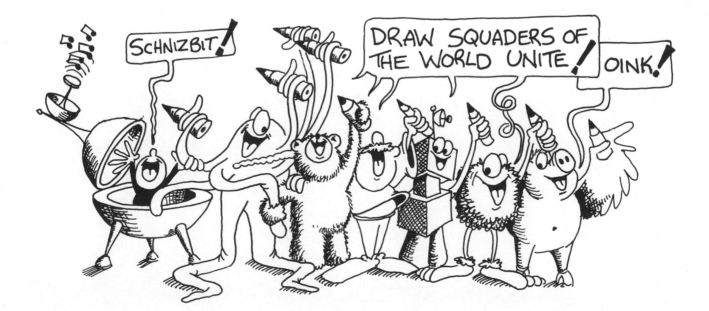

My Goals

My goals for this book are simple. I want to: sell you on your own awesome, creative potential; to dissolve the myth that you *can't draw a straight line;* to guide you through a series of 30 sequential drawing lessons. These lessons are structured into a format that will teach you how to draw.

I promise you. If you listen to me and follow the lessons *you will learn to draw.*

FOREWORD by James M. Clarke

Who is the most noted art educator in the history of modern art education? Have you ever heard of Viktor Lowenfeld? J.W. Janson? Kimon Nicolaides? Betty Edwards?

If you walked into an elementary, middle, junior high or senior high school classroom in many U.S. cities, and asked the students about Lowenfeld, Janson, Nicolaides or Edwards—I would imagine that no one, not even the teachers, would know how important these individuals have been to art education. However, if you asked the same group who "Commander Mark" is, I would wager that many would know the answer. This is why I say—without reservation—that Mark Kistler, alias "Commander Mark," is the most noted art educator in the history of modern art education. He has touched the hearts of millions of children and made "Draw! Draw! Draw!" a national pastime.

When I was first introduced to Mark Kistler, it was by one of my "best" friends—my seven-year-old son Brandon. At the time, three years ago, I knew Mark Kistler only as the star of "The Secret City" public television show which appeared on KUHT-TV in Houston, Texas. It wasn't long before my other two children—James and Kristen—were members of "The Secret City" Drawing Club and I wanted to know more about how and what he was teaching.

I was skeptical at first of the young drawing enthusiast with his special recipe for teaching children to draw; however, in 1987 I had the opportunity to see Mark in action when he conducted workshops in several Houston area school systems. I was impressed! He single-handedly turned two school systems into drawing fanatics. He worked with the administrators, teachers, parents and most importantly, the children. He spoke like an art educator with many years of experience. He knew what art education and children's art were all about and explained it in a way that all could understand.

On the whole, art educators are always leary of television artists with sure-cure elixirs and quick fix-it-all remedies to teach people how to draw or paint; but the more I watched his show and saw him in action, the more interested I became in Mark Kistler the art educator. As an art teacher and supervisor, I was always in search of the "ultimate" lesson plan to teach my pupils—whether child or adult—how to draw, how to paint, how to sculpt, how to understand and acquire the skills to create great art that each of my pupils could be proud of.

At one time or other, all art educators are influenced by an art professor or teacher with a specific method of teaching him or her how to paint or draw. Do you think that Michelangelo's teacher Donatello had a step-by-step way of teaching his pupils to draw? I do! Kimon Nicolaides, the master of *The Natural Way to Draw,* had a method, and so does Betty Edwards, author of *Drawing on the Right Side of the Brain.* Mark Kistler's way of teaching children to draw is as creditable as all of those before him. His method gets results!

Mark! Thank you for helping the art educators of the world teach our students to Draw! Draw! Draw!

James M. Clarke,
Former President, Texas Art Education Assoc.
Art Curriculum Director, Aldine School District, Houston, TX

FOREWORD by Mona Brookes

As I traveled through the school systems teaching representational drawing, I began to hear about "Commander Mark." Teachers and students would ask me if I knew him or had ever drawn cartoons or super cities with him. I consistently noticed energetic and happy expressions on their faces as they inquired, and their arms went into lively animation as they described to me what he did. When I first began to see the drawings that were generated by his method, I understood their excitement. I saw a different type of drawing than I taught, but one that obviously had tremendous benefits. As I looked at a page filled with endless buildings overlapping one another, streets and bridges going in every direction, renderings with understanding of perspective, shading, volume, size and dimension, I was thrilled with the *learning* I knew was going on. As I looked at imaginary cartoon characters that were whimsical and funny, I was relieved that children were exposed to fun images instead of violent ones.

I learned Mark was concerned about issues such as too much television-watching and its focus on enemies, rivalry, competition, and violence. I heard he was trying to stop what he called the "Creativity Crunch Syndrome," by exposing children to drawing in a way that would raise their self-esteem and confidence. I heard that he was supportive of other methods and encouraged students to try different styles and approaches. I was so pleased that someone else was out there showing kids, teachers and parents how to have a positive spirit and how to enjoy the magic of drawing.

Many artists and educators might wonder at my excitement over wanting to support Mark Kistler's drawing method. "After all," they would say, "with a book on drawing, why would you want to recommend someone else's methods? He's one of your competitors." As an art educator I hear this type of comment, along with negative criticism of other teachers' approaches and work. Actually, this is one of the major reasons I am so delighted to write a foreword to Mark's book. It provides me with a wonderful opportunity to state how I view such opinions. I think that artists and art educators must stop competing among themselves if we are to break down the Creativity Crunch Syndrome that Mark talks about. Fine art, commercial art, or cartooning are simply different expressions of artistic communication and are not to be compared. Each calls for an equal but different kind of creativity. If we display judgmental attitudes toward one another's work, our students get the misconception that there is a "right way" to draw. And, since there is no *real* agreement as to what this "right way" is, students are not willing to risk judgmental criticism and simply refuse to try.

It has been estimated that over 90% of the population stops drawing by the age of ten. When I ask adults who are sure they can't draw, to try anyway, they produce the same stick figure drawings they drew when they were around eight years old. When they are given a safe environment in which to explore, where they are free to look at each other's work, given permission to share ideas with each other, and denied the habit of using words like "good," "bad," "better," "best," or "mistake," I see those same adults quickly making skillful drawings. I am so glad I have a drawing buddy who agrees that competition and criticism of one another's drawings are two of the main blocks to achieving creative expression.

There is another major block I feel is keeping people from experiencing the ability to draw. The 90% of the population that feels thay cannot draw needs a practical and structured approach to the subject. Mark recognizes this need and

leads hundreds of non-drawers to simple and easy success. There has been a philosophy in the field of art education that you should not teach a child how to draw because it will stifle his or her creativity. This doesn't seem to be true to a lot of us now. Imagine a child or a beginning adult trying to learn a musical instrument, to write a poem or to master dance form without first being given instruction on how to learn the scales and play simple songs, to learn the alphabet and write simplified compositions or to be shown body positions and copy basic dance steps. Since only 10% of the population was experiencing some drawing success without guidance, some of us decided to give training in how to use basic drawing tools. The trick was to teach some principles about the basic components of drawing and leave room for the imagination to interpret that information in its own way. The problem was that drawing, like jazz improvisation, was one of those few subjects that the artist simply had a hard time knowing how to teach. Many artists admit they don't know how to explain the way they draw.

When I finally met Mark we talked for hours. We discussed how we had devoted years to analyzing and field testing how we drew, in order to find out what worked best. When you experience the enthusiasm of Mark's students and see the school walls lined with imaginative drawings, you know that his system is simply to encourage creativity. When you read the stories that accompany the wild and exciting drawings his methods produce, you realize more creativity is going on than meets the eye. He captures the attention of a generation of children who are observers and motivates them to participate. As they express their ideas visually they get more involved in their environment and become more open to life.

The only drawing that I saw going on in elementary schools ten years ago was stick figure drawings except for a few rare children who drew with what was considered "inherited" talent. Stick figure drawing is simply another kind of drawing. It is extremely important to the development of a child and should be allowed to flourish. When parents and teachers see the way young children can draw through structured methods like Mark's, they can mistakenly fall back into those comparative habits again. They can decide that structured methods are better and try to stop the natural growth of the symbolic stick figure process. Stick figure drawing, imaginative cartooning, and representational drawing are all different types of drawing and can co-exist in a child the same way ballet and tap dancing can. The point is to give children as many forms of drawing as possible so that when they no longer want to draw those stick figures they have options open to them other than quitting.

I think society has a habit of trying to figure out who's got the best, or the biggest, or the smallest, or the fastest, or the one and only way to do something. It's my contention that the more ways you are open to doing things the more possibilities you have of communicating your ideas and visions. Like Mark, the method that I have developed is a structured approach to teaching drawing, and I am convinced that it enables people to be more creative. Mark is teaching people how to use their imagination in the field of cartooning and guiding them to understand how to give their drawings depth and dimension. I am teaching people an alphabet of the elements of shape, so that when they look at objects in their world, they know how to draw realistic interpretations of them. I have watched a core group of my private students from age 4, who are now turning 12, use this type of structured method. They were regular

preschoolers when they first started and were dependent on the structure in the beginning stages. By the time they were 8-years-old they had no intention of stopping and were capable of independently tackling still life, people, animals, landscape, design and multi-media drawing projects that I never saw until I entered university. As they are turning 12 they are being designated by their schools as artistically gifted and are winning local art contests hands down. Even though these students received demonstration in the beginning and images to copy, their drawings became uniquely individualized and independently expressive.

I believe that if you combine structured and unstructured methods you can't miss and I recommend that you integrate as many different drawing approaches as you can. When I met Mark I was delighted he felt the same way. We talked about how teachers were reporting student gains in basic reading skills, concentration levels, and problem-solving abilities while participating in this type of drawing program. We told stories involving thousands of people, of all ages and walks of life, who were amazed at how quickly they were able to draw with some structure and guidance.

Commander Mark is an exciting experience. He has a great time with people while demonstrating how easy it is to take charge of a pencil and a piece of paper. He gives you permission to explore stimulating ideas and invent imaginative environmental drawings. While he's at it, he gives you some solid basic skills in volume, perspective, line, and shading. He has created this book so that you can experience the benefits of visual communication and have a lot of fun while you're doing it. I hope you have a wonderful time drawing with him.

Mona Brookes, Author
DRAWING WITH CHILDREN, A Creative Teaching and Learning Method That Works For Adults, Too

Paul Dutschmann, age 16
Hawaii
"Paradise"

Chapter 1
"I Can't Even Draw A Straight Line"
Dissolving a Popular Myth

What if I handed you a piece of blank paper and a pencil and asked you to draw a house. What would you say? I've asked this question to thousands of adults in my workshops, and invariably they give me the same response: *I can't even draw a straight line!*

You've probably always believed that you needed talent before you could learn how to draw. Consequently, you've wished that you had some. Well, I've got a surprise for you -- you have enormous stockpiles of talent stored away. It's just that you've never been exposed to a systematic program, offering rules to follow, structured goals to achieve, and step-by-step lessons to build your drawing talent.

Mark Kistler's Draw Squad is the culmination of everything I've learned from my master teacher, Bruce McIntyre, and from my nine years of classroom teaching.

My first class began with only 20 students. Within a year the enthusiasm generated by those first students burst the classroom seams to 600 students! "Hey, I can draw!" excitement has been building ever since. From the thousands of schools where I've lectured throughout the country, to the airing of my childrens' television show, "The Secret City," on national public television, literally millions of students have been able to dissolve that ridiculous myth of "I can't even draw a straight line!"

Each of these students has conquered the flat surface of a piece of paper with what I call "pencil power." Pencil power is the understanding of the Ten Key Words of Drawing.

My philosophy is simple. I'll teach you the Ten Key Words of Drawing. You take these words and nourish them with a daily 20-minute drawing workout. In one week, you'll see an incredible difference in your drawing skills. Once you understand the Ten Key Words, you will be drawing creatively and *confidently* in three dimensions. I promise. It's that simple. I call it "The Drawing Diet." Don't get alarmed; it's the easiest diet you'll ever go on!

Are you still skeptical? I mean, sure *kids* can learn to draw. They're brimming with imagination just waiting to get out. What ever happened to that creative spontaneity we once had in kindergarten, anyway? What happened to that "art attack" (this is what I call that uncontrollable need to draw...Draw, Draw, Draw!) enthusiasm we once had back in the first grade? Remember plunging your hands into a milk carton of bright wonderful paint and splashing it across an oversized sheet of paper? Remember splashing it across your entire desk, your clothes, and the kid sitting next to you (now that's an art attack!)?

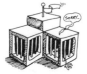

Where has our childhood magicland of imagination gone? Ah...I truly believe this wonderfully powerful imagination hasn't gone anywhere at all. It's sitting there inside of us just where we left it years ago. It's back with all those other childish things we slowly lost confidence in and eventually traded for adulthood.

But, you can avoid this breakdown in confidence and creativity. I believe that it stems, in part, from the fact that no one has approached the teaching of drawing skills in the same successful method that reading and mathematics have been taught; that is, starting with the fundamentals.

In mathematics classes, students begin with simple, simple, simple addition and subtraction (with visual aids, I might add! Three oranges minus one orange

equals...). After that comes multiplication and division, and after that the more complex branches of math, but even so, the fundamentals are always maintained.

Reading and writing are treated in the same systematic way. First the alphabet is introduced, then a vocabulary is built, then sentences, etc., etc., etc., and, oh, yes, lots of books need reading and lots of essays need writing, but still, the most important element is daily practice! I think you see my point now. We can't expect a student to solve math problems by giving him or her a piece of paper and a pencil and saying, "Okay, do math." Yet, it's very common to give a student that same piece of paper and pencil and say, "Okay, draw, and by all means, be as creative as you like!"

That's exactly what happened to most of us as kids. After thousands of attempts at drawing and very little success at conquering a simple piece of paper, we found a way out, the I-can't-even-draw-a-straight-line escape. This is what I call "The Creativity Crunch Syndrome."

Don't worry. The teaching of drawing hasn't been completely abandoned. A giant art wave is sweeping through our nation's school system. Teachers everywhere are realizing the importance of drawing in the classroom. We are starting to notice the impact of years of brilliant work by international, national, and statewide art education associations. Moreover, the publication of the thoughts and programs of such geniuses as Bruce McIntyre (*Drawing Textbook*), Betty Edwards (*Drawing on the Right Side of the Brain*), Mona Brookes (*Drawing With Children*), and the former president of the Texas Art Education Association, James Clarke (*The 4th "R" in Education is Art!*) have contributed enormously. In addition, such institutes as The National Art Education Association, The Getty Foundation, and The John F. Kennedy Center have, through innovative research and classroom application, developed many workable and results-oriented programs. With all of these super brains behind quality art education, I'm confident students today won't need to endure the "creativity crunching years" like we did.

Let me give you a little history on how I became so involved in the systematic teaching of drawing. I was fortunate enough to study for 12 years under the guidance of Bruce McIntyre, a man so dedicated to kids that he left Walt Disney Studios for them. He decided to dedicate his life to teaching kids how to draw. Building from Bruce's 44 years of experience, I developed a series of drawing lessons designed to strengthen a child's self-esteem. My success-oriented drawing lessons first splashed across the country in my 1985 national public television role as "Commander Mark" of the Secret City, a wonderful show of fun, fantasy, and adventure. Millions of viewers learned how to draw using the very system that you are about to learn. Over 150,000 letters from kids, parents, grandparents, and teachers motivated me to turn my program into an informative, yet enjoyable book. During the past two years, since the show began airing, I've compiled notes from my classroom video productions, classroom lectures, summer art "flight" schools (we let our pencil leads do the flying), and a national school assembly tour.

And, here it is...30 incredibly fun, enriching, sequential lessons that will teach you how to blast across a two-dimensional surface with pencil power. You will learn how to turn that simple white piece of paper into an amazing three-dimensional space! In a few short weeks, I know you'll be looking at your "Daily Drawing Journal" and saying exactly what all of my students say:

"Wow, like this is totally rad, man. I really can, like, draw. Wow!"

So, are you ready to get started? Complete the following pre-test:

The Pre-Test

"Oh, no!!! Not a drawing test! Augh! I can't even draw a straight line!!!"

I knew you'd say that. I assure you, this is only a gauge for you to measure your current drawing skills. As time goes by, you'll have this pre-test as a reference with which to judge your progress, and as a "before-and-after" journal entry.

When I ask elementary school kids to draw me a house, these little, creative geniuses don't just draw me a house, they draw barns and castles and space stations. It takes a lot of coaxing to get adults' creative self-esteem high enough to allow them to draw.

Before I show you how most adults draw a house and why they draw it the way they do, I want you to put aside that *I can't even draw a straight line* notion, and draw a house. Relax, loosen your fingers...and let your pencil fly!!!

Take another couple of minutes and draw me an airplane. What? I heard what you muttered under your breath, but you're wrong. You can draw! The house and the airplane drawings are important in proving a point! So, even if you think these drawings look like over-cooked spaghetti, keep them for comparison's sake. I promise you. You're going to be amazed by your progress in less than an hour! Now, draw an airplane.

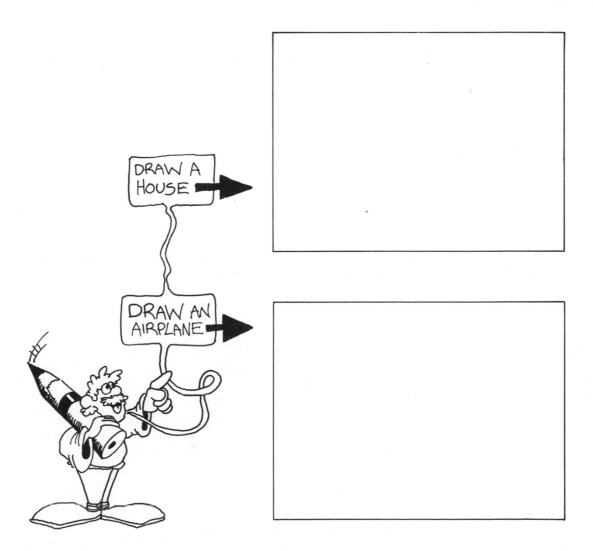

Okay, so you're wondering what's the point? Are you keeping your hand nonchalantly over your sketches out of amused embarrassment? Ninety-eight percent of the adults I've worked with respond the exact same way. Their drawings look like these:

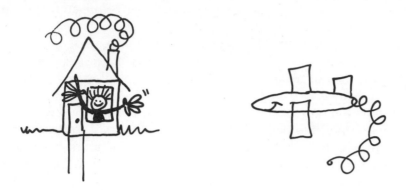

How do your drawings compare? (In my seminars, most adults would be laughing hysterically right now, especially when I have some kids' drawings on a chalkboard in front of the group!) The kids and adults are drawing on the same skill level. The house drawing above is a two-dimensional, flat symbol for a house. We all loved to draw when we were very young, but, unfortunately, the skill of drawing was not taught with a thorough, sequentially structured program such as math or reading. Our drawing skill abruptly stopped developing before our creativity had a chance to blossom.

I call these pre-test houses "McHomes" because million of people draw exactly the same symbol for a house. The same for "McPlanes." A subtle revenge against the airlines for too many delays, too much turbulence, too much lost luggage...running out of honey-roasted peanuts! We could crank out these McPlanes in no time. Just think, a lifetime supply of soggy, turkey sandwiches, vacuum-packed in plastic baggies, each served with a single leaf of lettuce, half a pickle, and a radish!

Okay, enough is enough. You're probably thinking, "Gee, what a sensitive drawing teacher." Honestly, most adults draw exactly like they did as children because that's when their artistic development stopped. But, the jokes and hysterical pointing do have a point. I'm breaking down the Creativity Crunch Syndrome! The resiliency of people is so inspiring. These same adults who laugh hysterically at their own drawings (I hope you're laughing by now!), will throw away 30, 40 and even 50 years of creativity crunching, pick up a pencil, flip over their pre-test (saving their "flat" drawings for comparison's sake), and will keep right on drawing with me! Each one walks out of my seminars with a fistful of excellent three-dimensional sketches, a positive, creative attitude, and an uncontrollable desire to buy three large sketchbooks!

To Teachers (society's true heroes):

Chapter 3 is a "Teachers' Section" where I'll outline why drawing is critical in your classroom, how drawing can be used as the hub of your curriculum, and how you can harness the enthusiasm this program generates to build each student's self-esteem. I'll share with you some "hot" classroom drawing techniques with a guarantee to extend "on task" project time. Yes, every chatterbox, eraser-throwing, tack-taping-on-chairs Johnny will sit quietly for LONG periods of time, completely engrossed in geography, social studies, math, or any subject where drawing is used as a teaching vehicle.

To Parents:

Chapter 6 is a "Parents' Section" where I'll outline activities for you to try with your children to utilize that powerhouse of creativity within them. It wouldn't hurt for you to do the activities with them. I'd also recommend that you check out the "Teachers' Section." There are some great ideas there that I don't go over in your section. But of course you'll read it; You're a 24-hour-a-day teacher!

To High School Students:

Chapter 8 is a special note for you. I tell you about my personal story of drawing success. How I've utilized drawing to visualize and achieve my dreams (one of which is this book). Use my story as an enthusiastic energizer to launch *your* dreams! Say "Yes to Drawing and No To Drugs."

To Kids:

You're about to launch into the world of drawing, a place of exciting adventure! A place where your pencil will blast across the paper to create wonderful three-dimensional drawings. Beginning with Lesson 1, I'll guide you through 30 drawing adventures. Each of these will ignite your imagination and will keep you drawing all day long. Grab your paper and pencil and get ready to Draw, Draw, Draw!

One Last Thought

Before you actually begin the lessons, let me leave you with one last thought, no, one MORE thought (I never have a final thought!). So, think about this. Visualize your progress. Eventually (sooner than you think), you'll be drawing it! So, get ready. This systematic drawing program into which you are about to plunge will be like surfing the crest of an artistic tidal wave.

You are about to taste the fruit of *confident* creativity. Bon Appetit!

The Draw Squad's
TEN KEY WORDS OF DRAWING

These Ten Key Words can be successfully combined to create the illusion of three-dimensional drawing.

This method, which has worked tremendously well in my classrooms, teaches the students fundamental drawing skills in a structured format to ensure success. I've found that the "idea launch" or the "extra button" is the motivator in getting students to use the Ten Key Words without copying my illustrations. This helps each student develop his or her own style of skilled visual expression.

Foreshortening

Distorting objects or parts of an object to create the illusion that one edge is actually closer to your eye.

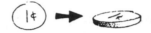

Shading

Adding darkness to a surface that is opposite an imaginary light source adds depth to your drawing.

Surface

Drawing objects or parts of an object lower on the surface of the paper makes them appear closer (with the exception of objects in space i.e. birds, clouds etc.).

Size

Generally, objects drawn larger will look closer, except when overlapping.

Contour Lines

Lines wrapped around the contour of a round object adds volume and shape to the object.

Overlapping

Objects drawn in front of others will make the front objects appear closer.

Density

Images drawn darker, and with more detail, will appear closer than images drawn lighter and with less detail. This adds "atmosphere" to the drawing.

Shadows

Shadows are cast off the object from the shaded side. This anchors the object firmly onto the surface. Shadows can also be used to create an "overhang" or "hover" illusion.

Attitude

A student's self-esteem and confidence are critical elements to be nurtured when teaching any skill. The previous key words produce results which enhance attitude. However, positive role-modeling, quotes, ideas and encouragement are constantly needed. Remember, keep a POSITIVE MENTAL ATTITUDE.

Daily Use

All nine of the previous key words are practically useless to the student's pencil power without daily application.

Your Drawing Lesson Format

Each of the following 30 lessons is broken down into nine components. These lessons follow a student-tested sequential format. Within this format, you will learn the *Ten Key Words of Drawing*. These important, basic ideas will help you understand and apply all the techniques I'm going to teach you.

Before we start, let me give you a short description of each of the components that comprise a lesson.

Component 1: The Warm-Up

An imagination exercise loosens up your fingers and your creative mind. Athletes stretch their muscles before working out; bassoonists limber up their lips and fingers; dancers stretch their toes; programmers warm up their computers; and artists loosen up their fingers with *Drawercise!*

Component 2: The Key Drawing Word

Knowledge builds confidence. This section focuses on a single skill. A specific key word is defined and the technique explained. Twenty leading art educators from around the world assist me in defining these words for you. This exciting collective effort assures your success in the program!

Component 3: The Lesson

Practice builds skill. Each lesson focuses on a special drawing skill through six step-by-step exercises. These detailed lessons, designed for *daily* 30-minute practice sessions, will build your drawing skill.

Component 4: The Student Gallery

This section is used exclusively for promoting positive, creative thinking through drawing. I've selected 30 student drawings (from the hundreds of thousands of drawings I've collected through my seminars) that best illustrate the Ten Key Words. I'll also use a selection of quotes from my heroes and art attitude energizers. With each lesson I want to strengthen your drawing confidence.

Component 5: The Motivator

I include former students' "before and after" drawings. By studying these drawings, you'll fuel a positive, I-can-do-it attitude. These drawings are also great "idea banks."

Component 6: The Bruce McIntyre Success Scale

This scale measures your drawing skill improvement. Starting with Bruce McIntyre's seven levels of success, I have created a system that offers one success level per lesson. This series of small attainable goals will move you closer to mastering specific drawing skills. From lesson to lesson you will tackle more difficult challenge levels. The result? Increased confidence, interest, and enthusiasm.

Component 7: Draw Sheet/Wrap-Up

This is a practice page toward the end of each lesson for reviewing the lessons you've just learned. It's a full page of drawing activities that you complete directly in the book. The Wrap-Up, at the bottom of the Draw Sheet, summarizes major points of the lesson and suggests ways you can utilize your spare moments such as when you are waiting in line, waiting on hold, or taking a coffee break.

Component 8: The Drawing Contest

This is designed to encourage you to go beyond the basics of the lesson. By applying the Key Drawing Word, you blast off with skill and confidence. You're encouraged to add "extras," your own creative touches like swirls, doors, windows, fur, knobs, peaks, stairs, wraps, creatures, caves, people, and color. A fun element of student competition is added by listing the record holders of each contest. For example, the record holder in the Flying Saucer Contest has drawn over 2,000 flying saucers within a given space!

Component 9: Daily Drawing Journal

With a drawing journal, you'll be able to visually track your skill improvements. That's right, you're actually allowed to draw in this book! (In fact you must!) After two weeks of faithful daily entries you'll be absolutely amazed with your drawings. Your rapid improvement will be logged for all to see. This journal strengthens the understanding of the key drawing word **daily.** Without daily practice, the other nine key words are practically worthless.

These nine components make up the drawing success formula:
Ten Key Words + extras + daily practice = Superb Drawing Skill.

Supplies You Will Need

Paper

Get yourself two spiral bound sketchbooks of at least 100 sheets each. 8 ½″ x 11″ is a good, standard size.

Pocket-size sketchbooks are also good to have around because they can be carried easily. You never know when an art attack is going to hit!

Drawing Tools

Pencils are the cleanest and easiest tools to work with. Standard #2 pencils work well. If you want, you can use mechanical pencils. Use 2B leads or a comparable hard lead. You'll want to buy plenty of pencils, standards or mechanical--you know how they always seem to get misplaced.

Bananas

There are many types of bananas to eat while you are drawing. I recommend the yellow ones, a bit soft, with freckles on them. If your felt pen is handy you can warm-up by drawing thoughtful faces on your banana. Be sure to remove this ink covered peel immediately, as to avoid ink poisoning and the subsequent arrest of the drawing maniac who suggested that you draw on a banana.

Miscellaneous

Besides the above mentioned basic supplies (the basics), the rest is up to your imagination. I always encourage experimentation. You may find that a soft lead works best on shadows (it does) or that a thick felt pen will give you a strong line (it will). Using colored paper instead of white may change the character of your drawings. Textured paper will help you create contrasting surface. I find it best to leave the supply list open. You're more likely to discover your own set of supplies this way instead of getting bombarded with tools that I say you'll need.

Robert Johnson
Draw Squader
Macomb, IL
"Pencil Power"

LESSON 1

Warm-up

All right, we've covered the basics: why drawing is important, how this book will teach you to draw, what to watch for, and the pre-test. Now, all we need to do is to get that pencil blasting across your paper in 3-D! Fuel up your "pencil power" by shaking out your drawing hand vigorously and wiggling your fingers for 15-30 seconds. It may look silly, but it's an important loosening-up exercise before each lesson. I call it DRAWERCIZE. (Thanks Judi Sheppard-Misset). Just as athletes stretch their muscles before working out, we artists warm up our drawing hands! Ready…Set…Go!

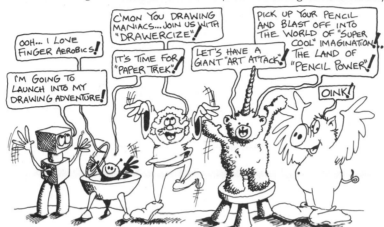

Key Drawing Word: **Foreshortening**

When you draw in 3-D, you create a visual illusion. By distorting images you make them appear three-dimensional even though your drawing surface is flat.

Foreshortening makes one part of an object appear closer than another. To understand this, take a coin between your thumb and index finger. Hold it directly toward you so it forms a circle. Now, tilt the coin away from you until it looks like this:

Voila! A **foreshortened** circle! **Foreshortening** makes any drawing surface appear three-dimensional!

Art Attack: Drawing #1

Happy Birthday Cake

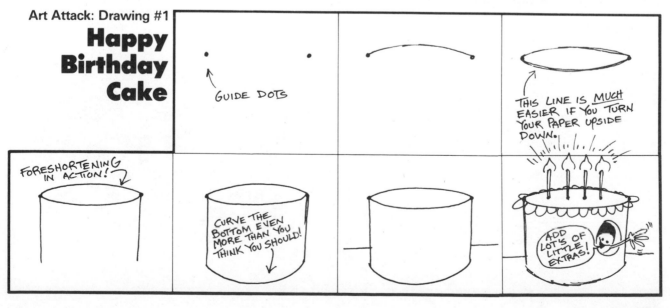

Art Attack: Drawing #2
Simple Television

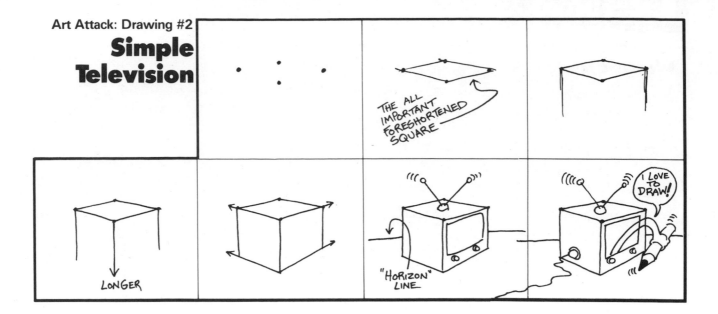

THE ALL IMPORTANT FORESHORTENED SQUARE

LONGER

"HORIZON" LINE

I LOVE TO DRAW!

Art Attack: Drawing #3
Simple Candle

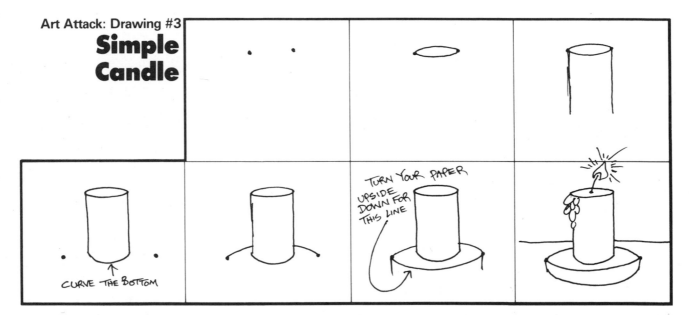

CURVE THE BOTTOM

TURN YOUR PAPER UPSIDE DOWN FOR THIS LINE

Motivator!

Here are two of over 144,000 drawings that I have collected. When you understand the Ten Key Drawing Words, you will experience the same kind of results!

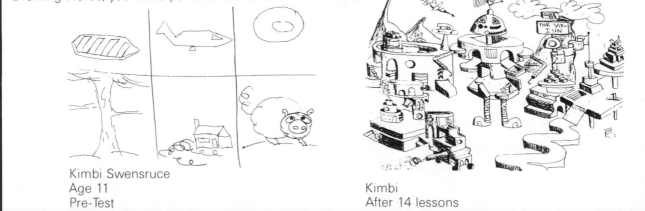

Kimbi Swensruce
Age 11
Pre-Test

Kimbi
After 14 lessons

Art Attack: Drawing #4
Simple Table

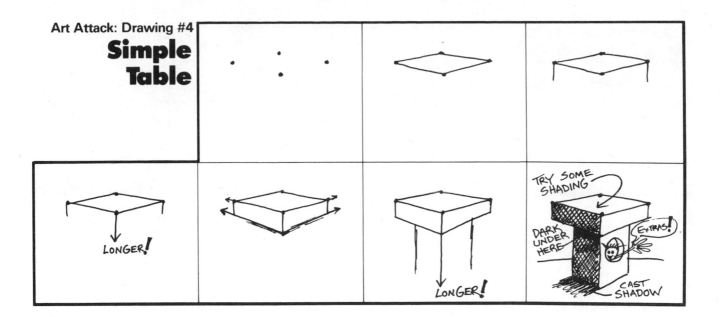

LONGER!

LONGER!

TRY SOME SHADING

DARK UNDER HERE

EXTRAS!

CAST SHADOW

Student Gallery

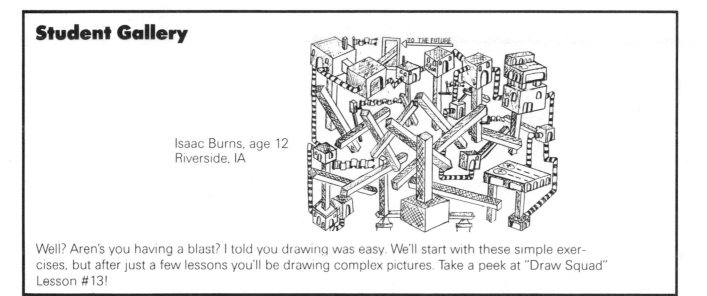

TO THE FUTURE

Isaac Burns, age 12
Riverside, IA

Well? Aren's you having a blast? I told you drawing was easy. We'll start with these simple exercises, but after just a few lessons you'll be drawing complex pictures. Take a peek at "Draw Squad" Lesson #13!

Art Attack: Drawing #5
Simple Witch's Hat

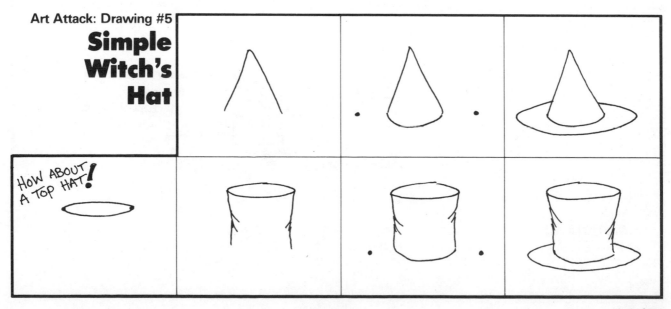

HOW ABOUT A TOP HAT!

Surprise Gift For Mom

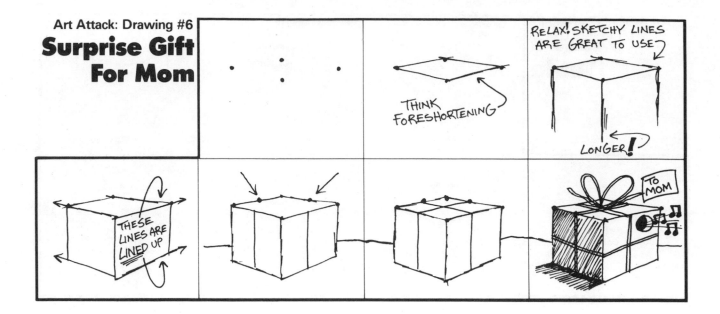

THINK FORESHORTENING

RELAX! SKETCHY LINES ARE GREAT TO USE

LONGER!

THESE LINES ARE LINED UP

TO MOM

The Bruce McIntyre Achievement Scale
Level 1

The Termite Club

Let's measure how much you have learned in just one easy lesson. Draw this simple table (below) three times. Now, have a friend time you. When you can draw it in 30 seconds, you'll be an official member of the Termite Club! There are only 29 more levels to go...Draw! Draw! Draw!

Trial Run #1

Time:

Club Entry

Time:

Trial Run #2

Time:

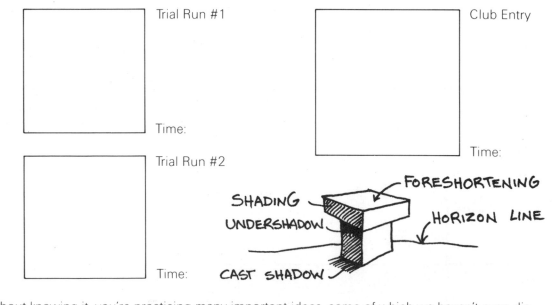

SHADING
UNDERSHADOW
CAST SHADOW
FORESHORTENING
HORIZON LINE

Without knowing it, you're practicing many important ideas, some of which we haven't even discussed yet!

CONGRATULATIONS! You've drawn Level 1 in under 30 seconds! Now you can join the Draw Squad! Mail your drawing into me for your official Draw Squad Club Card.

Check off your progress on the achievement chart!

Draw Squad Drawsheet

Review

Drawing in 3-D is the distortion of an object on a flat surface, creating the illusion of depth. Use **foreshortening** to pull one edge of an object closer to you.

Complete the **foreshortened** circles.

Complete the **foreshortened** squares. Use your guide dots!

Add bottoms to these shapes. Curve them a lot.

Draw the ribbon. Watch your angles!

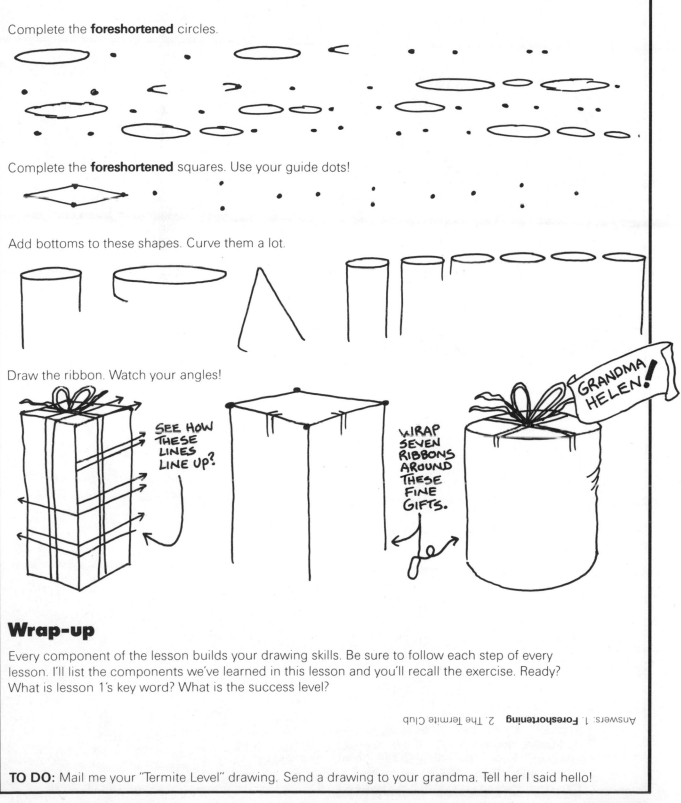

SEE HOW THESE LINES LINE UP?

WRAP SEVEN RIBBONS AROUND THESE FINE GIFTS.

GRANDMA HELEN!

Wrap-up

Every component of the lesson builds your drawing skills. Be sure to follow each step of every lesson. I'll list the components we've learned in this lesson and you'll recall the exercise. Ready? What is lesson 1's key word? What is the success level?

Answers: 1. **Foreshortening** 2. The Termite Club

TO DO: Mail me your "Termite Level" drawing. Send a drawing to your grandma. Tell her I said hello!

Drawing Contest #1: "Termite Opera"

Here's your chance to really let your imagination go! See if you can break Draw Squad member Katherine Wingfield's record of 300 single simple tables on one page. The point is to practice **foreshortening** hundreds of times while having fun! Once your page is full, push the "extra" button. Add dozens of extras! Do you see what is beginning to happen? You're building skill with the key word, then enhancing it with your imagination!

HINT: Begin by drawing tables at the bottom of your page. Then, work your way back into the distance. Add extras! Some small, some tall, some short, some fat....

Daily Drawing Journal

Entry Date / /

ALBERT EINSTEIN BELIEVED THAT IMAGINATION IS MORE IMPORTANT THAN KNOWLEDGE! USE THIS SPECIAL BOX TO STRETCH YOUR IMAGINATION. CONSIDER THIS AREA IN EACH LESSON YOUR **DAILY DRAWING JOURNAL!**

LESSON 2

Warm-Up

Okay, you just finished Lesson 1 and you're revved up. Soooo, you're trying to complete this entire book in one sitting, eh? Great! The more you draw, the more your drawing skill increases. Let's begin this lesson with drawercize for 30 seconds. Shake out all the sketching stiffness. Now, quickly blast across your sketchbook, drawing skinny **foreshortened** circles. Quickly, confidently, go...

Another row...blast!

Fun, eh? One more row...

Key Drawing Word: **Surface**

Each Key Drawing Word increases your ability to control objects on the flat **surface** of a piece of paper. Each word is a drawing tool to create depth—in other words, the third dimension. When you draw part of an object **lower** on the **surface** of your paper, you make it appear closer to you. For example, you curved the bottom of the cake instead of drawing it as a straight line. You also pulled the nearest corner of the package **lower** on the **surface** of your paper.

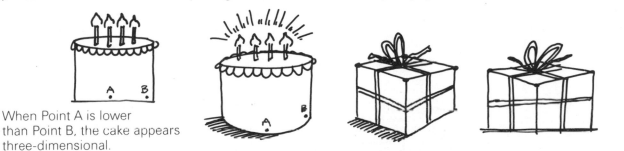

When Point A is lower than Point B, the cake appears three-dimensional.

Art Attack: Drawing #7

Cattail in the Water

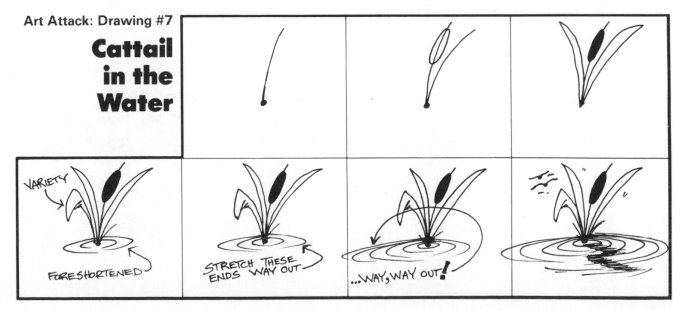

VARIETY

FORESHORTENED

STRETCH THESE ENDS WAY OUT

...WAY, WAY OUT!

Art Attack: Drawing #8

High-Tech Television

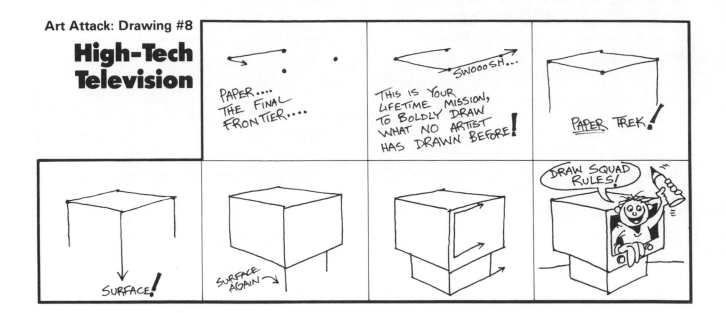

Art Attack: Drawing #9

Double Decker Cake

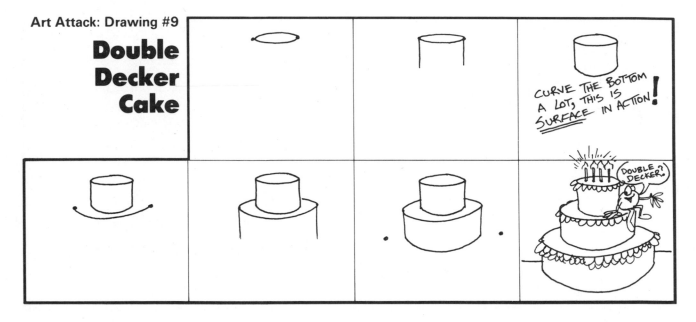

Motivator!

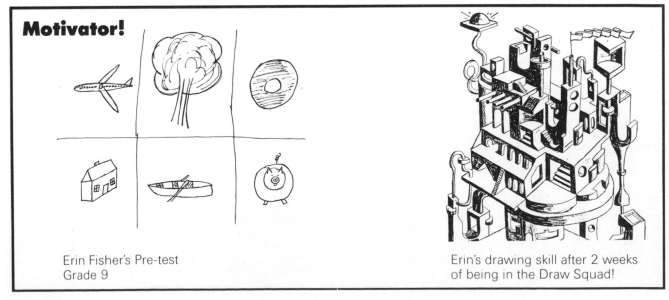

Erin Fisher's Pre-test
Grade 9

Erin's drawing skill after 2 weeks
of being in the Draw Squad!

Art Attack: Drawing #10
Old-Style Milk Carton

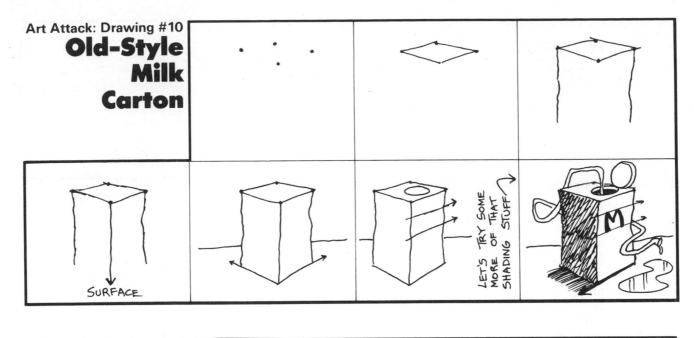

SURFACE

LET'S TRY SOME MORE OF THAT SHADING STUFF

Student Gallery

Gerry Wieck, a mother of 3 drawing students. Her kids taught her after they participated in these drawing lessons.

Gerrie Wieck, mother
Texas City, TX

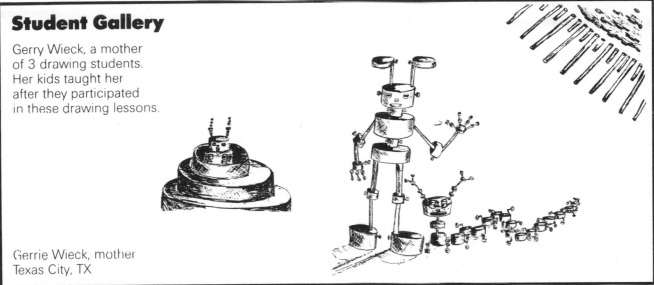

Art Attack: Drawing #11
"Jaws" in the Fishbowl

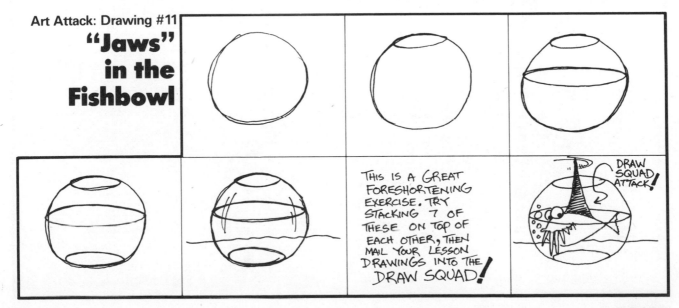

THIS IS A GREAT FORESHORTENING EXERCISE. TRY STACKING 7 OF THESE ON TOP OF EACH OTHER, THEN MAIL YOUR LESSON DRAWINGS INTO THE DRAW SQUAD!

DRAW SQUAD ATTACK!

Kristopher in the Box

(Draw Squad President)

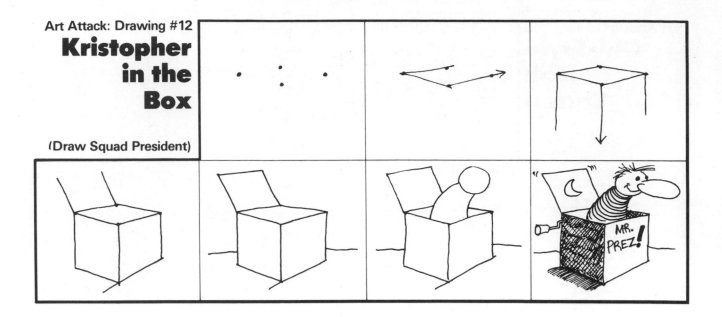

The Bruce McIntyre Achievement Scale
Level 2

The Super Termite Club

We're increasing the level of difficulty. I'll be a cool dude and give you three entire minutes to stack 15 high! Be sure to use the dot directly below the near corner for proper alignment. This also puts the near corner lower, making it seem closer.

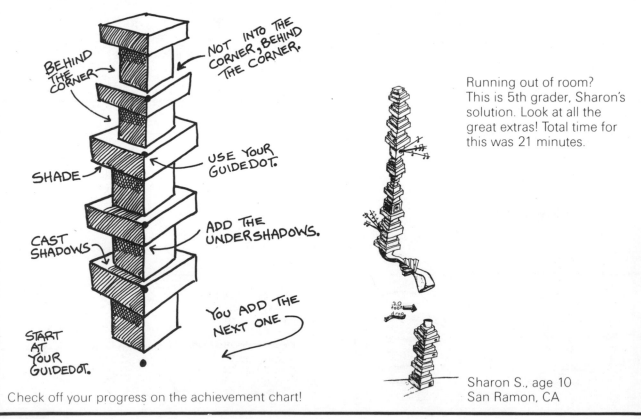

Running out of room? This is 5th grader, Sharon's solution. Look at all the great extras! Total time for this was 21 minutes.

Sharon S., age 10
San Ramon, CA

Check off your progress on the achievement chart!

Draw Squad Drawsheet

Review

Surface is our second Key Drawing Word. To use **surface** successfully, pull near objects lower on your paper. A good example is "Kristopher in the Box."

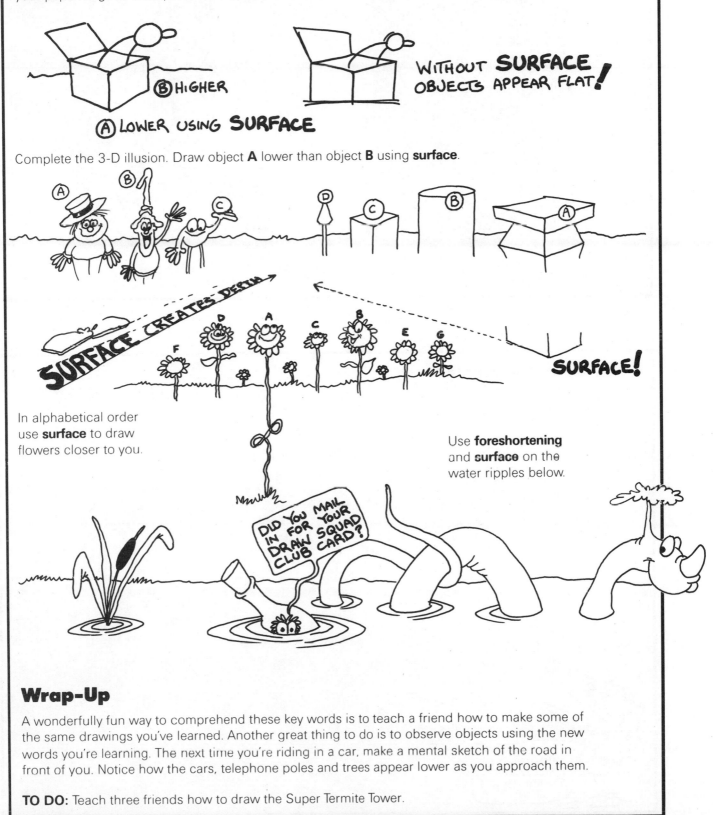

(B) HIGHER

(A) LOWER USING **SURFACE**

WITHOUT **SURFACE** OBJECTS APPEAR FLAT!

Complete the 3-D illusion. Draw object **A** lower than object **B** using **surface**.

SURFACE CREATES DEPTH

SURFACE!

In alphabetical order use **surface** to draw flowers closer to you.

Use **foreshortening** and **surface** on the water ripples below.

DID YOU MAIL IN FOR YOUR DRAW SQUAD CLUB CARD?

Wrap-Up

A wonderfully fun way to comprehend these key words is to teach a friend how to make some of the same drawings you've learned. Another great thing to do is to observe objects using the new words you're learning. The next time you're riding in a car, make a mental sketch of the road in front of you. Notice how the cars, telephone poles and trees appear lower as you approach them.

TO DO: Teach three friends how to draw the Super Termite Tower.

Drawing Contest #2: **The Super Termite Tower**

How many can you stack? How creatively can you stack them? How many extras can you add? Are you going to add color? When are you going to mail your entry to me?

Ricardo J., age 9
Seattle, WA

John F., age 10
Seattle, WA

Daily Drawing Journal

Entry Date / /

IT'S VERY IMPORTANT TO DATE EVERY SKETCH PAGE!

LESSON 3

Warm-up

We're rolling now! You've entered over a dozen sketches in your drawing journal! Way to go! Let's keep this momentum growing...begin with 30 seconds of finger aerobics.

Now a row of:

15 **foreshortened** squares. Ready...Go!

You might want to grab a glass of water for this lesson, to cool you down when you learn how to **shade**, you drawing animal!

Key Drawing Word: **Shading**

This is my favorite technique. With proper **shading**, you can make any drawing look three-dimensional! **Shading** is the darkness you add to an object on the opposite side from the light source. Round shapes have **"blended shading."** The darkness blends from dark to light, defining the curve of the object. For flat objects, such as a box, **"dark shading"** is used. This is a solid tone from edge to edge, making the corner appear sharp and the box appear solid.

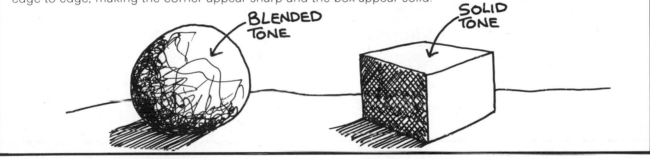

BLENDED TONE

SOLID TONE

Art Attack: Drawing #13

Table with Round Base

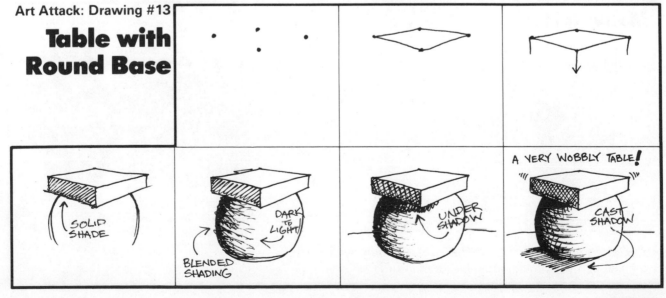

SOLID SHADE

BLENDED SHADING

DARK TO LIGHT

UNDER SHADOW

A VERY WOBBLY TABLE!

CAST SHADOW

Art Attack: Drawing #14

Cool Candle with Shading

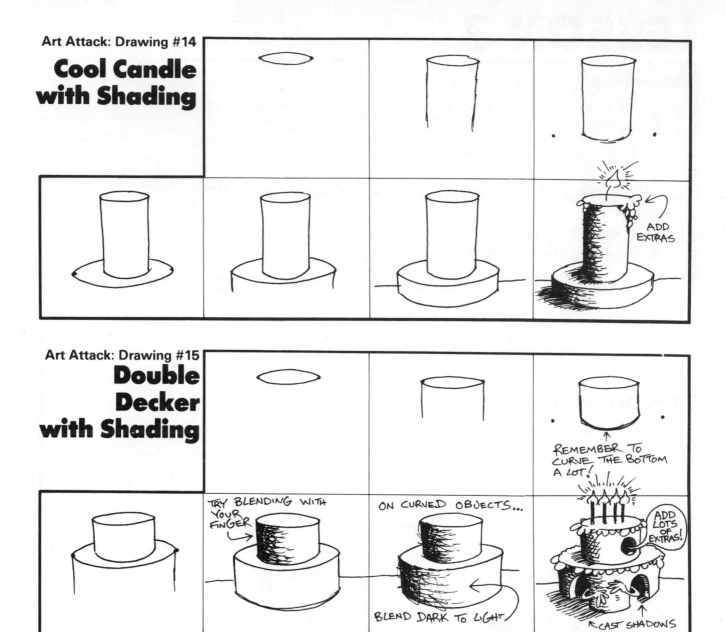

ADD EXTRAS

Art Attack: Drawing #15

Double Decker with Shading

REMEMBER TO CURVE THE BOTTOM A LOT!

TRY BLENDING WITH YOUR FINGER

ON CURVED OBJECTS...

BLEND DARK TO LIGHT

ADD LOTS OF EXTRAS!

CAST SHADOWS

Motivator!

Your before and after drawings are going to be just as brilliant as these!

Forrest Briscoe, age 10
University City, CA
Pre-Test

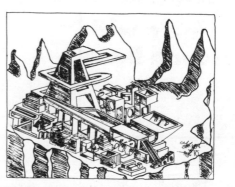

Now look at Forrest's work, after just 14 lessons!

You see? It really works! Learn the Ten Key Words by doing the exercises, then launch your imagination by adding extras.

Art Attack: Drawing #16

Draw Squad Headquarters

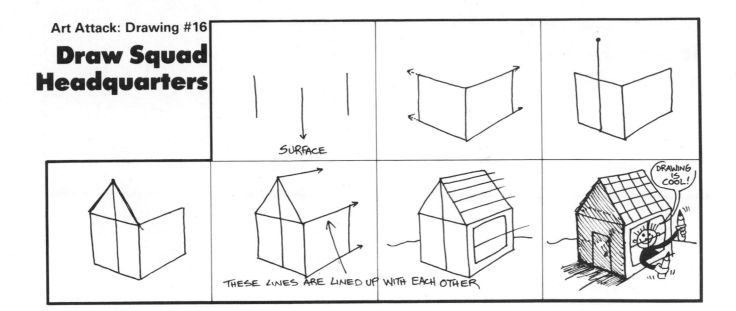

SURFACE

THESE LINES ARE LINED UP WITH EACH OTHER

DRAWING IS COOL!

Student Gallery

Look how creatively Jason Bason (nine-years-old) combined his house drawing into a super cool Secret City— And he did it after only seven lessons. Come on, you can do it, too! Draw, Draw, Draw!

Jason B., age 9
Los Angeles, CA

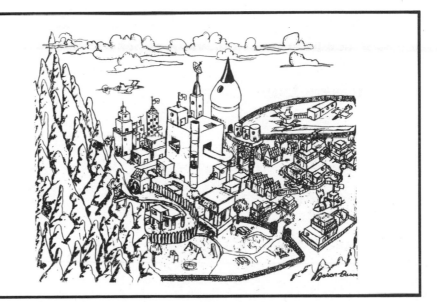

Art Attack: Drawing #17

Simple Flag

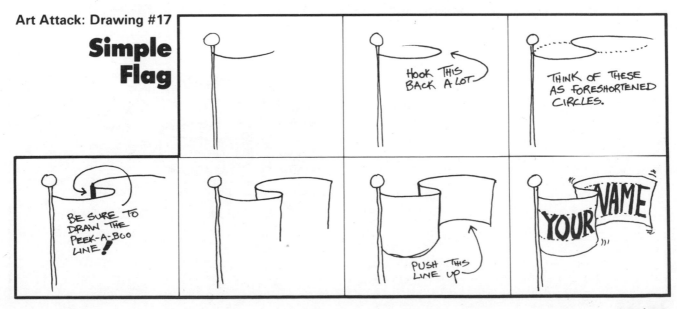

HOOK THIS BACK A LOT

THINK OF THESE AS FORESHORTENED CIRCLES.

BE SURE TO DRAW THE PEEK-A-BOO LINE!

PUSH THIS LINE UP

YOUR NAME

Triple-Decker with Shading

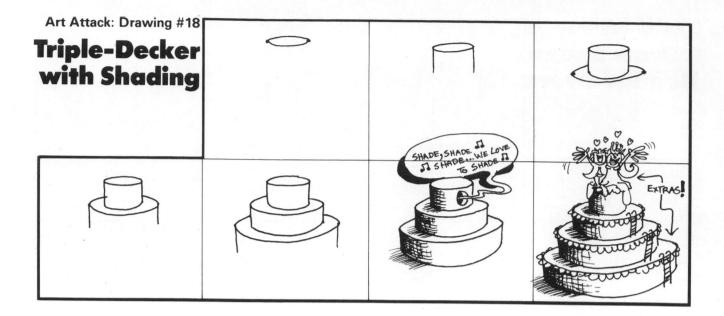

The Bruce McIntyre Achievement Scale
Level 3
The Hippo Club

We're moving through these levels like water! Way to go! Warm up with two trial runs, noting the time of each one. Finally, draw the Hippo Club in less than 30 seconds. Aim for neat, controlled dark lines with smooth blended **shading**. The under **shadow** and cast **shadows** are very important.

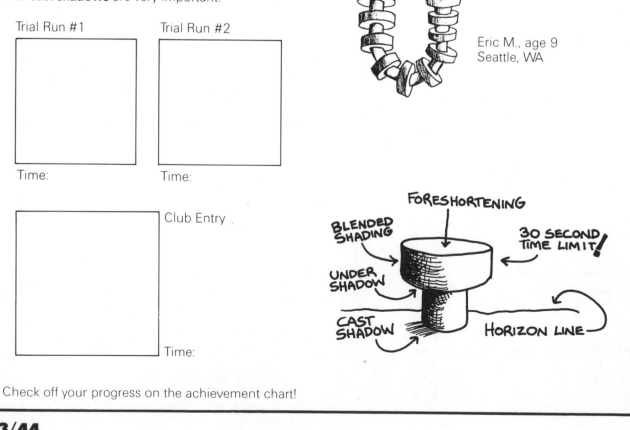

Eric M., age 9
Seattle, WA

Trial Run #1

Time:

Trial Run #2

Time:

Club Entry

Time:

Check off your progress on the achievement chart!

Review

Complete these flags.

IMAGINATION LAUNCH CHECKLIST

☐ Thirty seconds fingeraerobics?

☐ Lesson 3 Key Drawing Word understood?

☐ Drawing Exercises #13-18 completed?

☐ Redraw any two drawings and switch the **shading** to the right side.

☐ Run around the room waving your hands wildly and singing "I love to draw!"

☐ Teach one person to draw a double-decker birthday cake.

☐ Invent a new sketchbook to use in the shower for those drawing die-hards who can't stop drawing for anything.

☐ Write a letter to your local T.V. station asking for more responsible programming.

Add **shading** below.

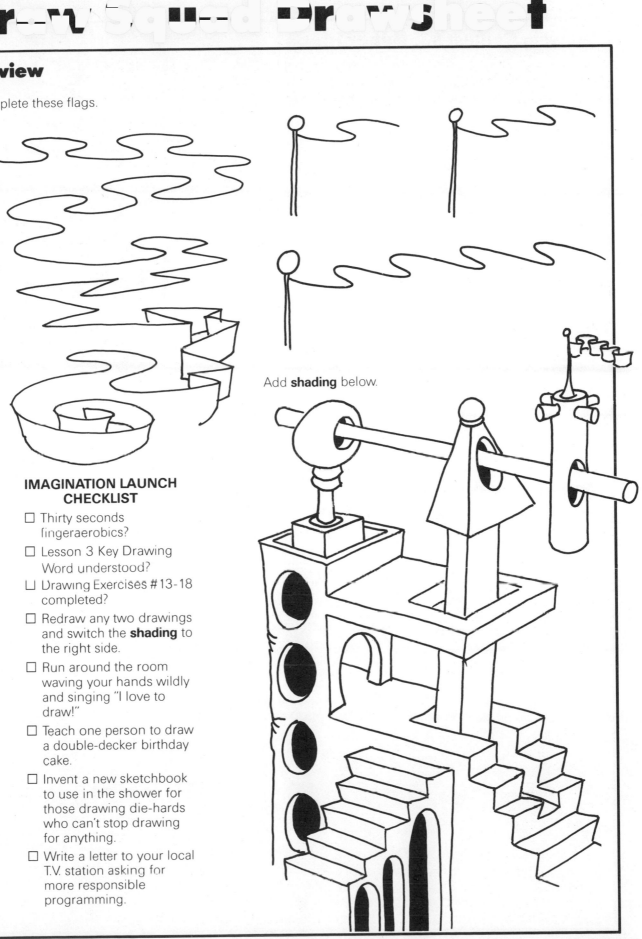

Drawing Contest #3: **Hyper Hippo**

Kimberly G., a fourth grader in New York invented this contest. Combine the Hippo Club and the triple-decker cake. How high can you stack them? Kimberly's record— 65 feet!

Sarah Vickers, age 11
Baltimore, MD

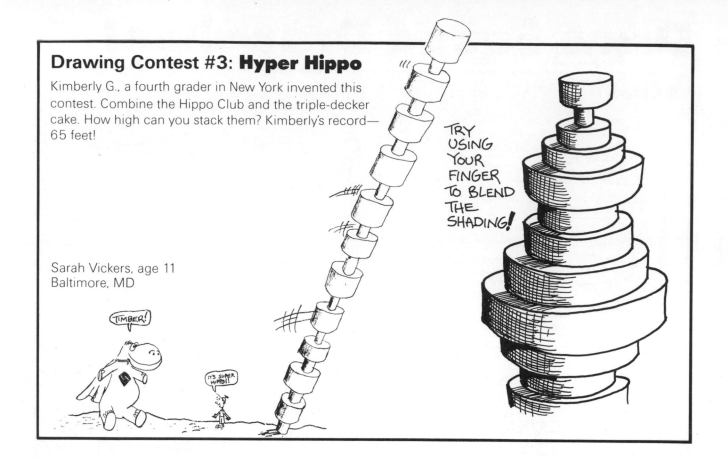

Daily Drawing Journal

Entry Date / /

LESSON 4

Warm-up

So, how do you like **shading**? Pretty neat, eh? I love it! Let's warm up with some of that great stuff now.

Shade these objects.

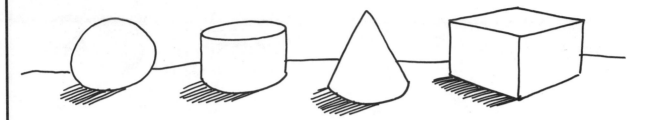

Key Drawing Word: Shadow

Shadow is your anchor in the ocean of drawing. **Shadow** is the darkness cast onto the ground by the object you're drawing. There are several types of **shadows**. Understanding each one will increase your drawing vocabulary.

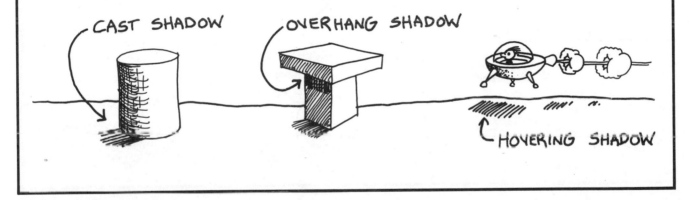

CAST SHADOW

OVERHANG SHADOW

HOVERING SHADOW

Art Attack: Drawing #19:

Termite with Directional Pegs

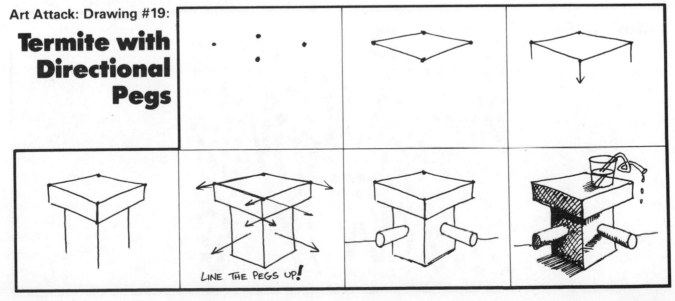

LINE THE PEGS UP!

Art Attack: Drawing #20
Flying Saucer with Melissa

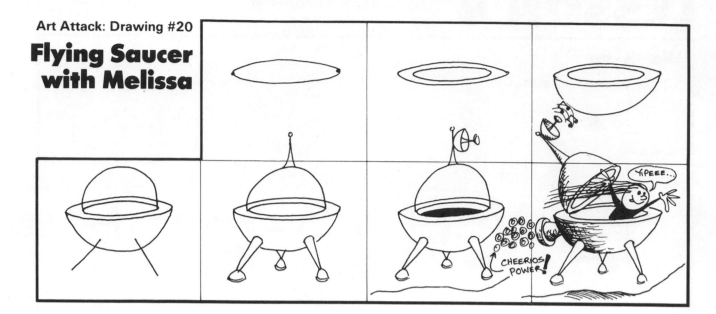

Art Attack: Drawing #21
Pencil in Direction 1

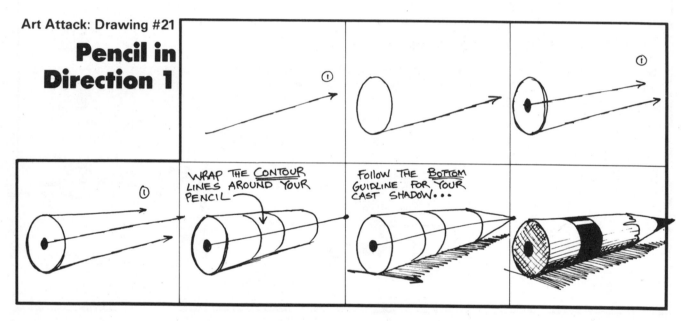

Motivator!

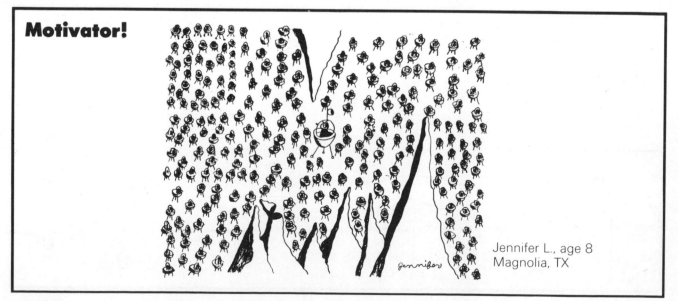

Jennifer L., age 8
Magnolia, TX

Art Attack: Drawing #22
Draw Squad Banner

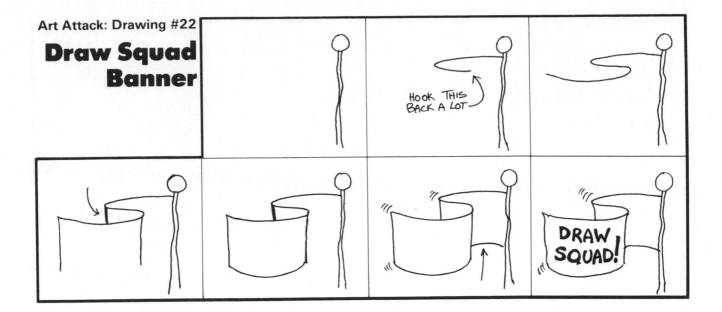

Student Gallery

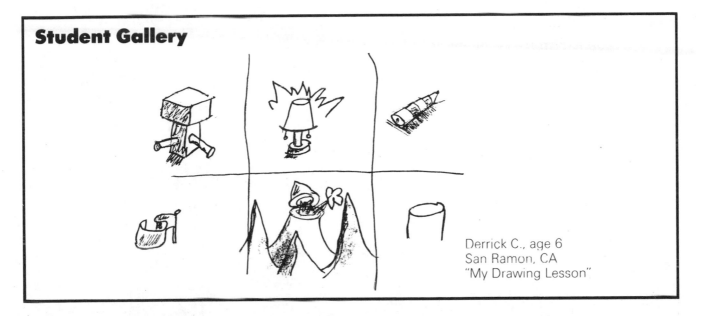

Derrick C., age 6
San Ramon, CA
"My Drawing Lesson"

Art Attack: Drawing #23
Hairy Scary in the Volcano

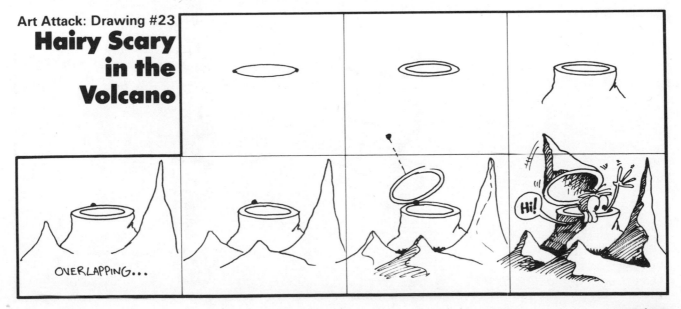

Cake on a Plate on a Table on a Furble

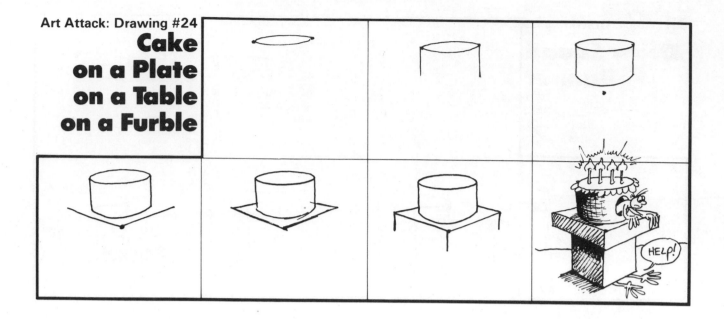

The Bruce McIntyre Achievement Scale
Level 4
The Paradise Club

Stack 30 high in eight minutes. Watch your **shading**! Draw neatly.

50% of your fun with this drawing program will come from adding "extras."

Jessica Kraintz, age 8
Everett, WA

Check off your progress on the achievement chart!

Review

What is a **shadow**? _____

What is Direction One? _____

How many cool saucers did you draw? _____

TRUE/FALSE

☐ ☐ You carry your sketch-book with you at all times.

☐ ☐ You draw at least 30 minutes a day.

☐ ☐ You've taught a fireman how to draw a flying saucer.

☐ ☐ You like my moustache.

☐ ☐ Trees are nice.

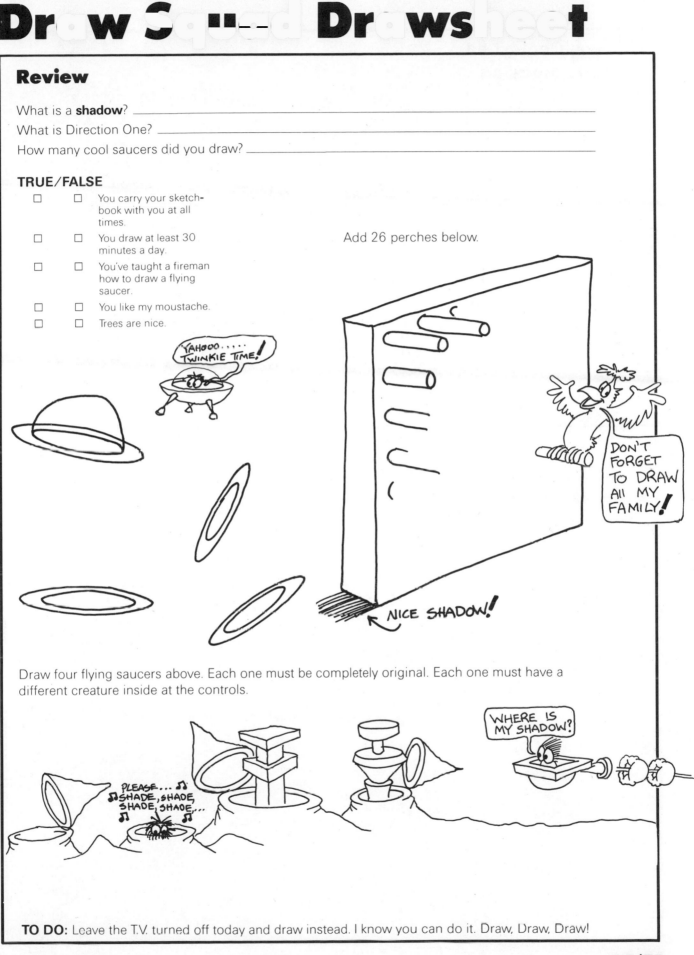

Add 26 perches below.

Draw four flying saucers above. Each one must be completely original. Each one must have a different creature inside at the controls.

TO DO: Leave the T.V. turned off today and draw instead. I know you can do it. Draw, Draw, Draw!

Drawing Contest #4:
Furblett Invasion

How many flying saucers can you fit on one piece of paper? Stephen K. holds the record with 3,042.

VARIATIONS: Who can draw the largest, smallest, most colorful, most detailed or the most unique flying saucer?

Janice Tan, age 17
Carlsbad, CA
"Traffic Jam"

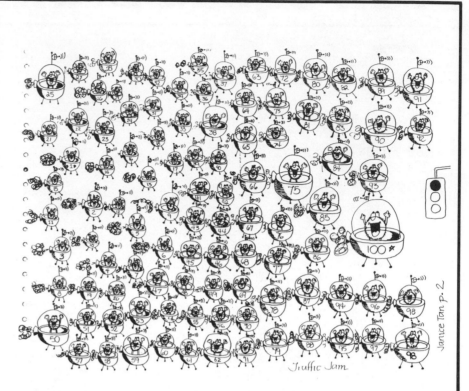

Daily Drawing Journal

Entry Date / /

ADD EXTRAS!

LESSON 5

Warm-up

We drawing maniacs have our own "styyyyle." As runners stretch their legs and trumpet players loosen their lips, we have Drawercize to loosen our hands, fingers, and imagination. With this in mind, let's launch with 45 seconds of Drawercize. Get ready...now shake 'em out!

Now shade in this strip from dark to light as fast as your pencil can fly!

TAKE A LOOK AT MINE...

NOW IT'S YOUR TURN.

Key Drawing Word: Density

Images drawn darker and with more detail will appear closer than images drawn lighter and with less detail. This adds up to "atmosphere" in the drawing. When you stand on the edge of a forest, trees that are near appear sharp with crisp and dark edges. The leaves are detailed and distinguishable from one another. As you look deeper into the forest, the trees begin to blend together, losing more and more detail. At the limit of your sight the trees are merely vague shapes and shadows. Remember this and you'll be able to create **density** in all your drawings.

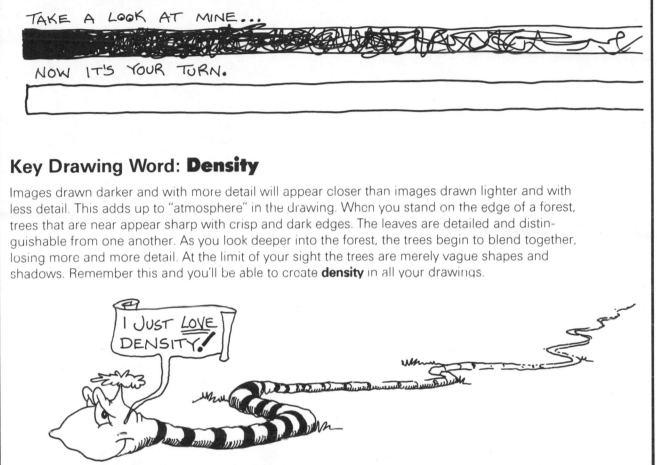

I JUST LOVE DENSITY!

Art Attack: Drawing #25

Telescope in Direction 1

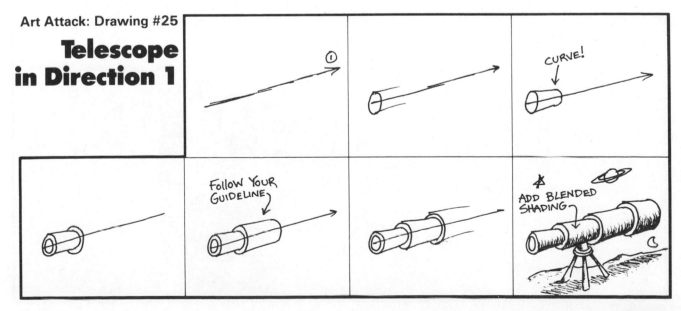

CURVE!

FOLLOW YOUR GUIDELINE

ADD BLENDED SHADING

Art Attack: Drawing #26
Radical Mountains

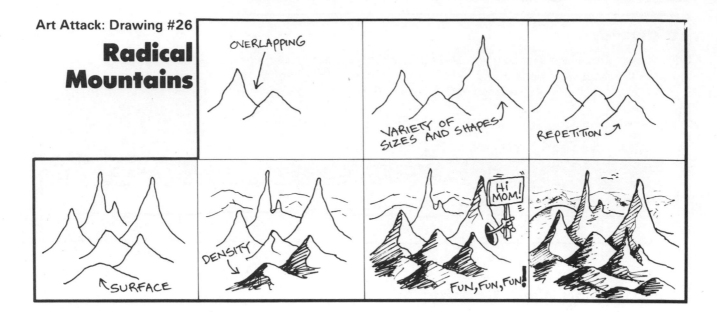

Art Attack: Drawing #27
Pail of Frozen Yogurt

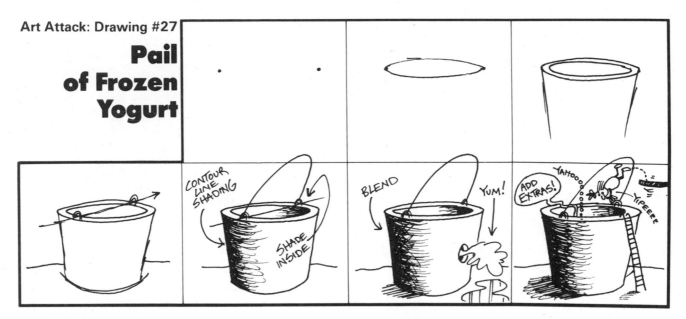

Motivator!

"Revenge of the Banana"
Me at age 14.
(I had to sneak in one of my art attacks)

Art Attack: Drawing #28

Name Scroll

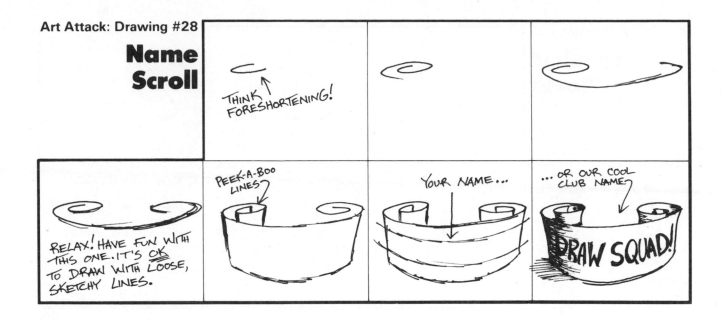

THINK FORESHORTENING!

RELAX! HAVE FUN WITH THIS ONE. IT'S OK TO DRAW WITH LOOSE, SKETCHY LINES.

PEEK-A-BOO LINES

YOUR NAME...

...OR OUR COOL CLUB NAME

DRAW SQUAD!

Student Gallery

Thanks, Mike for remembering to sign your drawing. NOTE: Draw Squaders—when you send in your drawings, please, please, please put your name, age, city and state on each "master piece" you send in.

Mike B., age 6
San Ramon, CA
"I Love to Draw"

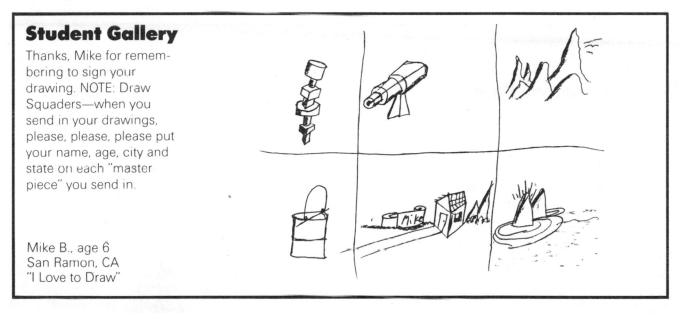

Art Attack: Drawing #29

My Dream Vacation Villa

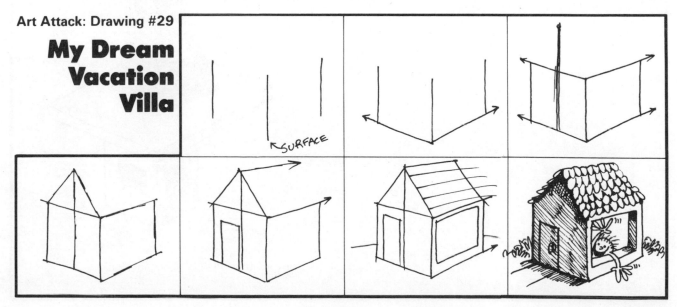

SURFACE

Radical Rocks

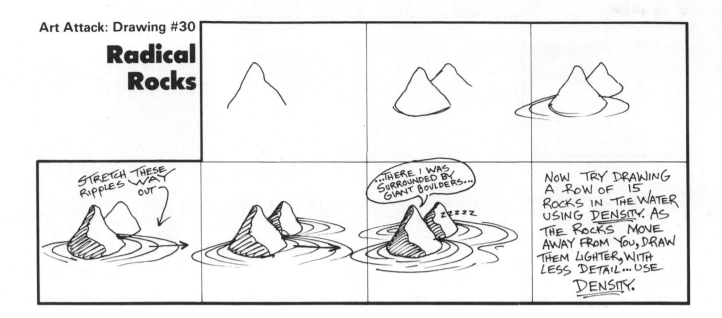

Panel text:
STRETCH THESE RIPPLES WAY OUT

"...THERE I WAS SURROUNDED BY GIANT BOULDERS..." ZZZZZ

NOW TRY DRAWING A ROW OF 15 ROCKS IN THE WATER USING DENSITY. AS THE ROCKS MOVE AWAY FROM YOU, DRAW THEM LIGHTER, WITH LESS DETAIL... USE DENSITY.

The Bruce McIntyre Achievement Scale
Level 5
The Aardvark Club

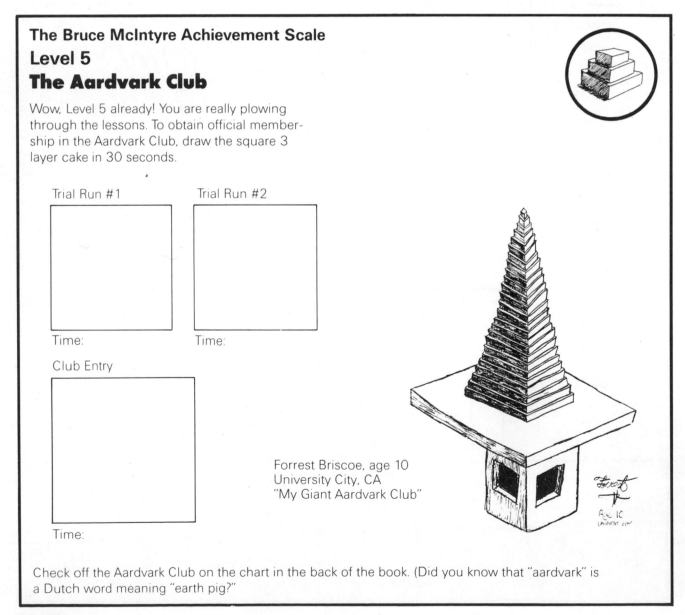

Wow, Level 5 already! You are really plowing through the lessons. To obtain official membership in the Aardvark Club, draw the square 3 layer cake in 30 seconds.

Trial Run #1

Time:

Trial Run #2

Time:

Club Entry

Time:

Forrest Briscoe, age 10
University City, CA
"My Giant Aardvark Club"

Check off the Aardvark Club on the chart in the back of the book. (Did you know that "aardvark" is a Dutch word meaning "earth pig?"

Draw Squad Drawsheet

Review

To make your three-dimensional illusion more effective, use **density**. Use little detail with light lines to make vague objects. These will appear miles away in contrast to the dark and detailed "close objects." Use **density, overlapping** and _____ .

DIRECTION ①

Draw a row of rocks with **density** in Direction 1.

Draw 16,000 segments on this telescope in Direction 1.

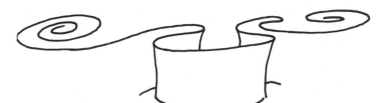

TALLY-HO

How many doors did you make in Contest #5?

Answer: _____

What is the total number of strokes possible in one pencil?

Answer: _____

List the Five Key Words you have learned so far.

#1 _____
#2 _____
#3 _____
#4 _____
#5 _____

TRUE/FALSE

- ☐ ☐ You have drawn everyday this week.
- ☐ ☐ You are having drawing nightmares.
- ☐ ☐ You still think my moustache is swell.
- ☐ ☐ These questions are vital to the lesson.

Complete the scroll.

Add **thickness** to the shopping mall.

Hi

Answers: 1. Lots and lots 2. Ten Key Words: **foreshortening, surface, shading, shadow, density.** True/False: 1. True 2. True 3. True 4. True

TO DO: So now you want to join the Draw Squad? All right! Send one of your drawings along with a self-addressed stamped envelope to the Draw Squad!

Copyright © 1988 by Mark Kistler

L5/57

Drawing Contest #5: **The Land of Doors**

How many doors can you draw in a giant castle at the Aardvark Level?

VARIATIONS: How creative are your doors? Consider adding some staircases. How about people frantically running around looking for their drawing books? Are your doors on hinges or were they knocked down during the last drawing lesson?

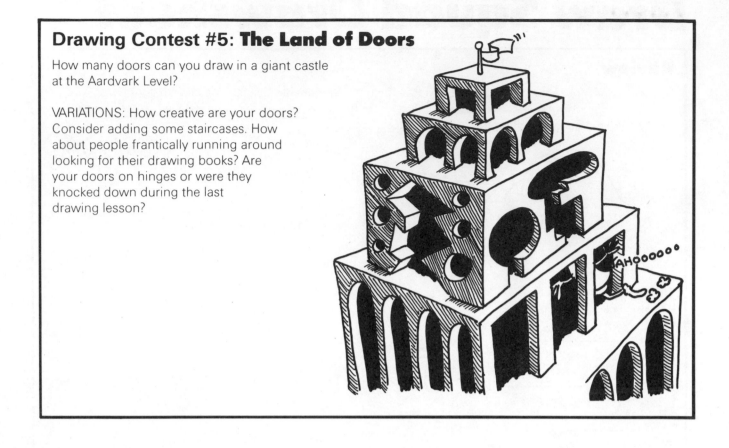

Daily Drawing Journal

Entry Date / /

LESSON 6

Warm-up

Wow, Lesson 6...Good job! You've made it half way to fully understanding the Ten Key Words of Drawing. The "drawing bug" should be setting in right about now. I always carry a pocket-sized sketchbook around in my coat, not just for the important "to do" lists but to accommodate my "art attacks"—those moments when I just have to draw. Do you get frustrated when you have to wait in line? A ten-minute wait? Consider it a "three-sketch line." Waiting in class for the bell to ring? Turn that extra time into productive, creative sketching time! Carry a sketchbook with you everyday. You'll never feel like you're wasting time again.

Key Drawing Word: **Contour Lines**

Contour lines give round objects shape and volume. These lines also add character to your sketches ...such as wrinkles to a shirt sleeve or fluffiness to a cloud. These lines are very cool to work with. You'll find that once you start applying **contour** lines, you'll never stop. Take a look at the effect it has on these objects.

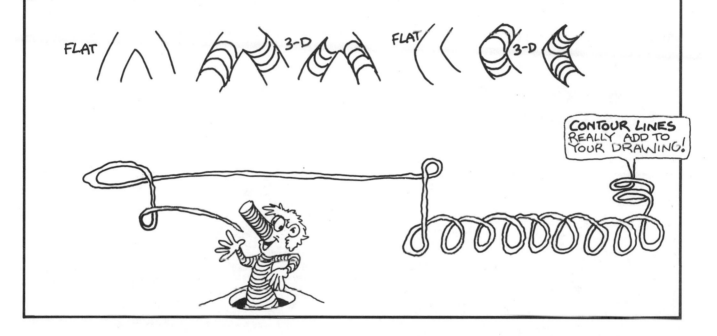

Art Attack: Drawing #31

The Uni-Ted

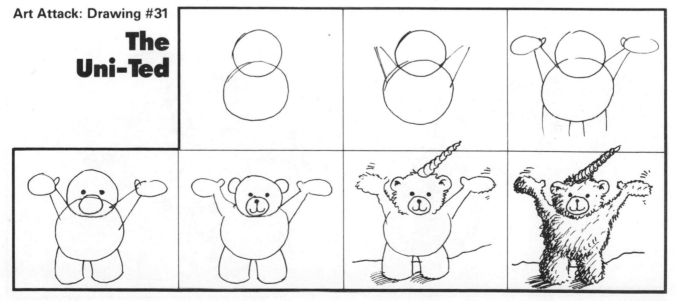

Art Attack: Drawing #32
Uni-Ted's Favorite Chair

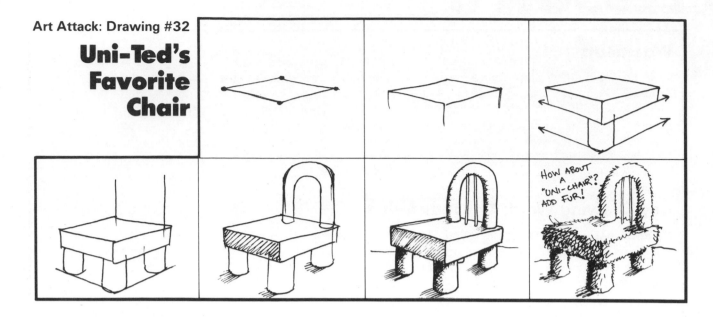

Art Attack: Drawing #33
Food For That Cute Furry Beast

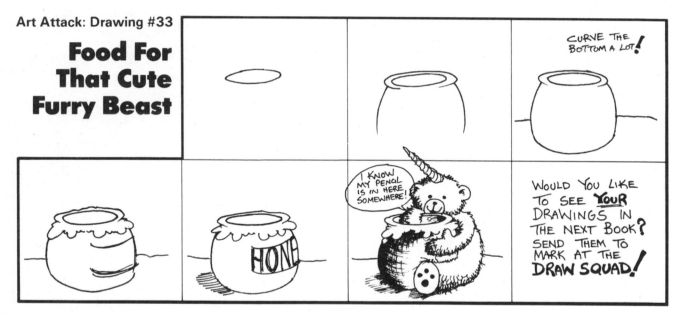

Motivator!

Matthew D., age 9
Trappe, MD

Brent Walter, age 11
Huntington, IN

Art Attack: Drawing #34

Uni-Ted in a Water Bucket

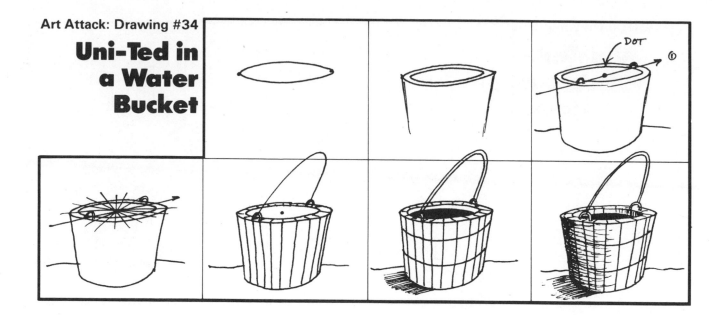

Student Gallery

Cindy Kahan, age 14
Baltimore, MD
"Uni-Bear in the Park"

Art Attack: Drawing #35

Uni-Ted's "L" Mobile

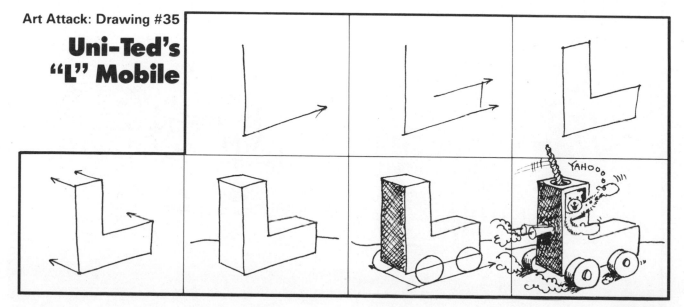

Uni-Ted's Illustrious Home

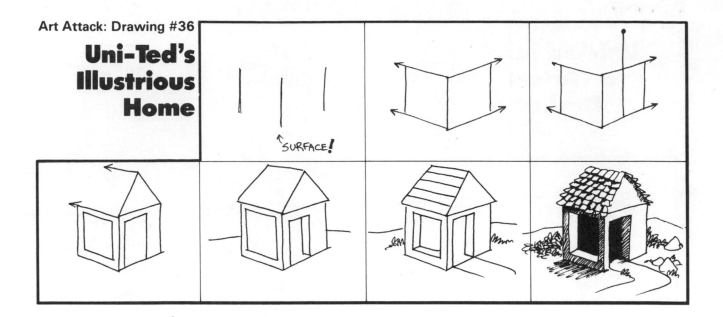

SURFACE!

The Bruce McIntyre Achievement Scale
Level 6
The Positive Mental Attitide (P.M.A.)

Forget about buying boring birthday, anniversary or other celebration cards. From now on you can create your own greeting cards in less than 30 seconds! Practice the P.M.A. Club below.

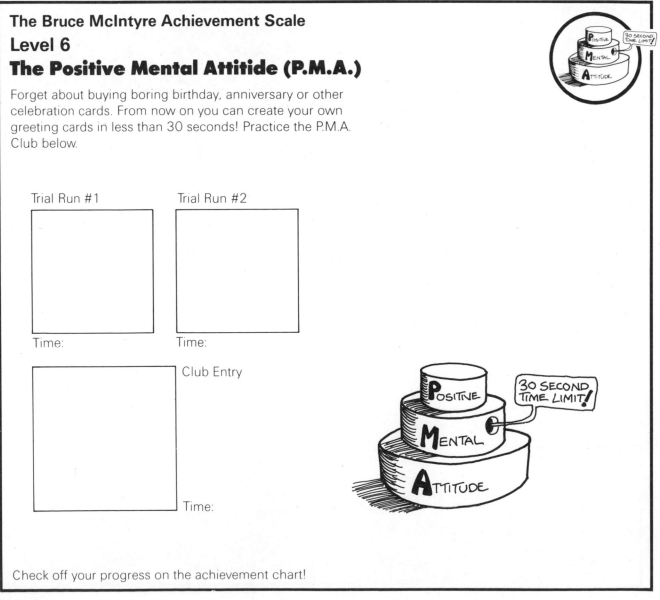

Trial Run #1

Time:

Trial Run #2

Time:

Club Entry

Time:

POSITIVE MENTAL ATTITUDE

30 SECOND TIME LIMIT!

Check off your progress on the achievement chart!

Draw Squad Drawsheet

Review

Whew! 36 drawings down and only 144 more to go! Did you get a pocket sketchbook yet? I know I've said this a zillion times, but the more you draw the better _____ you'll be. Draw, Draw, Draw! For today, add at least 12 **contour** lines to each of your sketches.

Contour lines control the _____ and the _____ of your drawing. By changing the direction of your **contour** lines you may control the _____ of your drawing.

Draw 37 million **contour** lines below. Add **shading**.

GET TUBED!

Answers: 1) dishwasher, 2) shape, 3) volume, 4) depth

Drawing Contest #6: **Uni-Tedville**

Teach a friend how to draw
Uni-Ted. Then have a contest to
see who can draw Uni-Ted in the
most unusual situations. Here is
one of my favorite examples.
This Uni-Tedville shows great
imagination.

This shows you what can be
done. Go to it! Pour out those
ideas! This is really your big
chance to explore with extras.

EXTRAS = IMAGINATION!

Ryan Baumgartner, age 8
Everett, WA
"Uni-Ted in Town"

Daily Drawing Journal

Entry Date / /

LESSON 7

Warm-up

Pull out your daily drawing journal and your pocket art attack sketchbook. Go through your drawings and count how many individual drawing exercises you have completed. Almost to the 100 mark? We're rolling now!

 Years ago I read a drawing book my master drawing teacher, Bruce McIntyre, wrote. In *Drawing Textbook*, he challenged the old teaching philosophy of drawing. The old idea of a few decades ago was that as soon as a student made his first 5,000 mistakes in picture sketches, he knew how to draw. This meant that anyone with the desire to draw had to learn everything on his own. The process would often take years and discouraged almost everyone who really wanted to learn. You can't really blame them for giving up. Who wants to keep repeating the same mistakes over and over again? Who wants to be frustrated by bad drawings without the knowledge to improve? Not many people have the patience to stick with the old teaching philosophy; therefore, people with drawing ability are few and far between.

 Bruce McIntyre developed the original Seven Key Word system. His major point is any mistake that you notice in your work or in other art work is the result of inattentiveness to one or more of the key words. The tragic "5,000 mistake theory" is really suggesting that students should misuse the key words over and over again. What a silly waste of time. The Bruce McIntyre system has saved me years of struggling with awkward sketches. He shared his "key concepts" with me. Here they are for you. Learn them well and they'll save you massive amounts of time.

Key Drawing Word: **Overlapping**

By drawing one object, or part of an object, in front of another, you can successfully create the impression that the front object is closer.

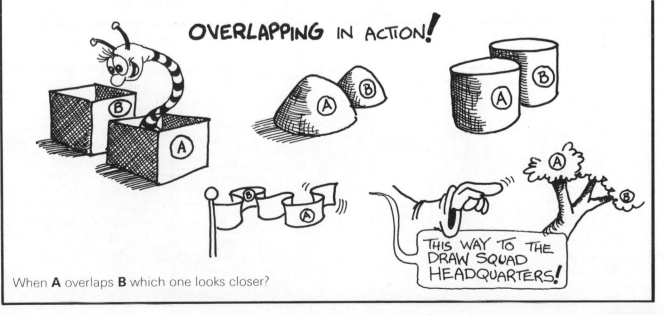

OVERLAPPING IN ACTION!

When **A** overlaps **B** which one looks closer?

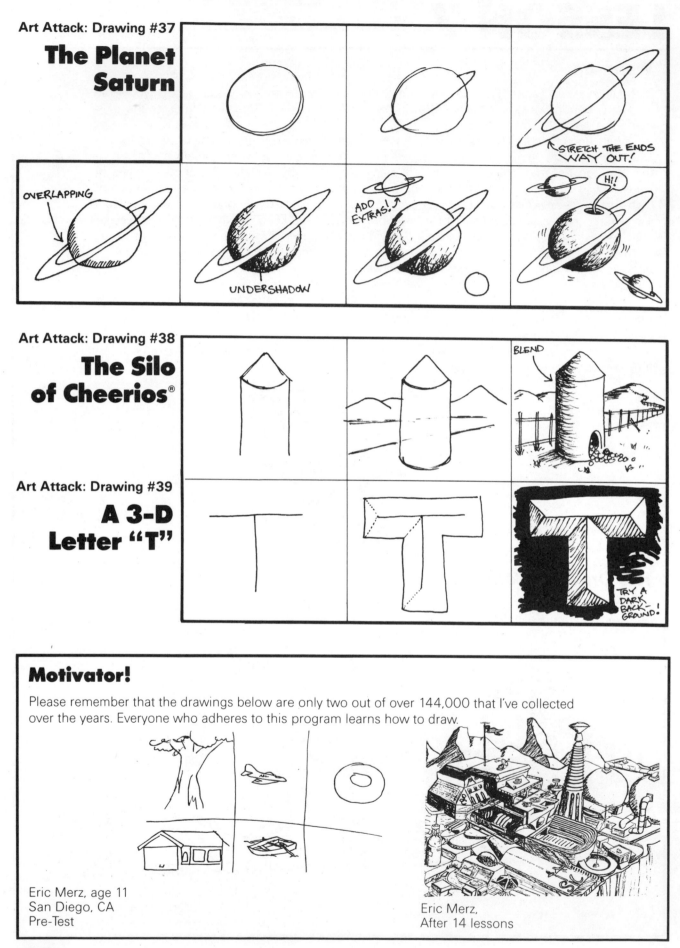

Art Attack: Drawing #37
The Planet Saturn

STRETCH THE ENDS WAY OUT!

OVERLAPPING

UNDERSHADOW

ADD EXTRAS!

Hi!

Art Attack: Drawing #38
The Silo of Cheerios®

BLEND

Art Attack: Drawing #39
A 3-D Letter "T"

TRY A DARK BACK-GROUND!

Motivator!

Please remember that the drawings below are only two out of over 144,000 that I've collected over the years. Everyone who adheres to this program learns how to draw.

Eric Merz, age 11
San Diego, CA
Pre-Test

Eric Merz,
After 14 lessons

Art Attack: Drawing #41

A Nice Table at Draw Squad HQ

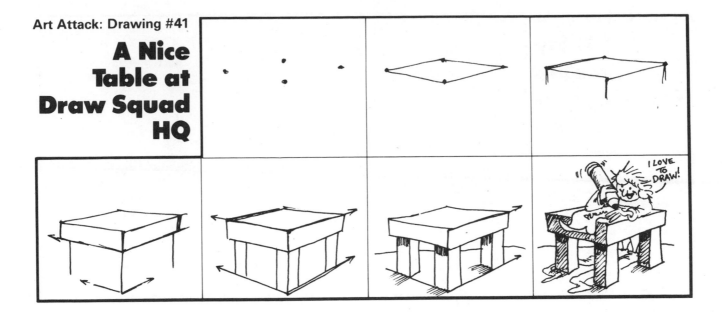

Student Gallery

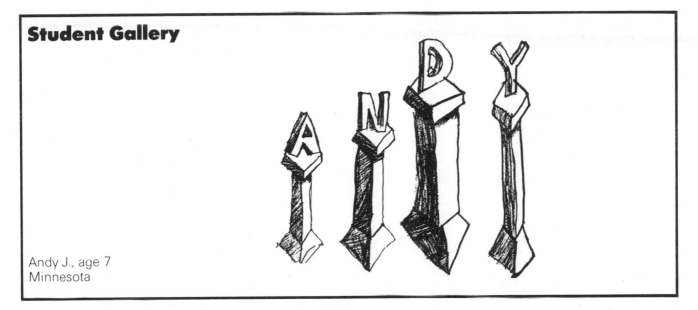

Andy J., age 7
Minnesota

Art Attack: Drawing #40

Barber Pole

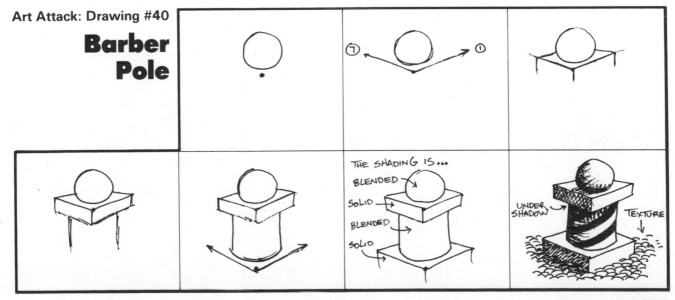

THE SHADING IS...
BLENDED
SOLID
BLENDED
SOLID

UNDER SHADOW

TEXTURE

I LOVE TO DRAW!

A Nifty Double Overlapped Flag

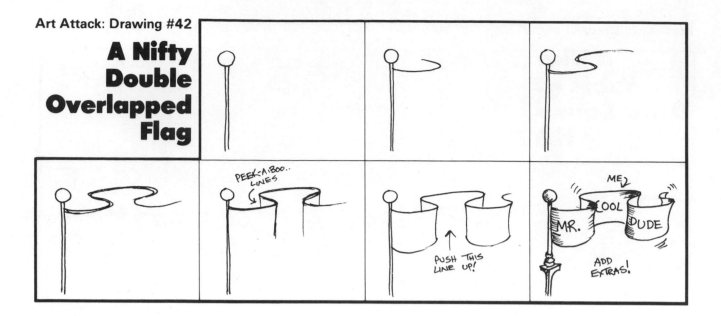

The Bruce McIntyre Achievement Scale
Level 7

The Rhino Club

This is my favorite club level. It's also the easiest. With a little practice, you'll be able to draw this in about eight seconds.

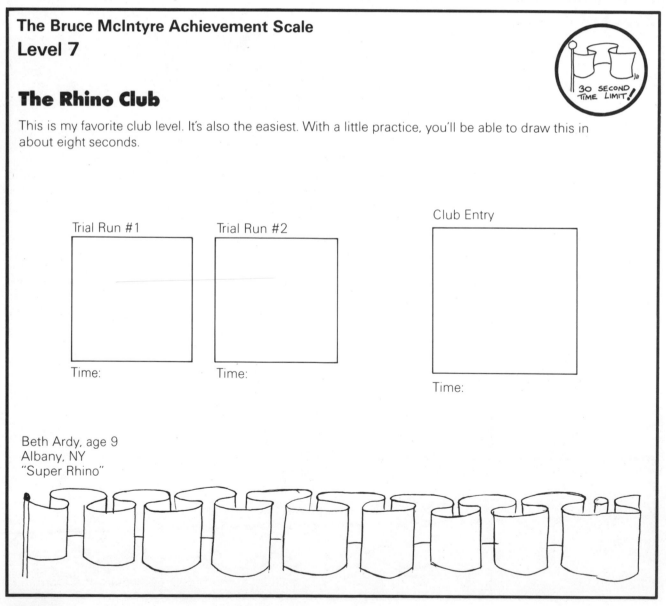

Trial Run #1

Time:

Trial Run #2

Time:

Club Entry

Time:

Beth Ardy, age 9
Albany, NY
"Super Rhino"

Review

The reason for learning the Key Words is to build, lesson by lesson, your 3-D drawing skills. Drawing in 3-D is the ability to distort objects in order to create "depth." **Overlapping** is a major device for accomplishing this task. By pulling some objects toward the eye while pushing others away, you create depth. **CAUTION:** OVERLAPPING IS HABIT-FORMING!

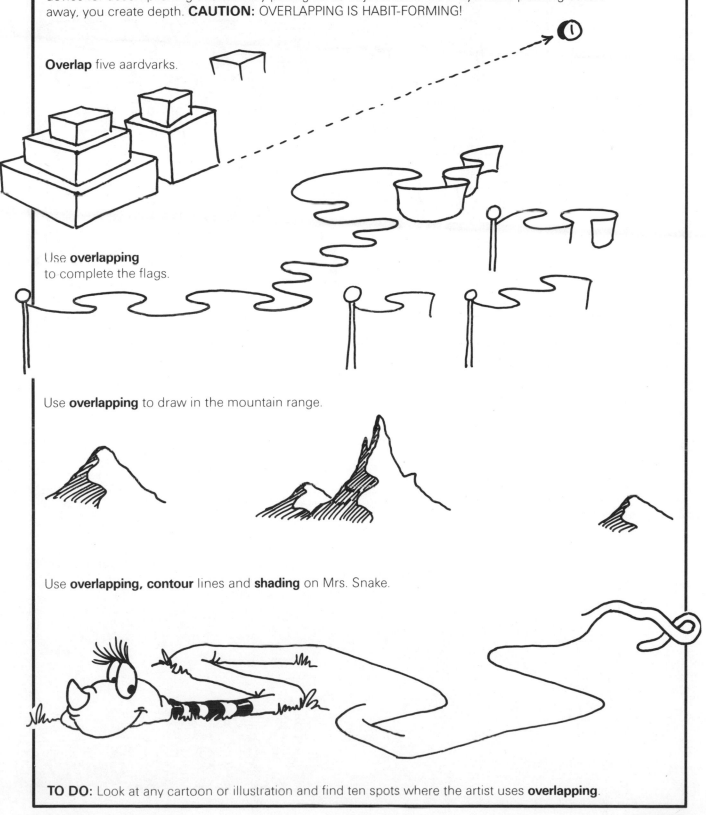

Overlap five aardvarks.

Use **overlapping** to complete the flags.

Use **overlapping** to draw in the mountain range.

Use **overlapping**, **contour** lines and **shading** on Mrs. Snake.

TO DO: Look at any cartoon or illustration and find ten spots where the artist uses **overlapping**.

Drawing Contest #7: **The Ultimate Flag**

How long can you stretch this drawing? The student record is 96 feet long by Rene Eads, age 23, of Cerro Gordo, IL

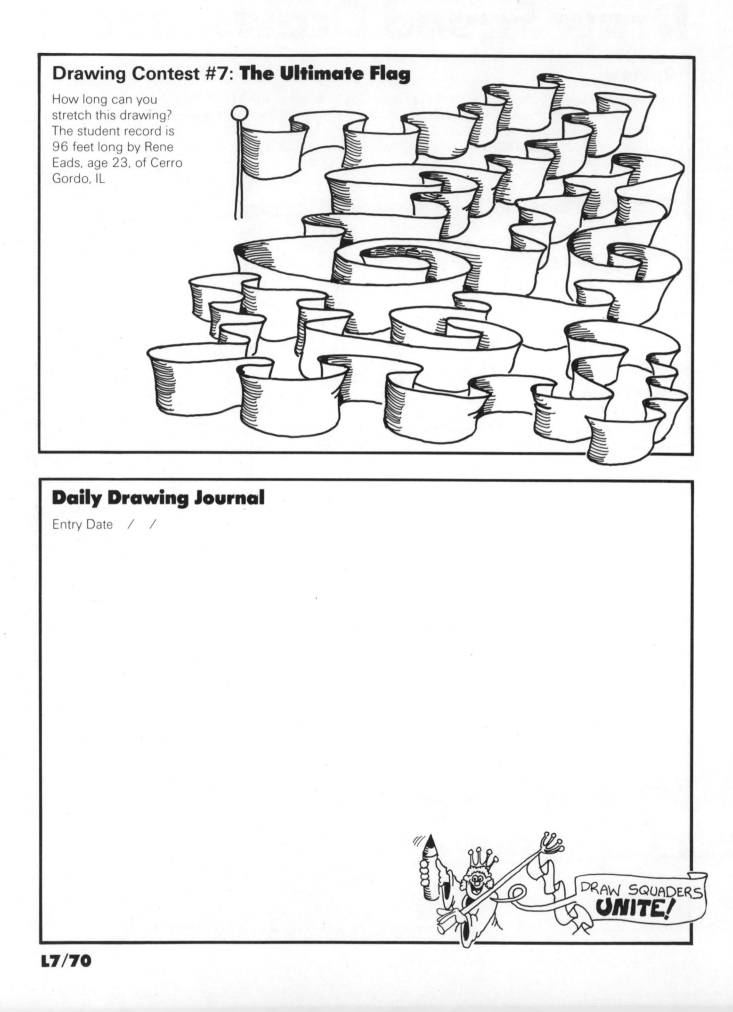

Daily Drawing Journal

Entry Date / /

DRAW SQUADERS **UNITE!**

LESSON 8

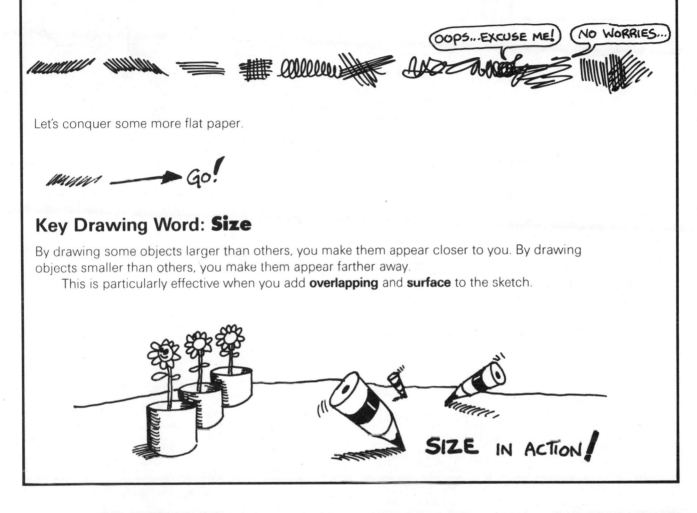

Let's conquer some more flat paper.

Key Drawing Word: **Size**

By drawing some objects larger than others, you make them appear closer to you. By drawing objects smaller than others, you make them appear farther away.

This is particularly effective when you add **overlapping** and **surface** to the sketch.

SIZE IN ACTION!

Art Attack: Drawing #43

A Dandy Little Candle with a Handle

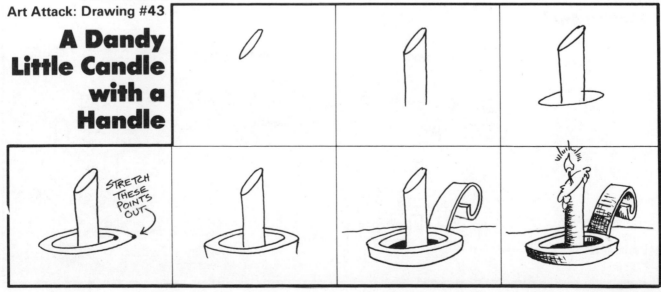

STRETCH THESE POINTS OUT

Art Attack: Drawing #44
Lonely Cans of Spinach

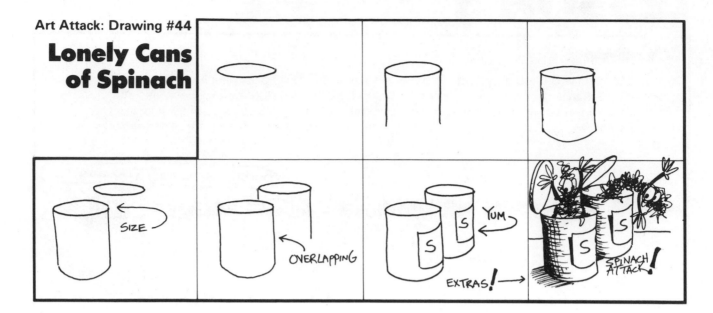

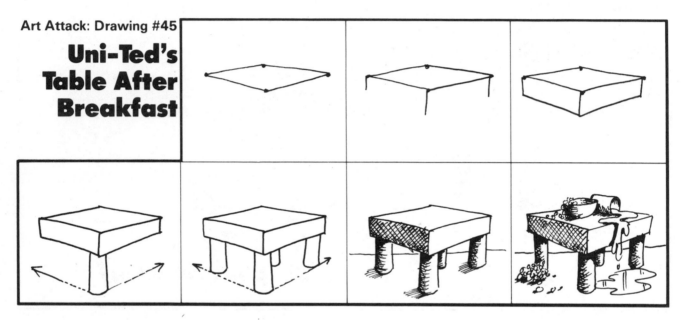

SIZE

OVERLAPPING

S S

YUM

EXTRAS!

SPINACH ATTACK!

Art Attack: Drawing #45
Uni-Ted's Table After Breakfast

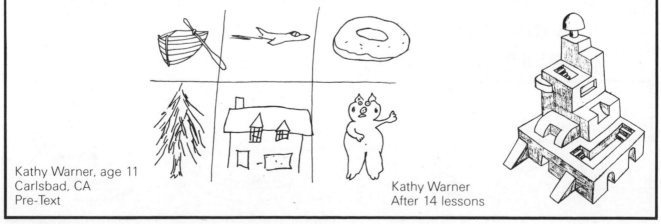

Motivator!

Here's Kathy Warner's two-week "before and after" sample. Her key to success was practicing an hour everyday. How did she find the time? Easy. Kathy didn't watch T.V. for two weeks!

Kathy Warner, age 11
Carlsbad, CA
Pre-Text

Kathy Warner
After 14 lessons

Art Attack: Drawing #46
Compass Star

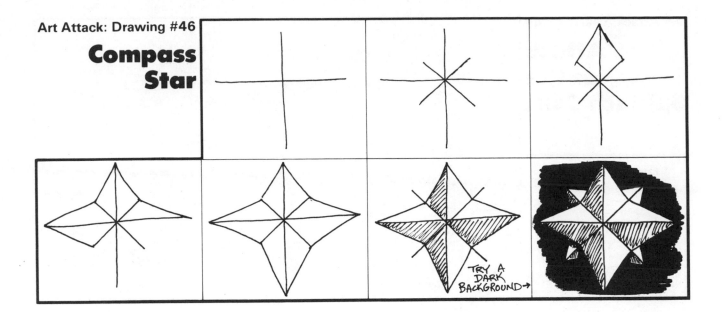

TRY A DARK BACKGROUND→

Student Gallery

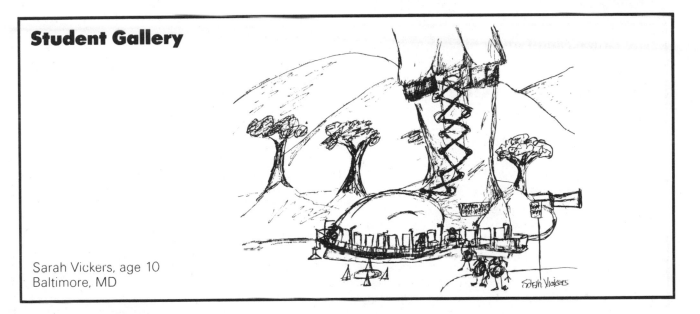

Sarah Vickers, age 10
Baltimore, MD

Art Attack: Drawing #47
Candle Using One-Point Alignment

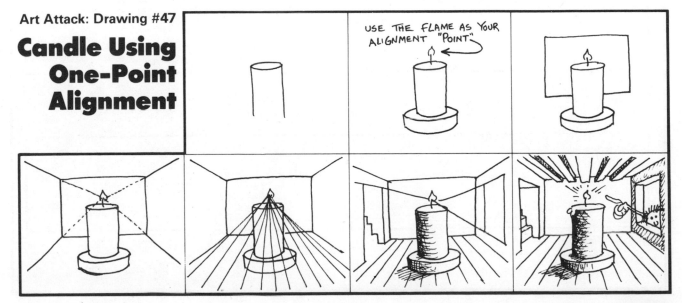

USE THE FLAME AS YOUR ALIGNMENT "POINT"

Attack of the Spinach Cans

The Bruce McIntyre Achievement Scale
Level 8
The Super Rhino Club

This club level forces you to practice **overlapping, surface, foreshortening** and **size**, not to mention the potential for adding extras. I've had students draw flag mazes, flag roadways and flag kingdoms. (Sarah, age 8, created a "queendom.") Teach your friends, and have a great flag race!

20 FOLDS LONG →
3-MINUTE LIMIT.

Trial Run #1 Time:

Club Entry Time:

Check off your progress on the achievement chart!

Review

If you draw an object larger than others it will appear _____ . This makes use of the 8th Key Drawing Word which is _____ .

Draw 65 cans of spinach. Yum...

Use alignment to make the planks appear as if they are receding into the background.

Draw legs on Uni-Ted's drawing table.

TRUE/FALSE

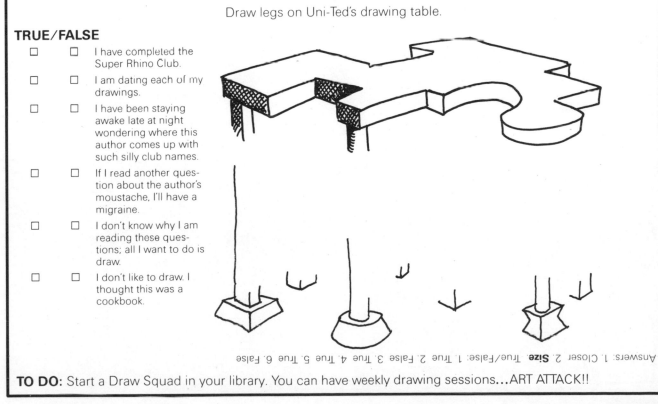

☐	☐	I have completed the Super Rhino Club.
☐	☐	I am dating each of my drawings.
☐	☐	I have been staying awake late at night wondering where this author comes up with such silly club names.
☐	☐	If I read another question about the author's moustache, I'll have a migraine.
☐	☐	I don't know why I am reading these questions; all I want to do is draw.
☐	☐	I don't like to draw. I thought this was a cookbook.

Answers: 1. Closer 2. **Size** True/False: 1. True 2. False 3. True 4. True 5. True 6. False

TO DO: Start a Draw Squad in your library. You can have weekly drawing sessions...ART ATTACK!!

Drawing Contest #8: **The Draw Button**

I challenge you to keep the T.V. turned off in your house for one week. Why? There are two reasons really. The first: It allows you to spend 10 to 15 more hours a week drawing instead of glued to the T.V. screen. The second: It causes you to be more selective with what you feed into your mind. I'm not attacking all T.V. (I have a T.V. show, you know!) I'm just saying that about 90% of what is on T.V. is negative garbage. By being more selective, you'll find you have much more time for the positive creative pursuits of your life.

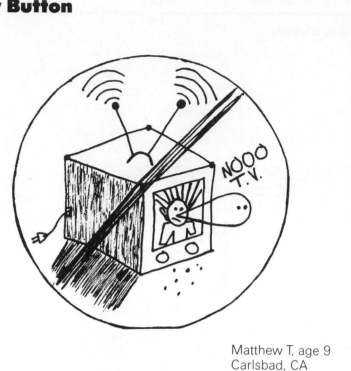

Matthew T, age 9
Carlsbad, CA

Daily Drawing Journal

Entry Date / /

WOW! GREAT SKETCHING DRAW SQUADER!

LESSON 9

Warm-up

Go through your sketchbooks and circle your 12 favorite drawings. Impressive! And you thought you "couldn't even draw a straight line." See how a few simple guidelines can change your entire creative outlook? Wait, I'm getting ahead of myself. Let's warm up with 30 seconds of Drawercize. Go! Stay loose and quickly fill an entire page with scribbles! It should be so loud that people turn around to see what's going on. You might even get kicked out of the room depending on where you are, such as the library, school, an executive board meeting, etc. But, don't worry about it. It's for a worthy cause—your creative self. Never mind the system if they can't tolerate a blooming da Vinci! Now that you're banished to the bench outside, take advantage of this isolation in the world of analytical thinkers and fill one more page of scribbles. This time draw twice as loud. Think Art Attack!

GET THAT PENCIL WARMED UP!

Key Drawing Word: Attitude

Attitude is a critical element during every moment of our lives. This is especially true when you're learning a new skill. With a truly positive, confident, this new-idea-is-great attitude, you speed up your success immeasurably. Likewise, a negative attitude is disastrous. This applies to learning new skills...academics, sports, public speaking, and, of course, the most important skill of all, drawing.

The world needs to designate Saturdays as official "draw days." We need to form the Global Saturday Draw Squad (GSDS). I can picture it now...buttons, T-shirts, bumper stickers and a 600-foot pencil in New York Harbor. Can you imagine the impact on society if everyone were able to tap into their positive creative resources just by picking up a pencil? Creative thinking would prevail. World peace through drawing! OK, I know I get carried away, but I hope you can see my point A positive attitude will open you up to new ideas and new skills. Positive attitudes will change the world.

POSITIVE ATTITUDE!
TURN UP YOUR ATTITUDE FULL BLAST...

G.S. D.S.

Art Attack: Drawing #49

Breakfast Time

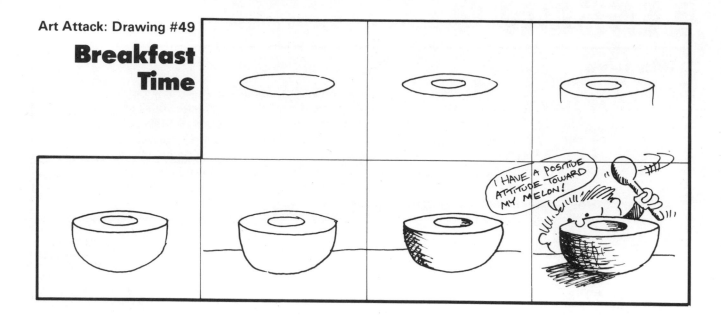

Art Attack: Drawing #50

Video Drawing Lesson in the Corner

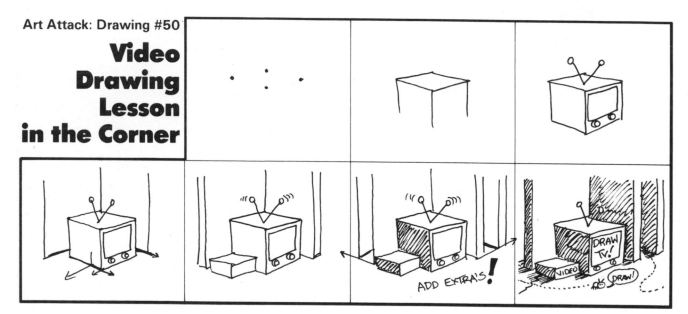

Motivator!

Christian Clausen is a great example of positive attitude in action. After two weeks of practice and thinking: "I'm a Draw Squad member, I'm smart, I can do it!" she was drawing like this:

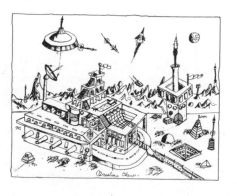

Christian Clausen, age 9
Carlsbad, CA

Art Attack: Drawing #51

Blended Shading on Round Objects

Art Attack: Drawing #52

Flag Looking Up

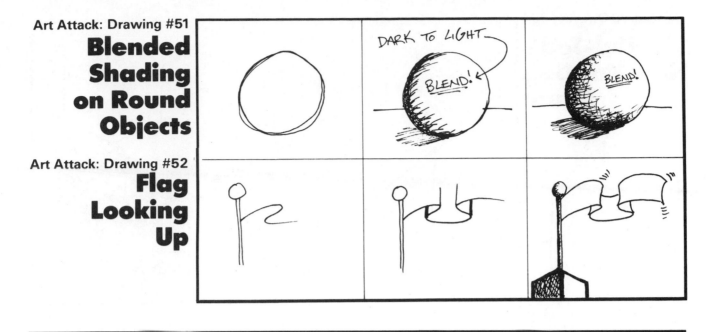

Student Gallery

Donald O'Connelles, Age 13
S.W. Albans, VT
"Self-Portrait"

Chad Thompson, Age 11
Lewiston, ME
"Self-Portrait"

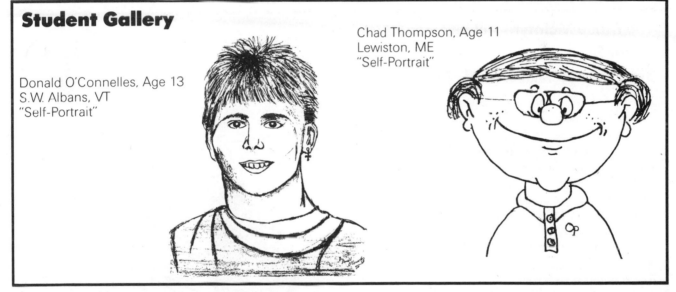

Art Attack: Drawing #53

Jaws

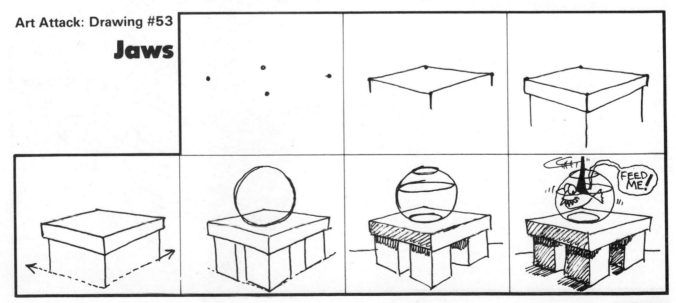

Uni-Ted's New Hot Dog Stand

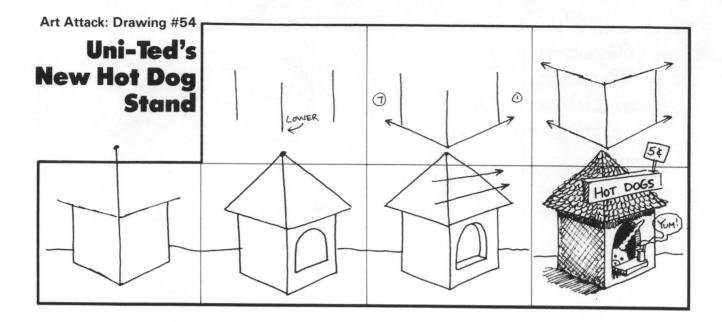

The Bruce McIntyre Achievement Scale
Level 9
The Super Aardvark Club

These timed exercises are really important. It's kind of like lifting weights; you are building your drawing muscles. The giant stack of square wedding cakes emphasize **alignment, foreshortening, surface, size, shading, shadow** and extras, all in less than three minutes. You see, when I give you a specific time limit, you're forced to draw without hesitating. The eraser becomes a thing of the past. With each continued success through these achievement levels, you become more and more confident. Remember these three points:

 1) It builds your motivation to practice, thus builds your drawing skill.

 2) It strengthens your positive drawing attitude.

 3) It inspires you to challenge the next level.

Draw a Super Aardvark in three minutes. Since you've been practicing, you'll finish with a minute to spare, but don't stop. Add extras.

Check off your progress on the achievement chart!

UNDERSHADOW

GUIDE DOTS

IF YOU RUN OUT OF ROOM, DRAW IN A PILLAR...

...OR SLANT THE SIDES IN

Stack 15 layers in three minutes.

Review

Draw **thickness** on the windows below.

Add **shading** to these objects.

Add **thickness** to these doors.

C'MON...LIGHT MY FIRE ♪♫

Add **contour** lines to the objects below.

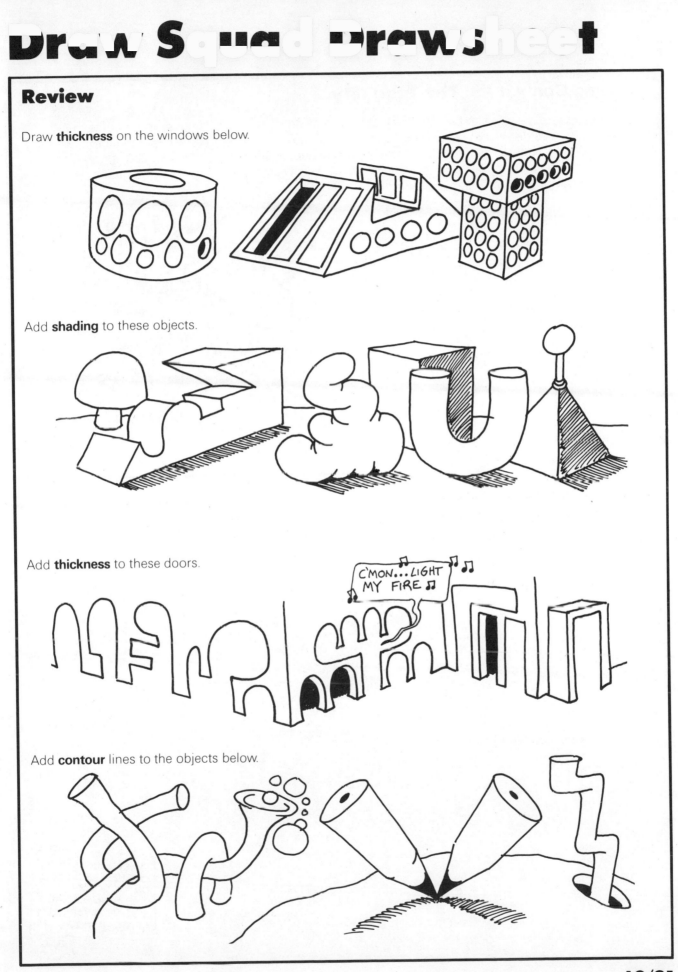

Drawing Contest #9: **The Tube City**

These contests are designed to be attitude amplifiers. You can have fun challenging your friends to draw. At the same time, everyone's attitude blasts off because your drawings are developing into wonderful 3-D creations. This Tube City Contest is a **contour** line challenge. Who can draw the most tubes? Who can turn the tubes into the most creative city? Are the tubes for travel, water or chocolate? Look at Matt Jerde's Tube City below.

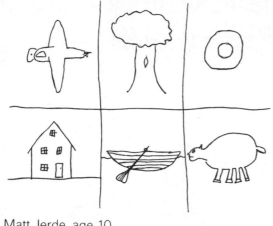

Matt Jerde, age 10
Carlsbad, CA
Pre-Test

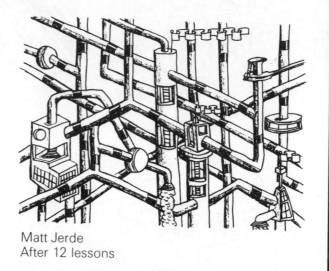

Matt Jerde
After 12 lessons

Daily Drawing Journal

Entry Date / /

DON'T JUST SKIP OVER THIS PAGE! DRAW AT LEAST ONE THING...SAY... LIKE, NEW YORK CITY AT RUSH HOUR!

LESSON 10

Warm-up

Let's try something energetically new. Instead of sitting while stretching with "finger aerobics," try this: Stand up and hop around the room on one leg waving your hands wildly while singing "Shade, Shade, I love to shade…yipee…oh…yipee…yeah!" Oh, no! Another art attack! Picture this…"Shade, Shade, Shade" hitting the top pop chart, while millions of people hop around on one leg. Forget MTV. We'll have Draw TV! Twenty-four hours of cool drawing lessons put to the sound of Mozart. Audio and visual art development. Creative thinkers unite! This is great. A new organization for the "G.S.D.S.ers." We'll call this the S.S.C.C.T.F.D.T.V. (The Society of Super Cool Creative Thinkers For Draw T.V.)! For your warm-up make 6,000 "S.S.C.C.T.F.D.T.V." buttons and distribute them among your pals.

Key Drawing Word: **Daily**

Here's an original idea: "Practice makes perfect." It's impossible for me to stress how important it is for you to doodle everyday even if it's only for ten minutes! You've got to keep that imagination muscle active. Use it or lose it! You've come this far, over 50 sketching exercises, Ten Key Words and hours of creative thinking. Let's make sure all this great stuff gets transferred into your long-term memory. Draw everyday!

Art Attack: Drawing #55

Furblina in Her New Leg Warmers

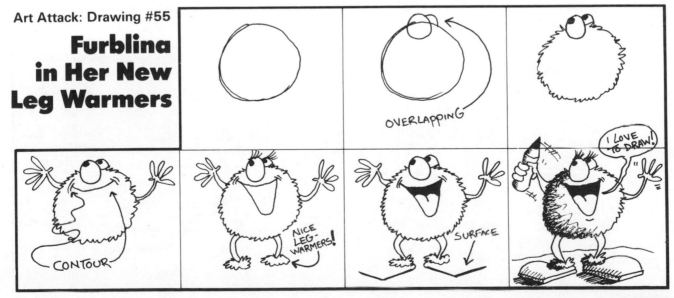

Art Attack: Drawing #56
Furblina's Draw Squad Table

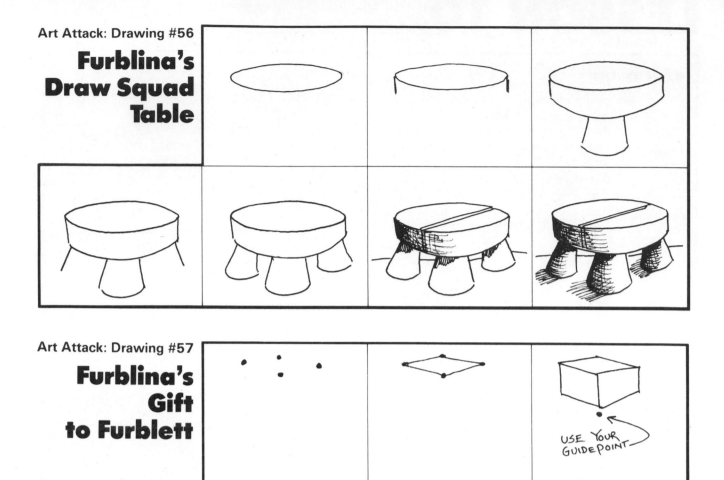

Art Attack: Drawing #57
Furblina's Gift to Furblett

USE YOUR GUIDEPOINT

BEHIND THE CORNER!

TO FURBLETT!

Motivator!

With **daily** practice, Laurel Haines was able to have this tremendous two-week before/after experience. Without **daily** practice, the other Key Drawing Words are worthless. Keep a pencil and pad of paper in your pocket. Draw everyday.

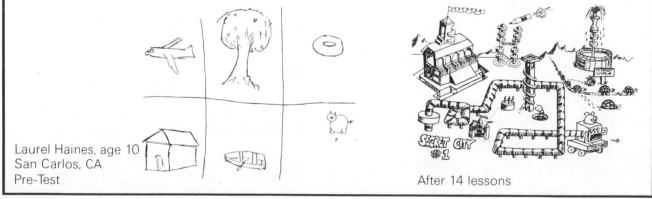

Laurel Haines, age 10
San Carlos, CA
Pre-Test

After 14 lessons

SECRET CITY #1

Art Attack: Drawing #58

Furblina's Queendom

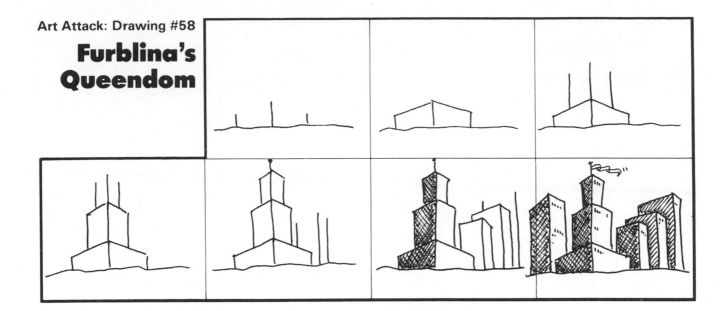

Student Gallery

Linda Jones, age 17
Kentucky
"Cindy"

Art Attack: Drawing #59

Queen Furblina's Banner

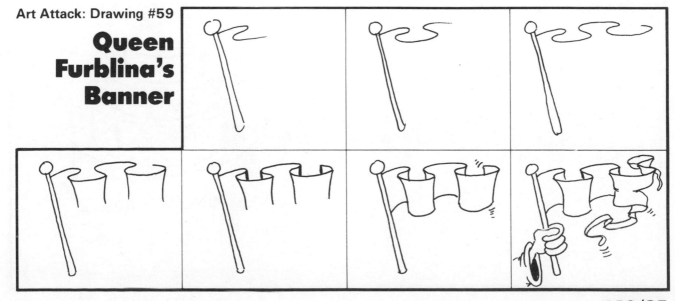

Furblett's Barber Chair

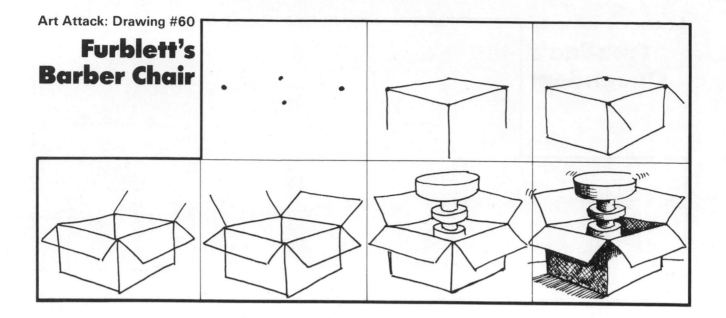

The Bruce McIntyre Achievement Scale
Level 10
The Super P.M.A.

Concentrate on keeping each layer very **foreshortened**. Use your finger tip to blend the **shading** because you are drawing a round object. Don't forget the cast **shadows**.

Trial Run #1

Time:

Trial Run #2

Time:

Club Entry

Time:

15 LAYERS HIGH WITH BLENDED SHADING.

ENJOY
A SUPER
POSITIVE
ATTITUDE!

3-MINUTE LIMIT!

Review

Visit your library and enjoy a book of da Vinci drawings. Look at his early sketches and compare them to his later work. See how daily practice improved his drawing skill. He utilized his skill in his medical studies, his inventions and in his personal journals. Draw everyday and it will improve your creative thought process, your creative problem-solving abilities and your creative positive attitude.

Draw three Furbletts below, one with a hat and tie, another eating a box of cereal, and the third, you make up.

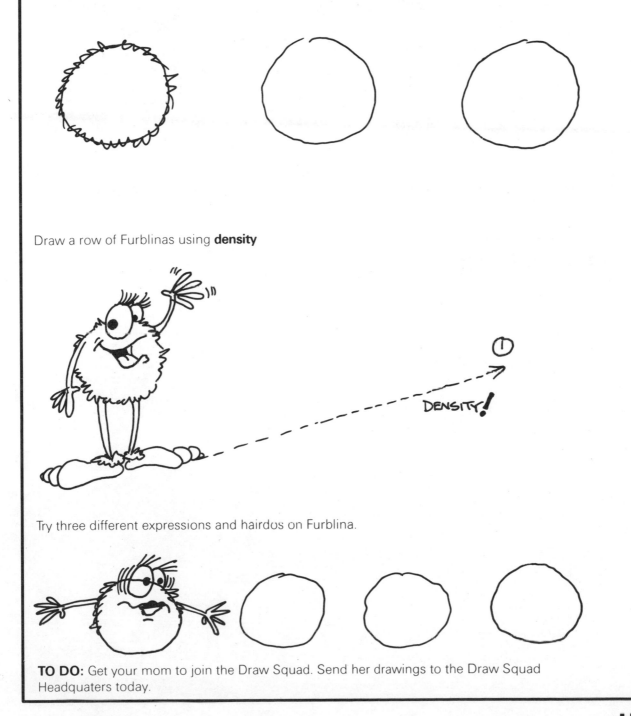

Draw a row of Furblinas using **density**

DENSITY!

Try three different expressions and hairdos on Furblina.

TO DO: Get your mom to join the Draw Squad. Send her drawings to the Draw Squad Headquaters today.

L10/87

Drawing Contest #10: **Furblinaville**

Go all the way with this one. Pull out all the stops. Who can draw the most Furblinas? Who can draw the wildest Furbleville? Who can draw the furriest, or the craziest Furblina? Or, who can draw a Furblina with the most contagiously positive attitude?

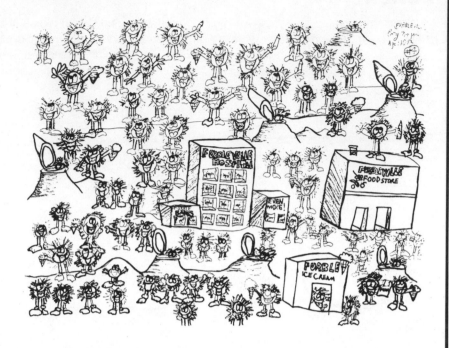

Corry Mongoven, age 10½
Carlsbad, CA
"Furbleville"

Daily Drawing Journal

Entry Date / /

LESSON 11

Warm-up

Fantastic! You've learned all of the Ten Key Words. List each of them on a page in your sketchbook. Over the next ten lessons I will be introducing a simple memory symbol for each of the key words. Once you learn all ten, you can look at any drawing and visually label where the artist is using the Ten Key Words to create three-dimensional illusions. Look below where **foreshortening** and **surface** are being used correctly.

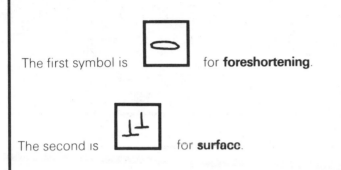

The first symbol is for **foreshortening**.

The second is for **surface**.

Key Drawing Word: Intermediate Foreshortening

My goal for this book is to establish the Ten Key Words of Drawing as permanent words in your thinking vocabulary. I gave you the best definitions I could come up with after eight years of teaching. Now, let's try an exciting experiment. Let's see how creatively different leading art educators from around the world define these same words.

As I called these friends, I was impressed at how willing they were to help me teach you how to draw better. An interesting thing happened as I was gathering these definitions; a few new words were introduced to me as drawing "keys." I've included these in the following definitions. How exciting! We get to learn from the best art educators in the world!

FORESHORTENING: I teach my students that **foreshortening** ties two other Key Words together for a successful 3-D illusion. Those two are **surface** and **size**. Look at the table in front of you, the top surface is distorted because the near edge is lower and larger, creating a **foreshortened** shape.

Mike Schmid, Art Teacher, Haverhill Elementary School/Fort Wayne, IN

WHERE IS THE LIGHT SOURCE ABOVE?

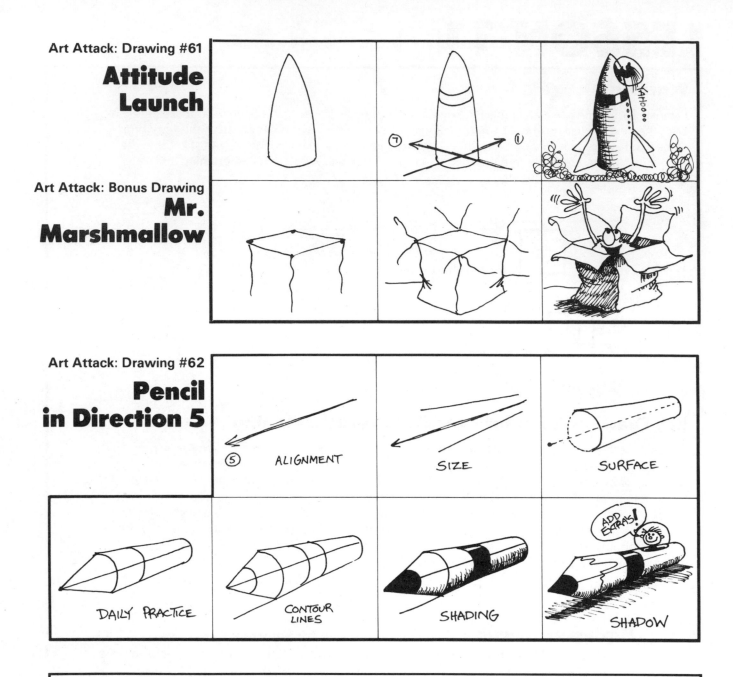

Art Attack: Drawing #61

Attitude Launch

Art Attack: Bonus Drawing

Mr. Marshmallow

Art Attack: Drawing #62

Pencil in Direction 5

⑤ ALIGNMENT

SIZE

SURFACE

DAILY PRACTICE

CONTOUR LINES

SHADING

SHADOW

Motivator!

Look closely at Bryan's use of **shading** and **overlapping**. I love his creative "extras" (the cracks in the buildings and the tiny windows). Mail your drawings into me. Maybe one of them will end up as a Motivator! Actually, mail one drawing a week to me for the rest of your life. This way I can keep track of your progress!

Bryan de Roo, age 15
Yreka, CA
"Floating Atlantis"

Art Attack: Drawing #63

Birdhouse with Three Mortgages

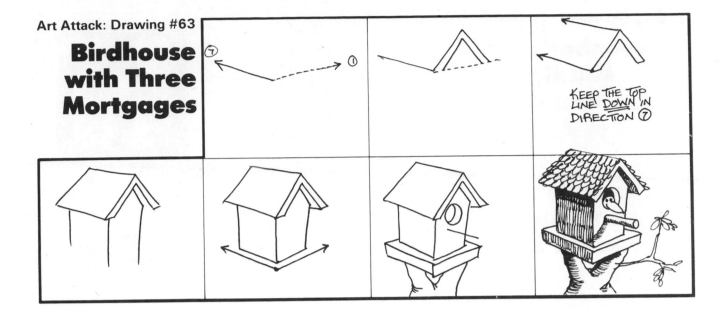

KEEP THE TOP LINE DOWN IN DIRECTION ⑦

Student Gallery

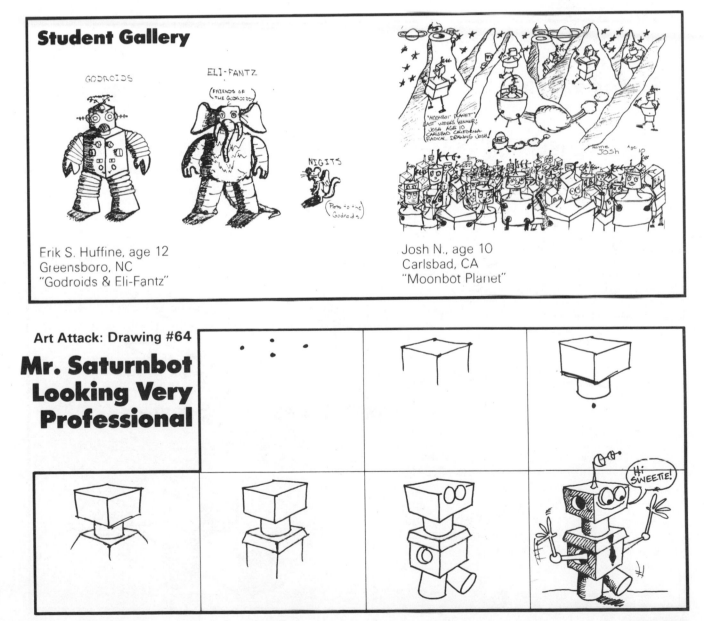

GODROIDS

ELI-FANTZ

(FRIENDS OF THE GODROIDS)

NIGITS

Erik S. Huffine, age 12
Greensboro, NC
"Godroids & Eli-Fantz"

Josh N., age 10
Carlsbad, CA
"Moonbot Planet"

Art Attack: Drawing #64

Mr. Saturnbot Looking Very Professional

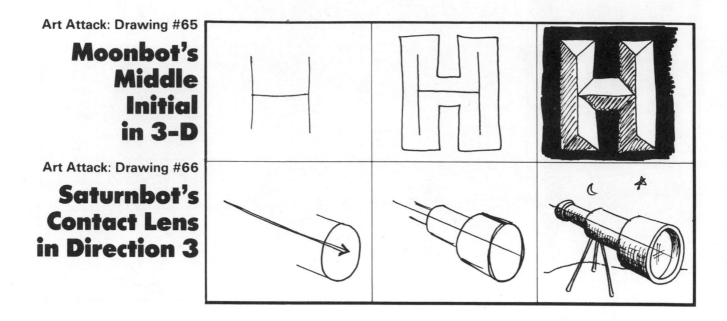

Moonbot's Middle Initial in 3-D

Saturnbot's Contact Lens in Direction 3

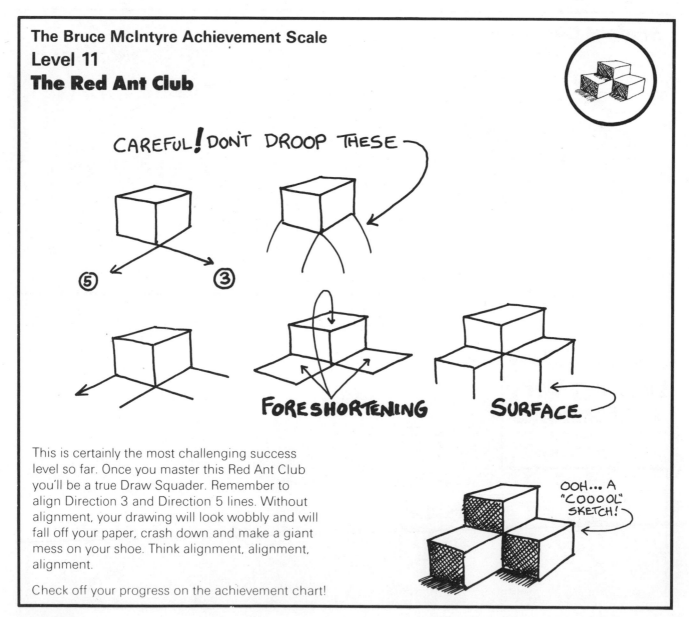

The Bruce McIntyre Achievement Scale
Level 11
The Red Ant Club

CAREFUL! DON'T DROOP THESE

⑤ ③

FORESHORTENING SURFACE

OOH... A "COOOOL" SKETCH!

This is certainly the most challenging success level so far. Once you master this Red Ant Club you'll be a true Draw Squader. Remember to align Direction 3 and Direction 5 lines. Without alignment, your drawing will look wobbly and will fall off your paper, crash down and make a giant mess on your shoe. Think alignment, alignment, alignment.

Check off your progress on the achievement chart!

Review

Okay, drawing maniacs, let's have a little pep talk. Do you ever have those days when you just don't seem to have any creative energy or any ooomph? In other words, have you ever had a bad case of the blues? I've got the perfect solution for you. In fact, it's so perfect, I use it every single day of my life. It has been worth over 30,000 drawing projects for me, and it can inspire you, too. What is this idea? It's called "positive thinking audio cassettes." It's like making idea deposits into your attitude bank. For more details on these tapes, your local library can help you out. (Be sure to look up information on one of my heroes, Earl Nightingale.)

Add **thickness** to the arches below. Add **shading**.

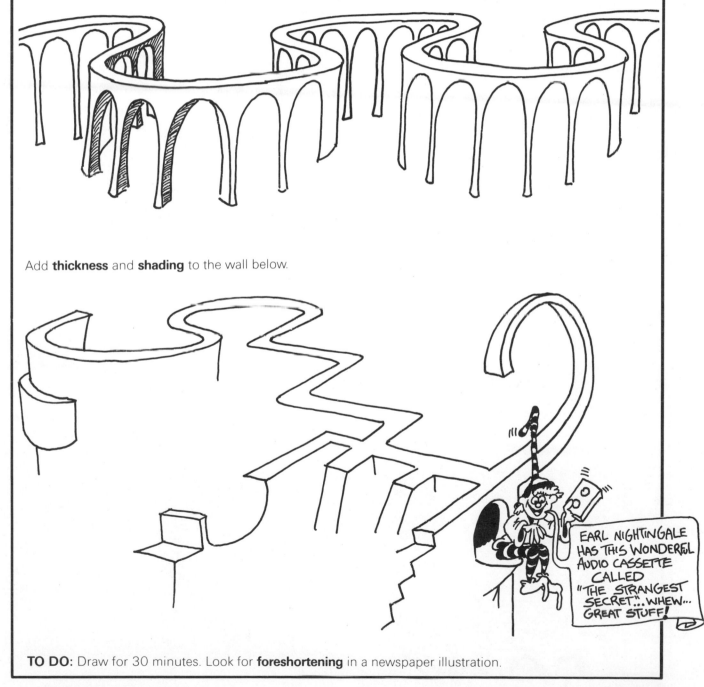

Add **thickness** and **shading** to the wall below.

EARL NIGHTINGALE HAS THIS WONDERFUL AUDIO CASSETTE CALLED "THE STRANGEST SECRET"...WHEW... GREAT STUFF!

TO DO: Draw for 30 minutes. Look for **foreshortening** in a newspaper illustration.

Drawing Contest #11: **Saturnbot Mania**

Draw a planet inhabited by
Saturnbots. Try to make each
one different. Use tons of extras.
Make some short and pudgy,
some tall and pudgy, some
ornate and some simple. How
many can you draw on one
piece of paper? The student
record is a zillion Saturnbots.
Can you add more extras than
there already are?

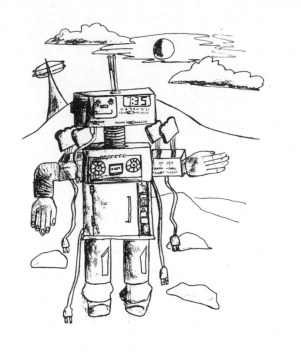

Justin Matlick, age 6
Anchorage, AK
"Saturnbot Says Hi"

Daily Drawing Journal

Entry Date / /

A DRAWING IS
DESSERT FOR
YOUR EYES!

LESSON 12

Warm-up

Let's loosen up and get ready to launch into the world of drawing. Shake out your hands, roll your pencil between your fingers, and pull up your chair. Open your sketchbook to your last drawings. Spend a few minutes darkening edges and shadows. This will get your hand rolling and help you recall the important points of the last lesson. Now, vigorously draw a row of dashes.

Key Drawing Word: **Intermediate Surface**

SURFACE: In Dutch this is called "dychtby un verweg" which translates as "near and far." Place some objects on a table such as a teapot, some fruit and a few eggs. Now stand back and look at the objects. Notice how the nearer items appear lower in your view. This is what "dychtby un verweg" means.

Hans van der Veen, Art Educator/Groningen, Netherlands

The key word symbol for **surface** is:

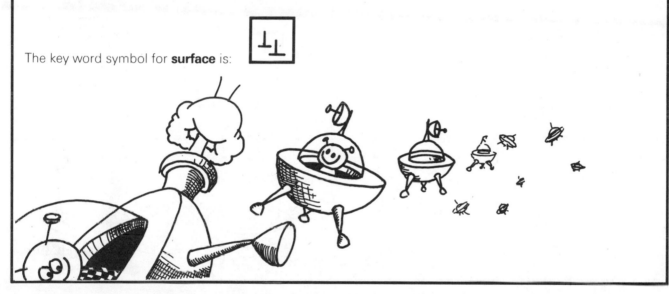

Art Attack: Drawing #67

Gingerbread Man Having a Bad Day

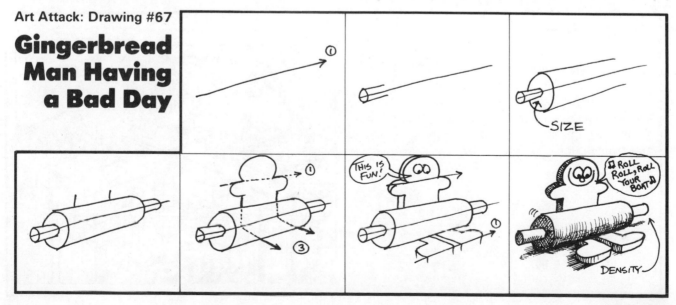

Art Attack: Drawing #68

Gingerbread Man's Doorstep

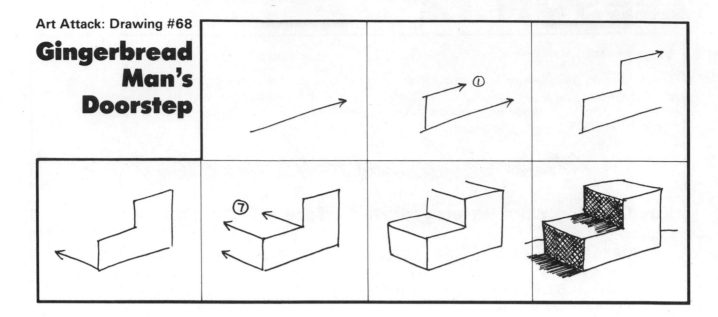

Art Attack: Drawing #69

Gingerbread Man's Thirst Quencher

CHOCOLATE MILK!

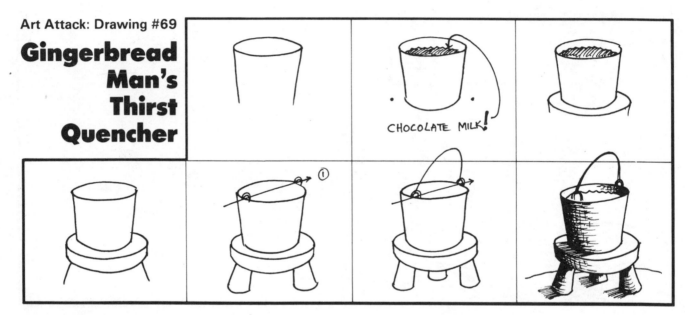

Motivator!

Look what happened to Sven's drawing skills after only 12 days of practice. If you draw everyday using the Ten Key Words of Drawing, you'll be drawing better, too! I promise. Keep a positive attitude and Draw, Draw, Draw!

Sven Olsen, age 14
San Diego, CA

Art Attack: Drawing #70
Gingerdog's Dinner

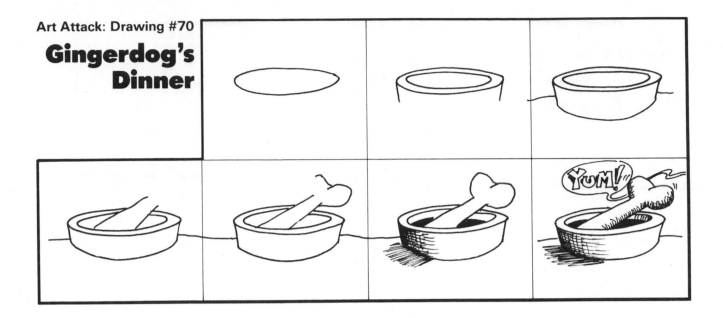

Student Gallery

Kevin Kraites, age 18
Gig Harbor, WA

Art Attack: Drawing #71
Gingerbread Man's Birthplace

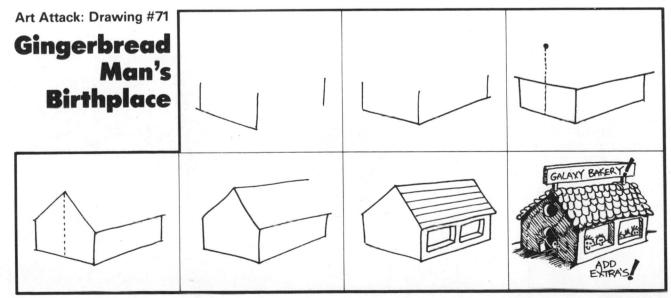

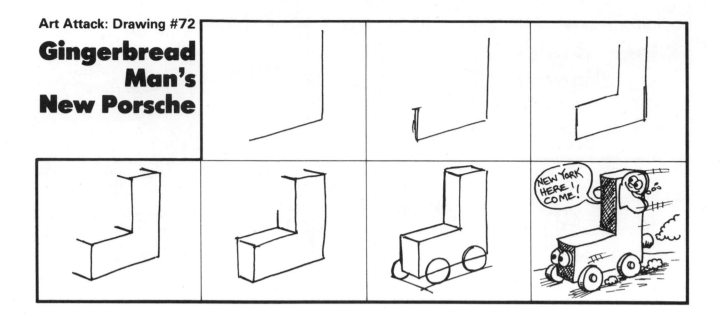

Gingerbread Man's New Porsche

The Bruce McIntyre Achievement Scale

Level 12

The Super Ant Club

To be an official, elite, super cool, member of Level 12, the Super Ant Club, you must successfully draw cubes stacked six high in five minutes. I have complete confidence in your pencil power. So, let the lead fly!

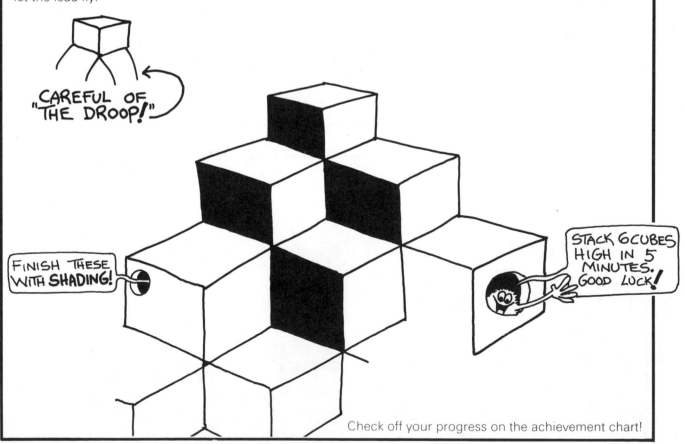

Check off your progress on the achievement chart!

Review

When you apply the principles of **density** to your drawing, you sketch nearer objects _____ and with _____ detail, and farther objects _____ and with _____ detail. Complete these stairs in Direction _____ . **Shade!**

Finish with **shading**.

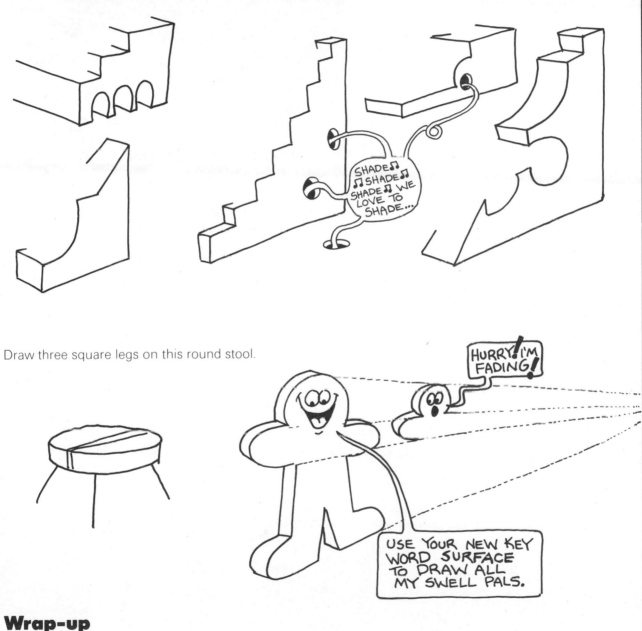

Draw three square legs on this round stool.

Wrap-up

Your drawing sketchbook is filling up nicely. The more pages you fill up with practice drawings, the greater your skill and confidence will be. Fuel your 3-D attitude and think, "draw daily, draw daily, draw daily." See you in Lesson 13!

Answers: 1. Darker 2. Greater 3. Lighter 4. Less 5. 5

TO DO: Teach a fireman how to draw. Get your drawings displayed in the library.

L12/99

Drawing Contest #12: **The Moonscape**

How many craters can you draw! Try **overlapping** 22 moons, then add craters. Nice effect, don't you think? This would make great wallpaper. Another Art Attack idea! Send this drawing to a wallpaper company and become rich and famous! The student record is 286 craters.

Daily Drawing Journal

Entry Date / /

LESSON 13

Warm-up

Shake out your hands!
Get your fingers loose with 42.3 seconds of drawercize. Stand up, flap your arms and sing in a jolly voice: "Oh, I'm a Draw Squad Maniac. Oh, I love to draw!" Feel better? Great! Here we go with Lesson 13. Only 17 more to go! Is your pencil sharp? Did you think positively today? Great! Draw 17 **foreshortened** circles!

Key Drawing Word: **Intermediate Shading**

SHADE, SHADOW & SHADING: Have you ever sat under a tree on a hot, bright, sunshiny day? Why did you sit there? More than likely you sat there to be in the **shade**—to get out of the sun—to be in the **shadow** of the tree! Was it darker or lighter in the **shadow** under the tree? Yes! It was darker! Why was it darker? Because the sunlight was partially blocked by the shape of the tree. If you were drawing the grass under the tree you would have to draw the **shadow** darker than the grass which is not in the shade. That is what you do when you **shade. Shading** is very important to drawing. **Shading** makes shapes and objects you draw look three-dimensional, to have form or volume, and to look more realistic. **Shading** makes what you are drawing look as if you could walk around it, sit under it or climb it. **Shading** is drawing from dark to light or from light to dark to make things look more interesting—to show how the light from the sun, a ceiling light, candlelight or some other light source hits a shape or object.

James M. Clarke, Board of Directors, National Art Education Association/Texas

The key word symbol for **shading** is:

Art Attack: Drawing #73

The Draw Squad Super Jet

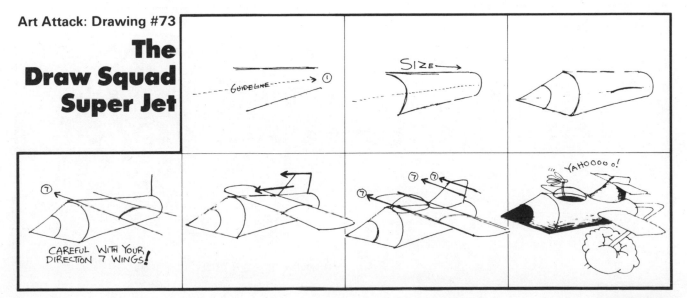

Art Attack: Drawing #74

A Doughnut For Your Drawing Diet

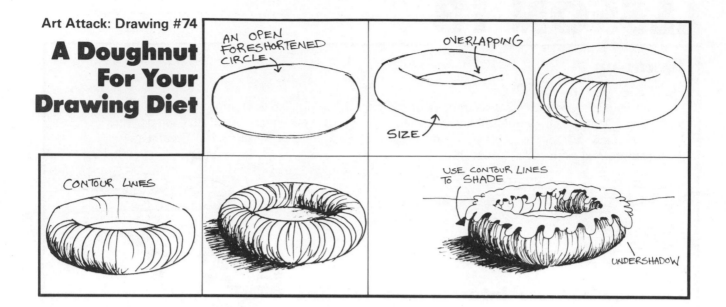

AN OPEN FORESHORTENED CIRCLE

OVERLAPPING

SIZE

CONTOUR LINES

USE CONTOUR LINES TO SHADE

UNDERSHADOW

Art Attack: Drawing #75

Three Steps to Success

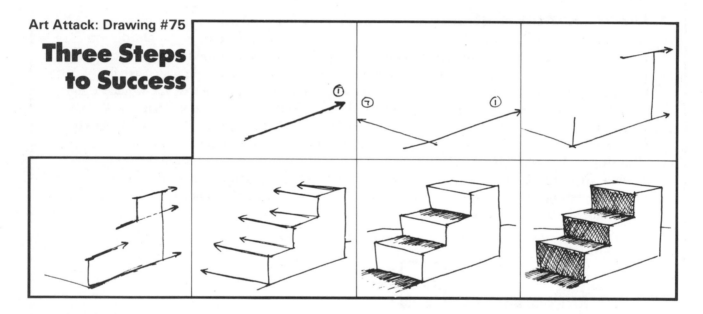

Motivator!

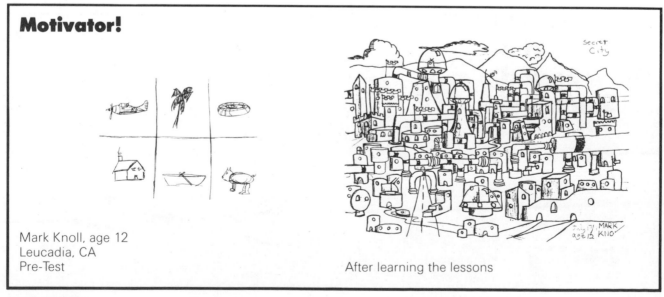

Secret City

Mark Knoll, age 12
Leucadia, CA
Pre-Test

After learning the lessons

A Flower For Mom

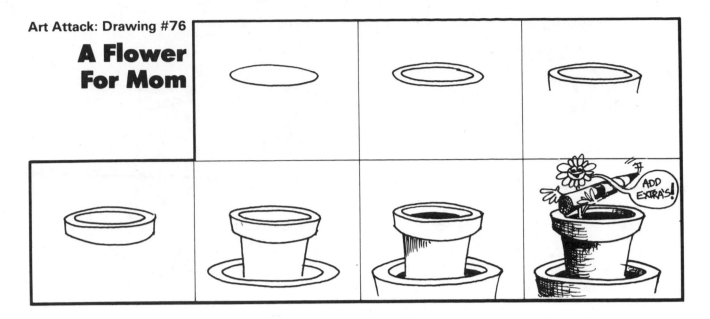

Student Gallery

Sarah Vickers, age 11
Owings Mills, MD
"Join the Club"

The Draw Squad

Finally! Here is the address to mail in for your official "super cool" club cards. Remember, all requests must be accompanied with a drawing.

Draw Squad Headquarters
P.O. Box 478
Oceanside, CA 92054
United States
Western Hemisphere
Earth
Solar System
The Milky Way
The Universe

Time For Lunch

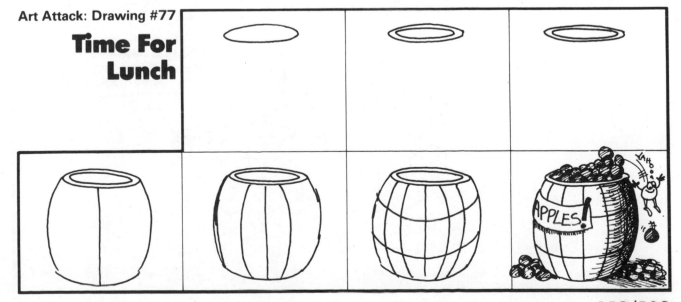

The Draw Squad Luxury Yacht

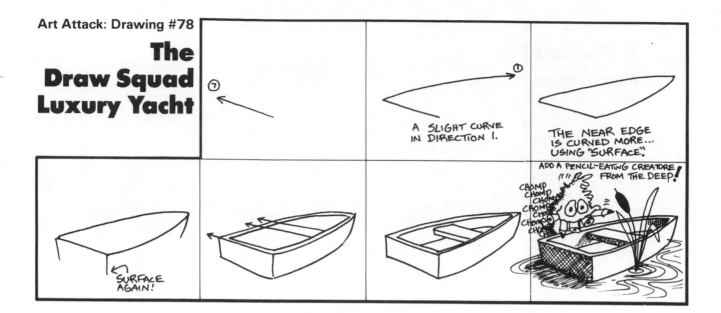

The Bruce McIntyre Achievement Scale
Level 13

The Giant Ant Club

Oh no! Not more cubes, aaaah! Just when you thought you were "cubed out," I introduce Level 13, the "Giant Ant Club." To pass this achievement test, you'll need to draw cubes stacked 15 layers high. Not 15 cubes total, 15 layers. A total of 130 cubes—all in less than ten minutes. Complete the **foreshortened** cubes below. Add **shading**. Test your pencil against the clock. Good luck, Draw Squader!

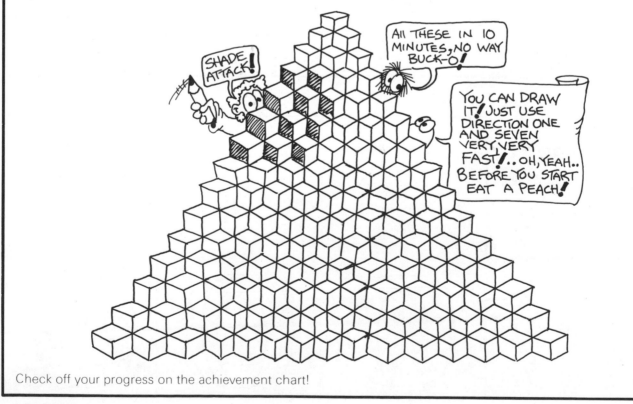

Check off your progress on the achievement chart!

Review

Add **shading** to the chimneys below.

Add **shadows** to the shingles.

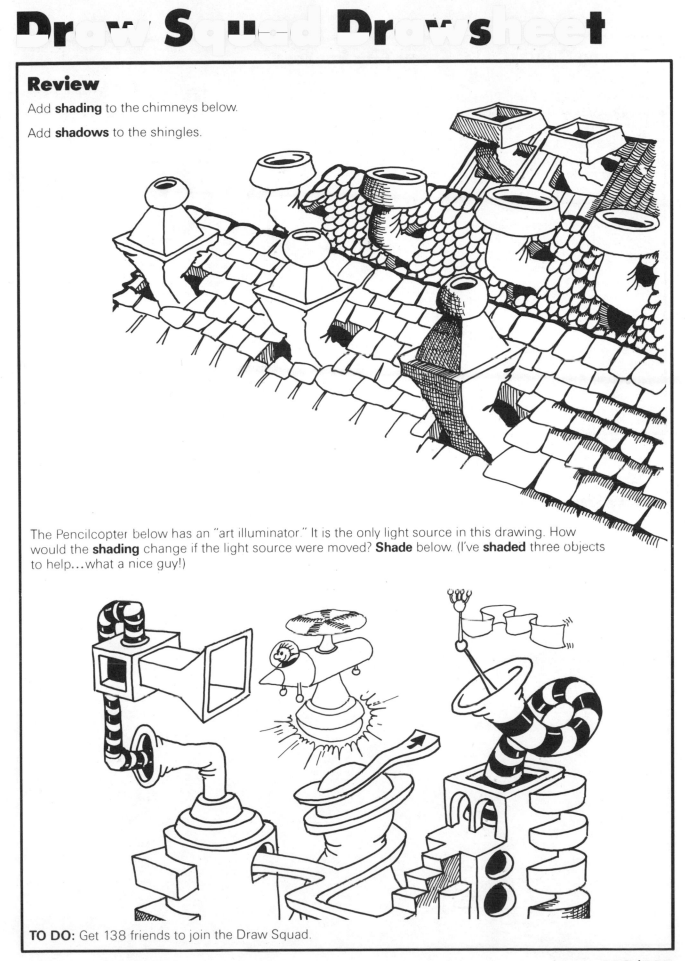

The Pencilcopter below has an "art illuminator." It is the only light source in this drawing. How would the **shading** change if the light source were moved? **Shade** below. (I've **shaded** three objects to help...what a nice guy!)

TO DO: Get 138 friends to join the Draw Squad.

Drawing Contest #13: **Super City Saucers**

Take another look at the students' draw-
ings in the Motivator and Student Gallery
sections of this lesson. How creatively
can you draw a Super City Saucer? How
about a Town Saucer? Or a Village
Saucer? How many can you draw in one
evening? Other ideas are: Draw a
Barbershop Saucer, a Grocery
Saucer, etc. Connect them with
transportation tubes, and be
sure to use **contour** lines.

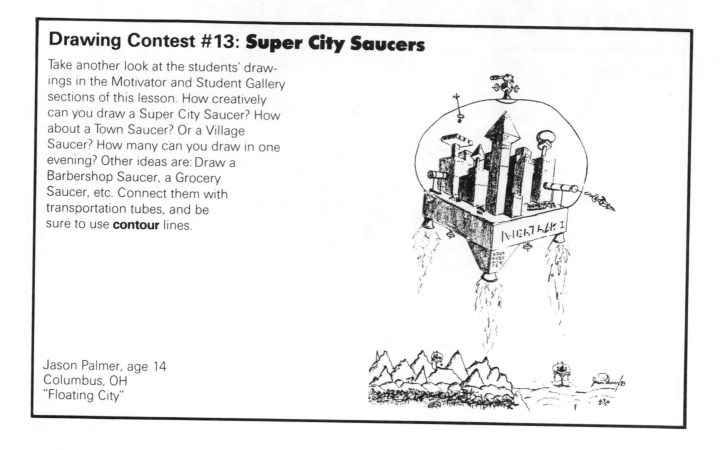

Jason Palmer, age 14
Columbus, OH
"Floating City"

Daily Drawing Journal

Entry Date / /

IT'S IMPORTANT
TO DATE EACH
OF YOUR DRAWINGS.

LESSON 14

Warm-up

Warm-up by drawing the Draw Squad oath in 3-D 472 times! Here's the oath: "I, _____, being the shade artist that I am (Notice how we say *shade* instead of *cool*; it's a new trend that's sweeping the nation, a kind of Draw Squad Mania with you as the pacesetter!), promise to blast across the paper with pencil power everyday for a minimum of seven hours. I also promise to complete each 7-hour daily drawing lesson by teaching eight friends how to draw." In keeping with this oath, this planet will be Draw Squad saturated by 2010 A.D.

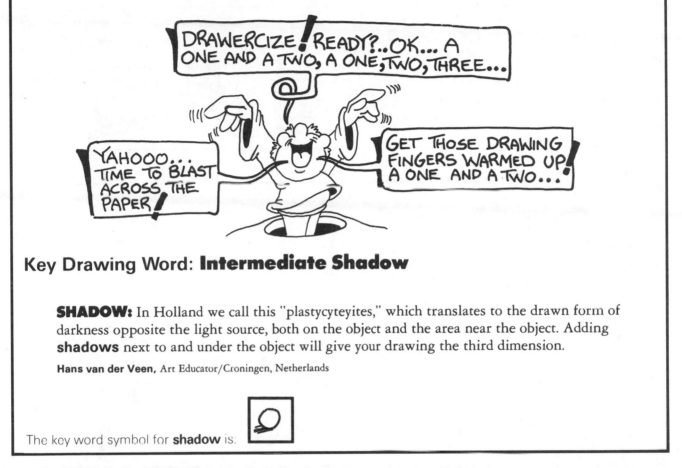

Key Drawing Word: **Intermediate Shadow**

SHADOW: In Holland we call this "plastycyteyites," which translates to the drawn form of darkness opposite the light source, both on the object and the area near the object. Adding **shadows** next to and under the object will give your drawing the third dimension.

Hans van der Veen, Art Educator/Croningen, Netherlands

The key word symbol for **shadow** is:

Art Attack: Drawing #79

A Mishap in Uni-Ted's Laboratory

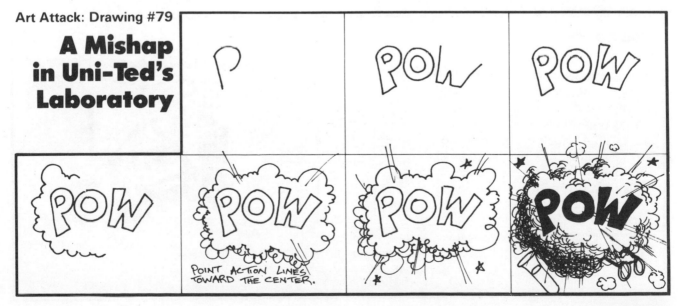

Art Attack: Drawing #80

Grandma's Gift

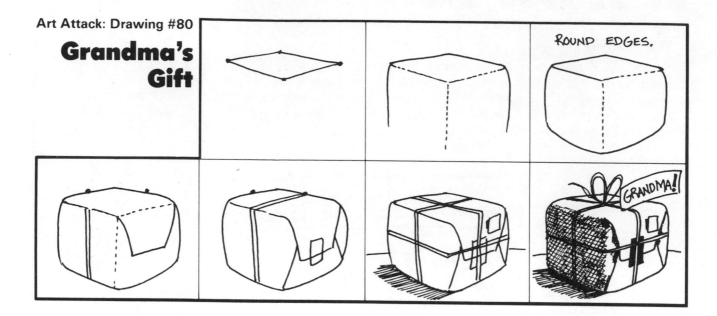

ROUND EDGES.

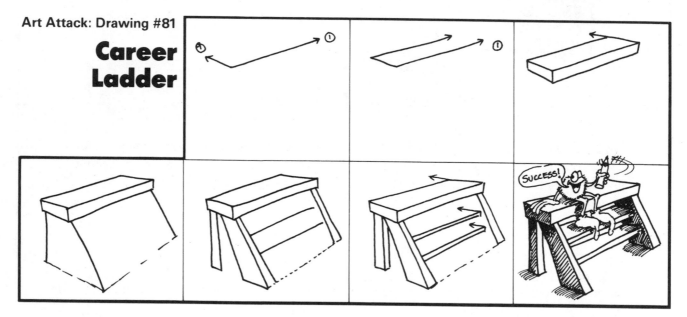

Art Attack: Drawing #81

Career Ladder

SUCCESS!

Motivator!

Here's an idea to help you get in the habit of practicing: Give your family 20 minutes to complete the Draw Squad pre-test (left-hand drawing below). Then teach them everything you know about the Ten Key Words. Practice with them for two weeks straight. You'll find that your enthusiasm will rub off on them and vice versa. This continual cycle of enthusiasm will make you want to Practice, Practice, Practice!

Jessica Rudolf, age 9
San Diego, CA
Pre-Test

After learning the lessons

Art Attack: Drawing #82

The 3-D "E"xtra Button

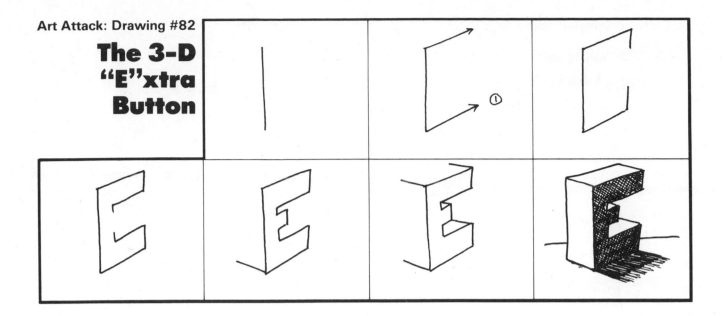

Student Gallery

Sharon Kim, age 14
Baltimore, MD
"Live Long and Prosper, Mark"

Art Attack: Drawing #83

"Oooh, It Has a Designer Label"

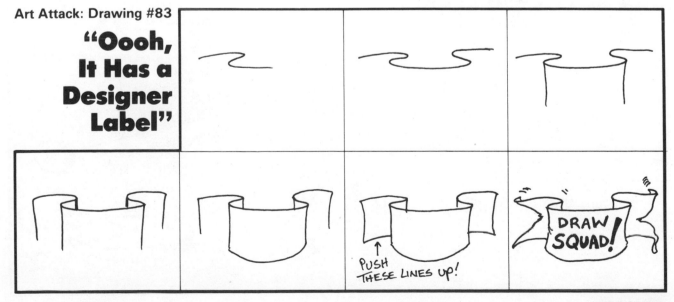

Furblina's Checkbook

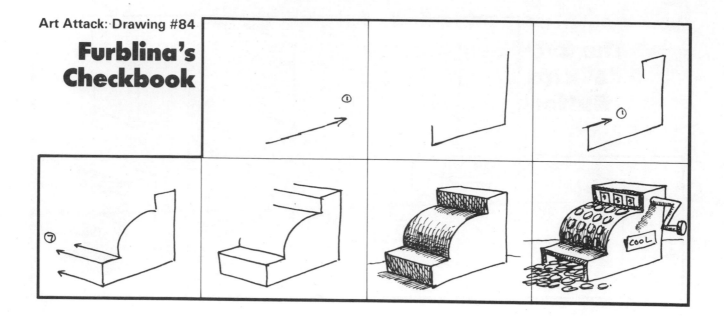

The Bruce McIntyre Achievement Scale
Level 14
The "L" Club

I've mentioned direction guidelines 1, 3, 5 and 7. These are the four most important positions in three-dimensional drawing. To avoid a "flat" look, you need to position the objects at an interesting angle.

Let me clarify this idea. Look at this "drawing clock." When it's **foreshortened**, the 1, 3, 5 and 7 become ideal guidelines to follow. Just as you need to keep your wheels in alignment to avoid a really rough ride, you need to keep your drawing in alignment to avoid a droopy, awkward sketch. The "L" Club emphasizes these four common drawing positions. To achieve the "L" Club status, you need to successfully draw three groups of "L's" on a "drawing clock." Being the nice guy that I am, I'll give you some extra time on this one…eight minutes. Got that? Three sets with four "L's" in each group. A total of 12 3-D "L's" in eight minutes. Good luck. Draw!

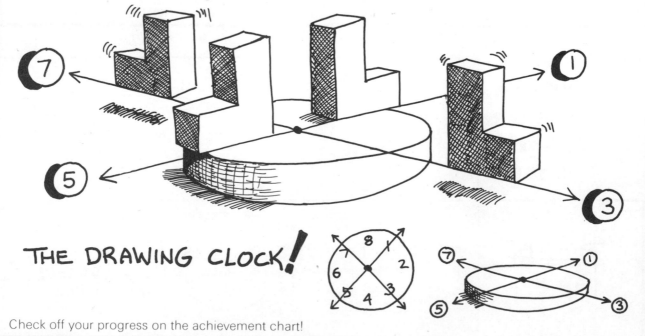

THE DRAWING CLOCK!

Check off your progress on the achievement chart!

Review

TRUE/FALSE

☐ ☐ Learning how to draw will make you the most popular person in town.

☐ ☐ *SUPER COOL* means a high-tech ice cube.

Add **shadows** and **contour** lines to these drawings.

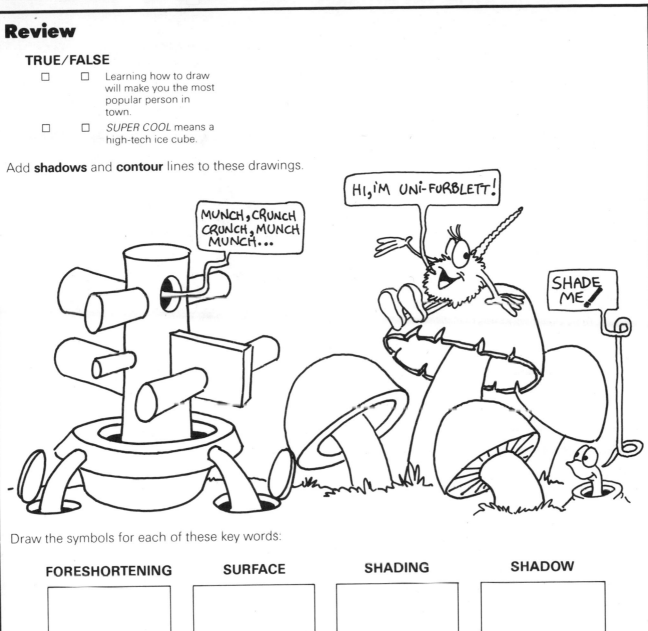

Draw the symbols for each of these key words:

FORESHORTENING	SURFACE	SHADING	SHADOW

These symbols are terrific learning tools. Grab a pad of small, yellow stick-ems and sit down with today's comics. Stick a yellow tag below each spot where the artists are using any of the above key words. Take your handy-dandy nice 'n' sharp pencil and draw the appropriate symbol on each yellow stick-em.

Answers: 1. True 2. True

TO DO: Go to your bookstore and take a look at Gary Larson's books *(The Far Side)*. His drawings are superb! Look at his excellent control of the Ten Key Words. Start your own comic strip using the Ten Key Words.

Drawing Contest #14: **Art Attack**

Are you enjoying this book? Are your drawing skills improving? Are you thinking in 3-D and creatively solving more problems? Great! Today's contest is an Art Attack competition. On how many of your friends can you pin Art Attack buttons? My record is 2,000 in one day at one of my lectures for kids. The idea is to get millions of people to wear these buttons. Perhaps they'll notice art more, think more artistically and draw more. Maybe they'll feel inclined to hop around on one leg, wildly waving their arms while screaming, "Art Attack!" Make a few hundred buttons today and pin them on your friends. Let's create a global ART ATTACK!

Tracy Stiffler, professional artist
Rochester, NY
"Art Attack Button!"

Daily Drawing Journal

Entry Date / /

ART ATTACK \ ärt ə'tak \ vb 1. A SUDDEN URGE TO RUN AROUND THE ROOM FRANTICALLY TUGGING OPEN DRAWERS AND CABINETS SEARCHING FOR PENCILS WHILE SINGING "♫OH...I NEED TO DRAW...♫OH YES... I DO!" 2. AN EXHILARATING SENSATION BEGINNING AT YOUR FINGER TIPS AND RAPIDLY SPREADING TO YOUR TOES, SIMILAR TO WHAT BOB SPRINGER FEELS 5 SECONDS AFTER EACH SPACE SHUTTLE LAUNCH.

LESSON 15

Warm-up

We're at the halfway point now. Congratulations! You've made it to Lesson 15. To warm up today, go on a **foreshortening** patrol. Walk through your home or office, arms slowly "radar circling," while humming, "**foreshortening, foreshortening, foreshortening.**" When you spot an object that is **foreshortened** from your point-of-view, beep loudly and have an art attack. Hop around the room, waving your arms wildly, causing as much commotion as you can. Since you've been jumping around screaming so much, we'll skip Drawercize for this lesson. Let's review a key word.

Key Drawing Word: Intermediate Density

DENSITY: This is a fun experiment. Take a handful of pencils and spread them out on your drawing table. As you focus on the nearest pencil, roll a few pencils farther away. What happens? The farther the pencils roll away the less detail you'll see. Try this outside with 40 tennis shoes.

Amy "Art" Krichko, Art Teacher/West Germany

The key word symbol for **density** is:

Art Attack: Drawing #85

Drawing in Stereo

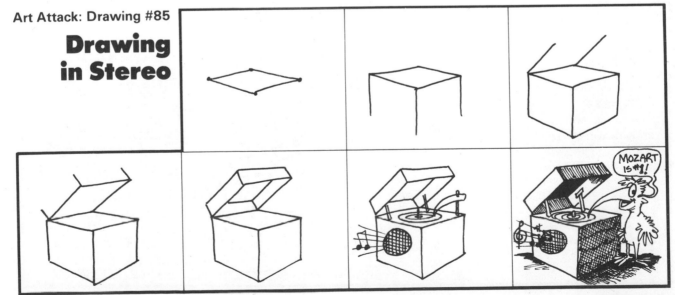

Art Attack: Drawing #86

More Steps to Success in Direction 7

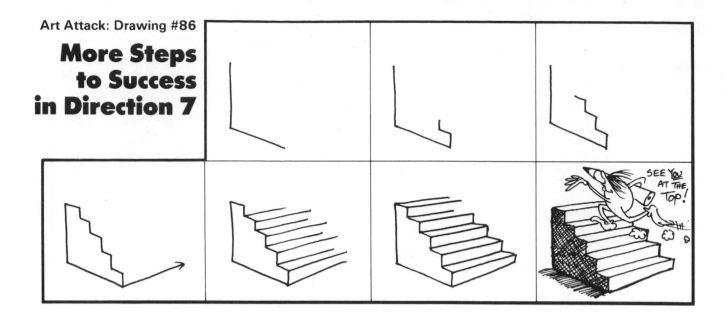

Art Attack: Drawing #87

Treasure Scroll

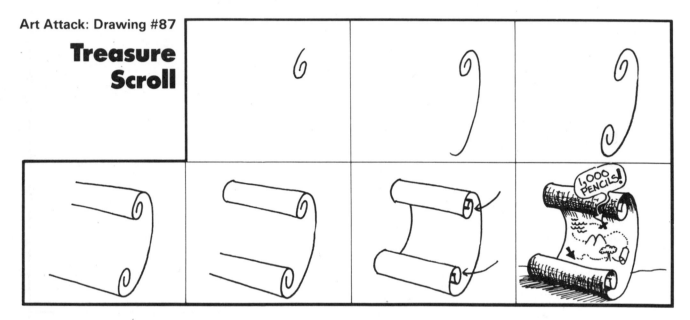

Motivator!

In this drawing Danny really grabbed hold of the "extra" button idea. He looked at his drawing, pushed his imagination "extra" button and added dozens of extras.

Danny Kraig, age 10
Fort Wayne, IN

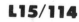

Art Attack: Drawing #88

Cuddly Furblett

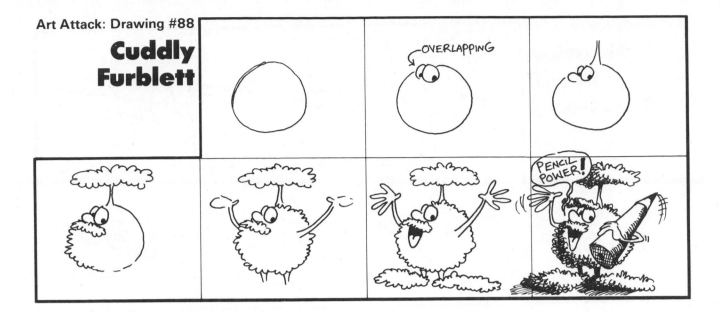

Student Gallery

Brad Perry, age 13
Nova Scotia, Canada
"Mount Rushmore"

Art Attack: Drawing #89

Furblett's Royal Banner

Floating Pencil in Direction 1

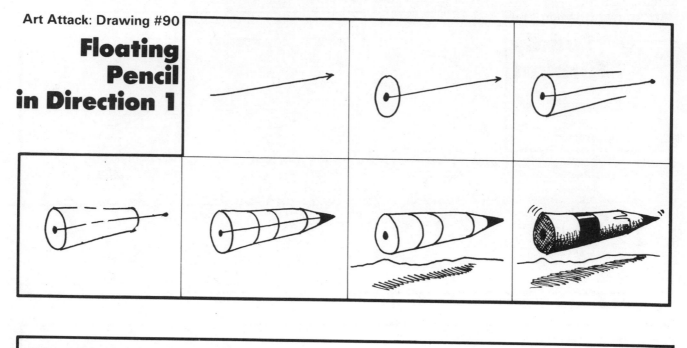

The Bruce McIntyre Achievement Scale
Level 15
The Red Pencil Club

This alternating-step building is another tough alignment challenge. When you can draw this building five levels high in 60 seconds, you will become an official member of the Red Pencil Club!

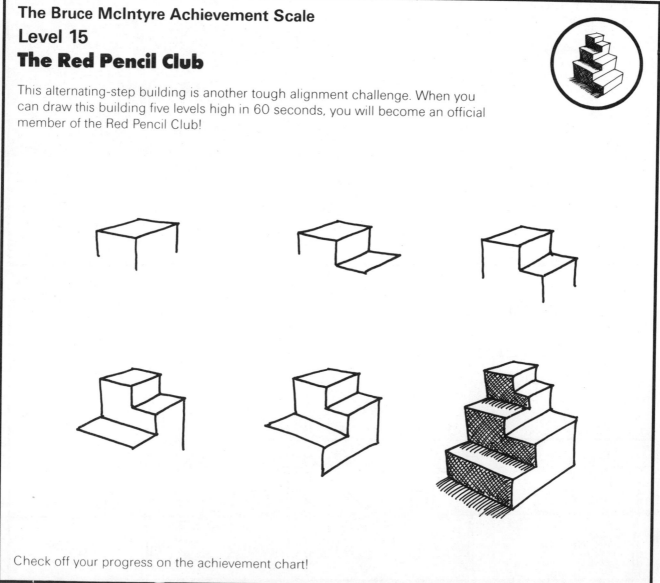

Check off your progress on the achievement chart!

Review

Draw a massive set of waves using **density** and **contour** lines.

Use **density** to draw 30 Pencil Shuttles launching into the world of art.

TO DO: Draw simple termites on 500 little yellow stick-ems and stick these little masterpieces on everything in your home. Surround your family in art!

Drawing Contest #15: **Cubeland**

Create a Cubeland using only cubes for all your buildings. The student record is 1,047.

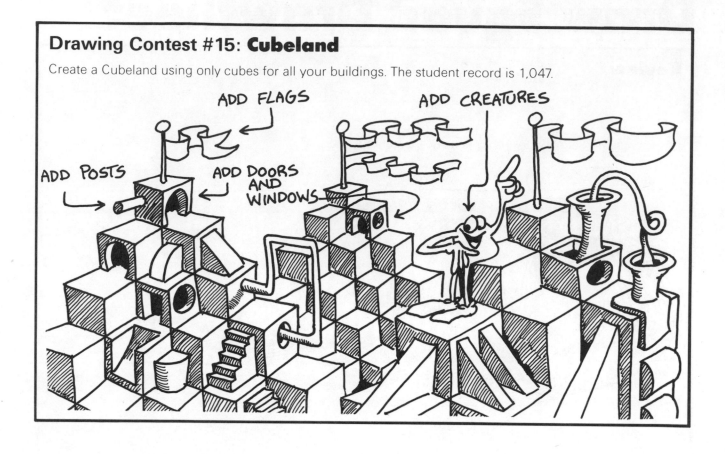

Daily Drawing Journal

Entry Date / /

Draw a scene using any one of the lesson drawings.

LESSON 16

Warm-up

Time to draw again, yahoo! Let's spend a day without T.V. Instead of reaching for the remote control, reach for your sketchbook. Skim through it. You are building quite an impressive portfolio. Today, warm up by designing some nifty stationery for yourself. On a blank piece of paper from your sketchbook, draw all around the edges, leaving the center blank for writing. Go to your local copy center and run off 100 copies on a rainbow of colored papers.

FORGET THAT 100 COPIES NONSENSE! I MADE MYSELF 3 MILLION! I'M IN STATIONERY HEAVEN...

Key Drawing Word: **Intermediate Contour**

CONTOUR: Contour lines are those lines which are drawn to show the outer edge of a form. The line that is implied where the form stops and space begins is drawn as a **contour line**. By using a variety of **contour lines** (e.g. dark, light, thick and thin), the values and textures of the form can also be shown.

Leslie Wingfield, Art Educator/Spring, TX

The key word symbol for **contour** is:

Art Attack: Drawing #91
Crooked Steps in Direction 5

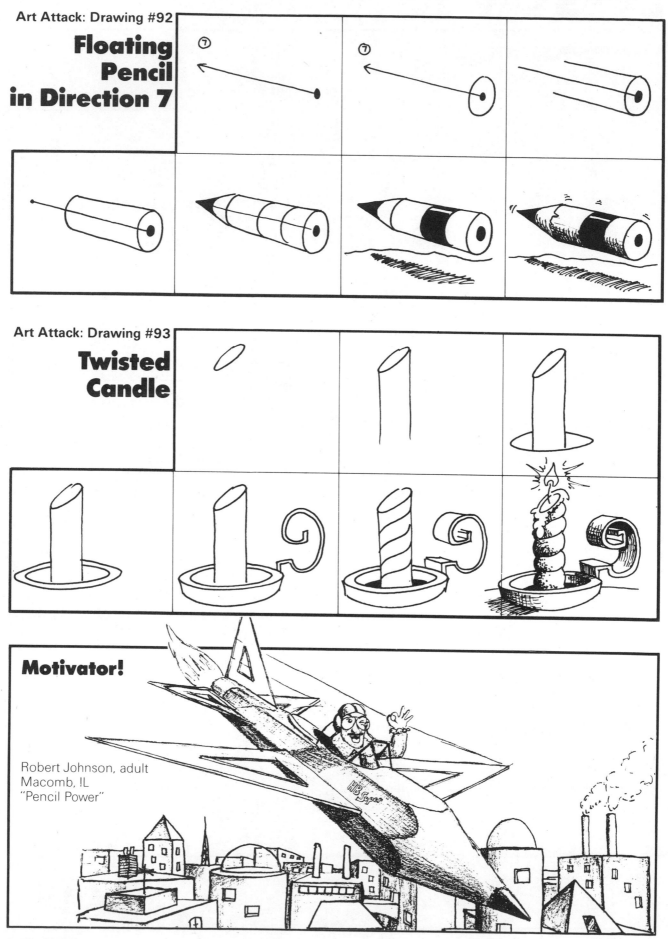

Art Attack: Drawing #92

Floating Pencil in Direction 7

Art Attack: Drawing #93

Twisted Candle

Motivator!

Robert Johnson, adult
Macomb, IL
"Pencil Power"

Art Attack: Drawing #94

Pencil Shuttle in Direction 3

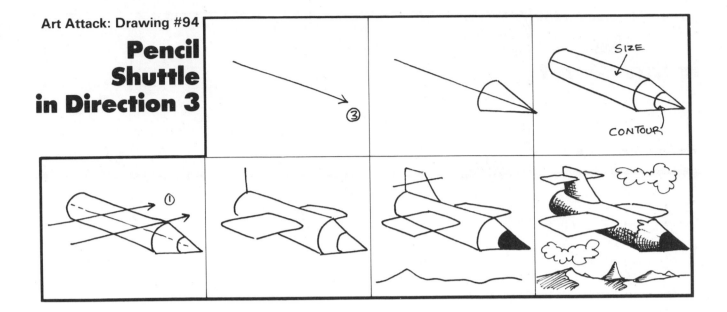

Student Gallery

Merilee Robinson, teacher
San Francisco, CA
"The Incredible Cave City"

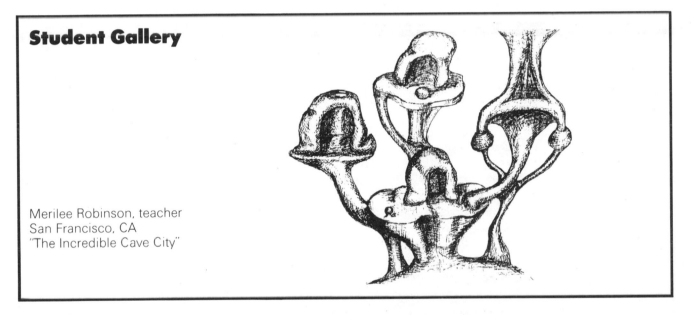

Art Attack: Drawing #95

Think Big!

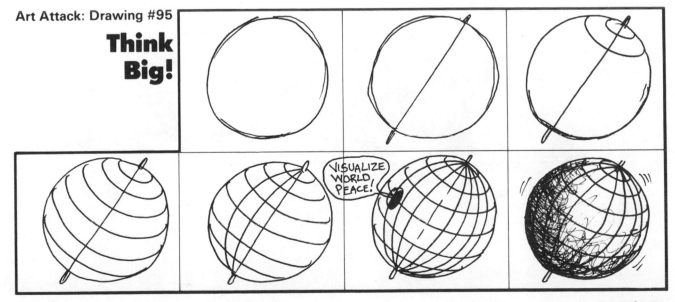

Mr. "L" in Direction 1

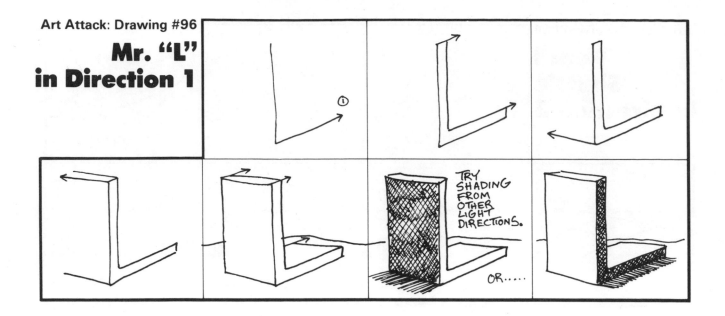

TRY SHADING FROM OTHER LIGHT DIRECTIONS.

OR.....

The Bruce McIntyre Achievement Scale
Level 16
Pencil Power Club

Let's practice alignment again. Draw a guideline in Direction 1. Cut it in half by another guideline in Direction 7. Label arrows pointing in Directions 1, 3, 5 & 7. I know this seems tedious, but it will help you gain control of positioning objects. I'm sure you've noticed a difference in your sketching confidence ever since you achieved the "L" Club. To achieve the Pencil Power Level, draw three complete sets of 4-positioned pencils in eight minutes.

Check off your progress on the achievement level chart in the back of the book and on the back of your Draw Squad Club Card.

Review

Add 17 washers to this Direction 1 post. Add **shading**.

Add **density** to my mom's name.

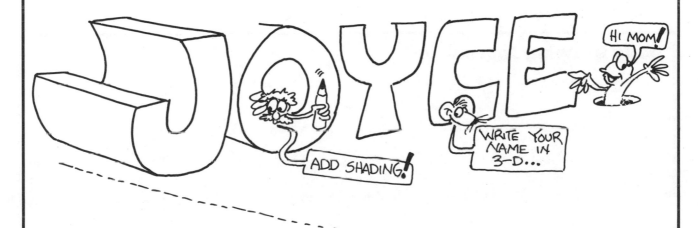

Write your name in 3-D. Position the name in Direction 7, yet face the letters in Direction 5.

TO DO: Teach your dog how to draw. Please send your pooch's drawings to the Draw Squad address so he can get his club card.

Drawing Contest #16:
The Road to Happiness

Fill a page of fascinating pathways, tunnels, bridges and intersections...a wild road city! How many roads can you draw? How many "extra" arches and vehicles can you add? How about a night drawing with headlights? How about roads built with marshmallows. The White Spongy Freeway! Enjoy drawing your road to happiness. Draw Squader!

Chris Marolt, age 11
Aurora, CO
"Road to Happiness"

Daily Drawing Journal

Entry Date / /

LESSON 17

Warm-up

Here's a great warm-up from a good friend of mine, Amy "Art" Krichko, who teaches Art in Bitburg, West Germany:

"Relax...your arms and legs are melting into energy...feel that energy...everything around you is art...keep relaxing your arms...now your hands...fingers...fill your fingers with art energy."

NOW THAT YOU'RE ENERGIZED, put your hands in the air and wiggle them for 60 seconds with Drawercize. Ready to draw? Go, Go, Go!

Turn on your imagination! Fuel up your pencil with the Ten Key Words and launch across a blank piece of paper with pencil power...Explore the Land of Art. Imagine! Create! Experiment!

Key Drawing Word: **Intermediate Overlapping**

OVERLAPPING: Think of it as layering that helps to give your pictures depth. It is how you can make things look closer to you and other things look farther away. It is the means by which you can place, set, arrange and position one thing in front of another. **Overlapping,** along with the other elements of drawing, will turn ordinary flat drawings into spectacular three-dimensional drawings.

Margaret Hansen, 1st Grade Teacher, Montevideo School/San Ramon, CA

The key word symbol for **overlapping** is:

Art Attack: Drawing #97

Uni-Ted Goes For a Morning Spin

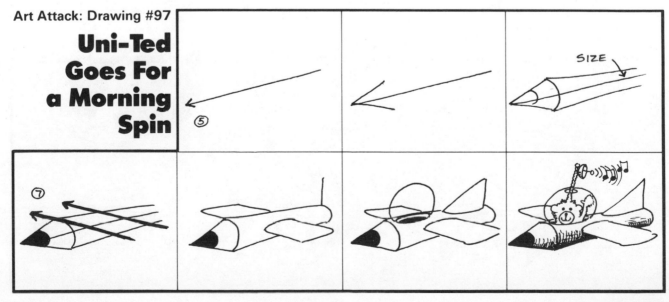

Art Attack: Drawing #98
A Romance Is Born

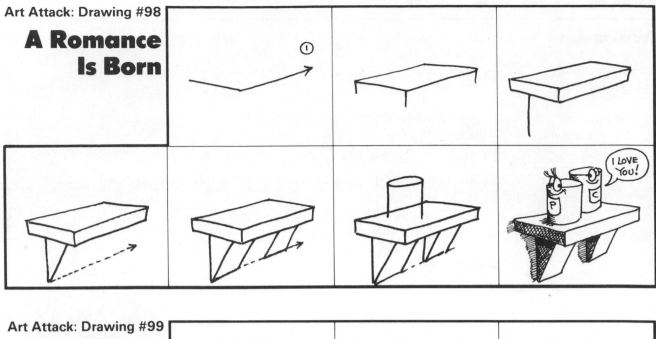

Art Attack: Drawing #99
The Official Draw Squad Chair

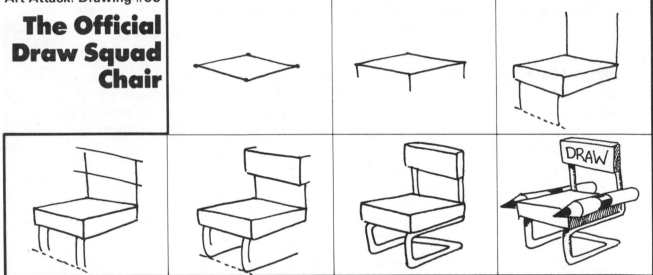

Motivator!

I asked Pat to write his name in 3-D. He didn't draw it just once. No, not this Draw Squader. He had five art attacks using the "extra" button each time. Great job, Pat!

Pat J., age 12
Canada

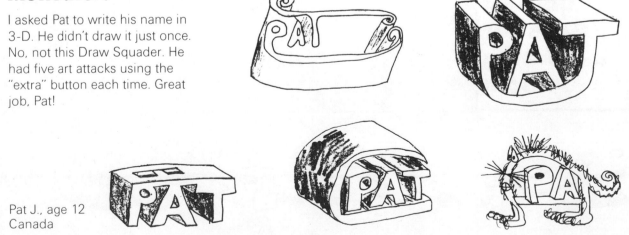

Art Attack: Drawing #100

A Calla Lily
For You

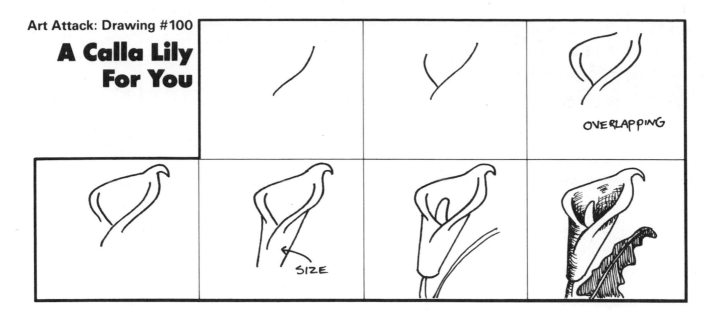

OVERLAPPING

SIZE

Student Gallery

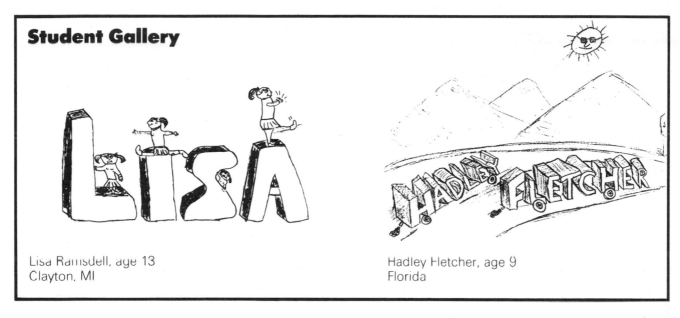

Lisa Ramsdell, age 13
Clayton, MI

Hadley Fletcher, age 9
Florida

Art Attack: Drawing #101

Mr. "E"
in Direction 3

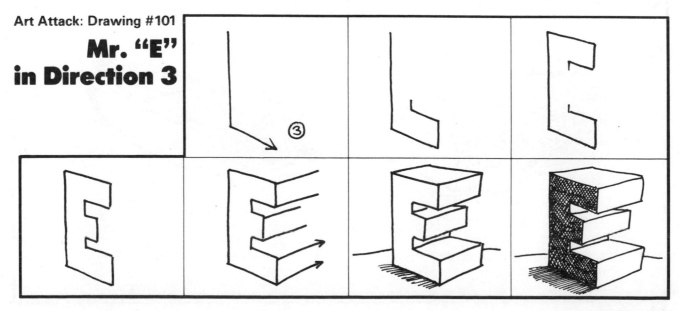

③

Mr. "T"
(Oh, Nooo!)
in Direction 3

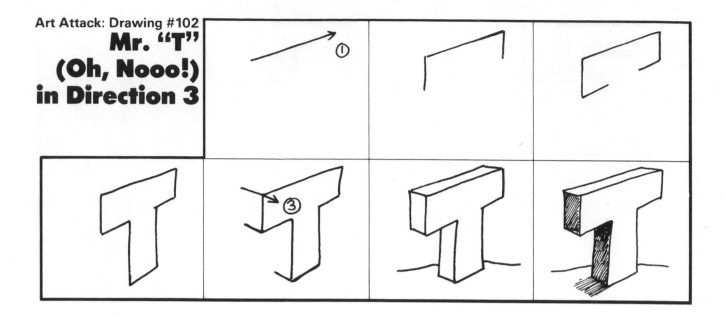

The Bruce McIntyre Achievement Scale
Level 17
The Radical Rowboat Club

To achieve the status of a Radical Rowboat Club Member, you need to draw three sets of rowboats in Directions 1 and 7. I'm giving you plenty of time on these challenge levels so don't start getting sloppy, OK? Concentrate on the alignment. The **foreshortened** rim of a rowboat is the tricky spot; the near side is curved much more than the far side. Try listening to some Mozart while attempting this club level. It will make it much easier. The time limit is eight minutes. Please remember not to dance on the table.

7 **1**

When you complete a total of six rowboats, three in Direction 1 and three in Direction 7, check off your progress on the achievement level chart.

Review

Add **shading** and **contour** lines to the Cheerios® manufacturing plant.

TRUE/FALSE

☐ ☐ Boy, is it good to see these silly questions again!

☐ ☐ I've mailed in for 27,000 Draw Squad Club Cards.

The Ten Key Words of Drawing are:

_____ , _____ ,

_____ , _____ ,

_____ , _____ ,

_____ , _____ ,

_____ and _____ .

"Art Attack" means _____ .

Pump some imagination through your _____ !

Learning how to draw is _____

If a dull pencil is used to draw with, it will _____

CHEERIOS...

YUM!

YOU FINISH THE REST!

TO DO: Start having weekly draw sessions with your friends...ART ATTACK!

Copyright © 1988 by Mark Kistler

Drawing Contest #17: **The Name Game**

I know you are having so much fun pinning swell little Draw Squad buttons on all your friends. So now we get to spread the drawing mania even further. Write each of your friends' names in 3-D, add color and add "Draw Squad Member" under the name. Buy 137 name tag holders (around 15 cents each) and stick a name inside each one. Time to pin 'em! Student record…nobody yet. I've never made a contest out of name tags before. I hope you don't mind being the lucky "tester." Send me your 3-D name tag. I have hundreds of them hanging in my drawing studio that I've collected from students over the years. Thanks!

Jenny S., age 8
Arizona

Tim Winkelman, age 12
Utah

Daily Drawing Journal

Entry Date / /

LESSON 18

Warm-up

Jump into the shower fully clothed. Now run around hugging your family while singing joyfully, "It's drawing time, it's drawing time." (I often wonder how many students take me seriously and really participate with me in these warm-ups.) I don't really intend for you to run around dripping wet. I'm just trying to grab your attention through my "quick wit." Ha! I'm just trying to share my enthusiasm for drawing with you.

My students and friends (yes, I really do have a few friends who put up with my craziness) know how I bounce off the walls with ENERGY when I'm talking about drawing. I really love to draw and hope you're enjoying these lessons as much as I am. While we're chatting, let me share my dream goal with you. I visualize in 3-D everyday that one million students will mail in drawings to join the Draw Squad. Can you imagine the impact of a million members teaching their friends? Wow, we're talking a lot of creative thinking! Get your friends to mail in a drawing for a Draw Squad Club Card!

Key Drawing Word: Intermediate Size

SIZE: This is defined as the largeness or smallness of an object relative to its surroundings. It can determine dominance and perspective. Draw closer objects larger and farther objects smaller. A good example is to place two apples on a table in front of you. Move one away from you and watch how it appears to shrink. This is **size** in action!

Tracy Stiffler, Professional Artist, WXXI T.V. 21/Rochester, NY

The key word symbol for **size** is:

Art Attack: Drawing #103

King Draw Squid's Throne

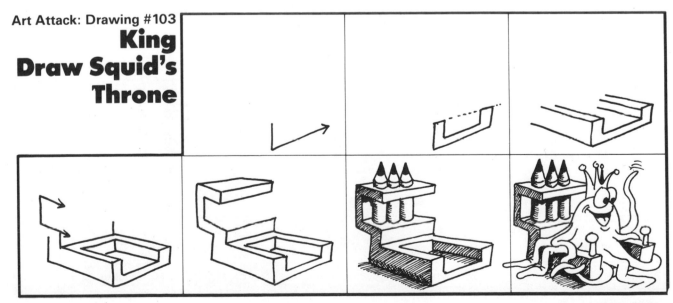

Art Attack: Drawing #104

A Tree on Sale

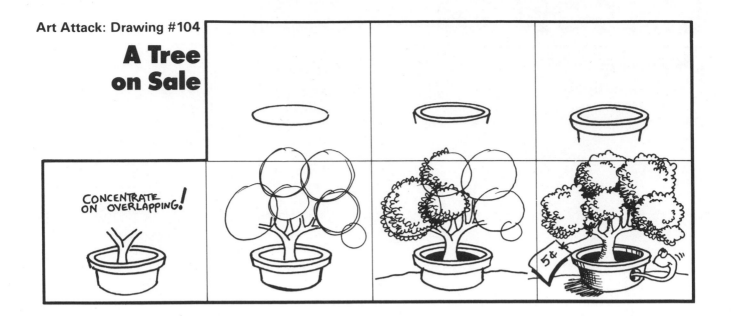

CONCENTRATE ON OVERLAPPING!

Art Attack: Drawing #105

Rings Around the Collar

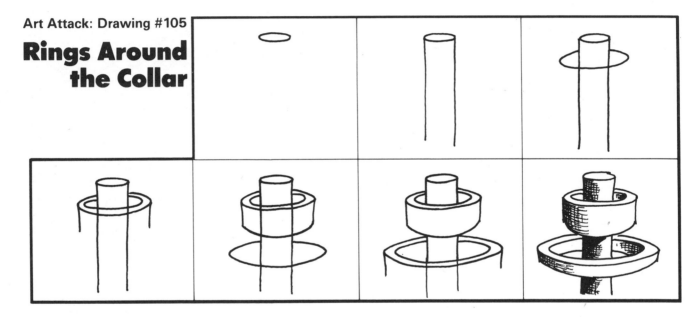

Motivator!

Cindy Kahan, age 14
Baltimore, MD
"Besoine City"

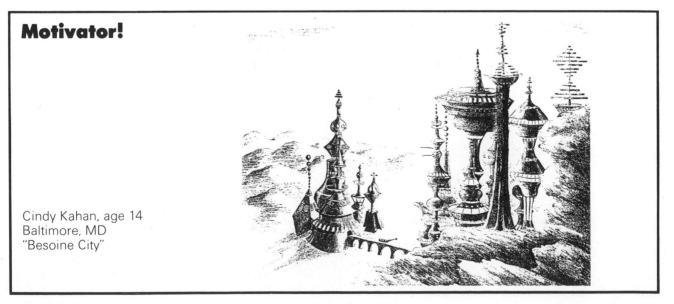

Art Attack: Drawing #106
Elaborate Steps to Success

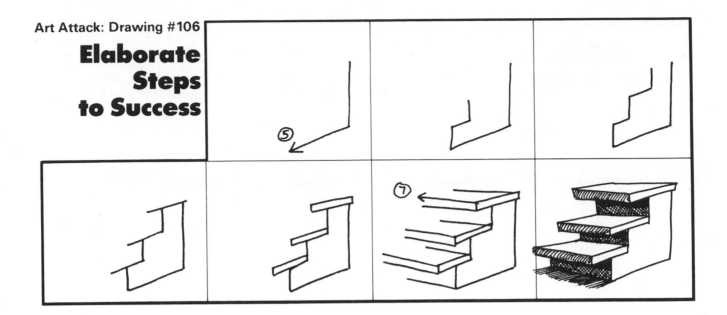

Student Gallery

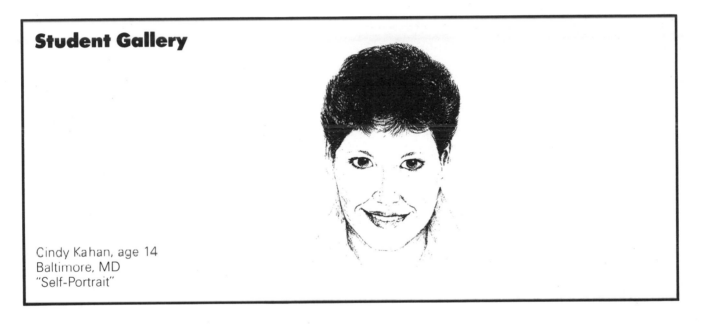

Cindy Kahan, age 14
Baltimore, MD
"Self-Portrait"

Art Attack: Drawing #107
The Secret Muffin Recipe

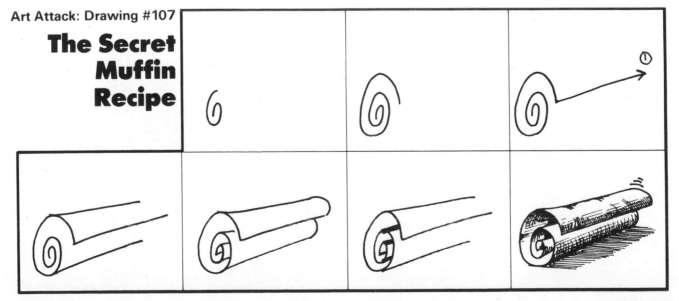

Melissa's Cute Bunny Needs Braces

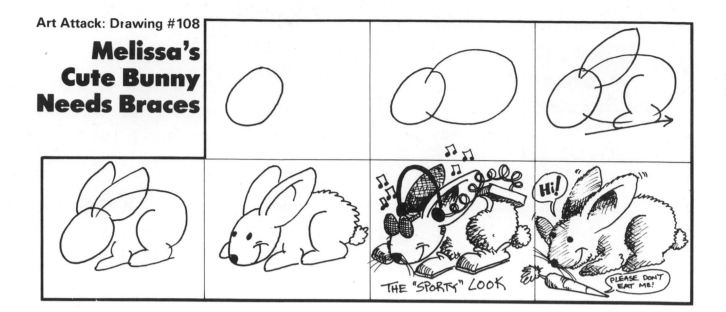

THE "SPORTY" LOOK

Hi!

PLEASE DON'T EAT ME!

The Bruce McIntyre Achievement Scale
Level 18

The "Rad" Rowboat II Club

OK! So you've got Directions 1 and 7 down perfectly. Now let's try three sets of these rowboats in Directions 3 and 5. To achieve this club level you need to draw three rowboats in Direction 3 and three more in Direction 5, all in eight minutes.

Don't forget to check your progress off on the chart in the back of this book

Review

Add **shadows** behind the Draw Squad letters.

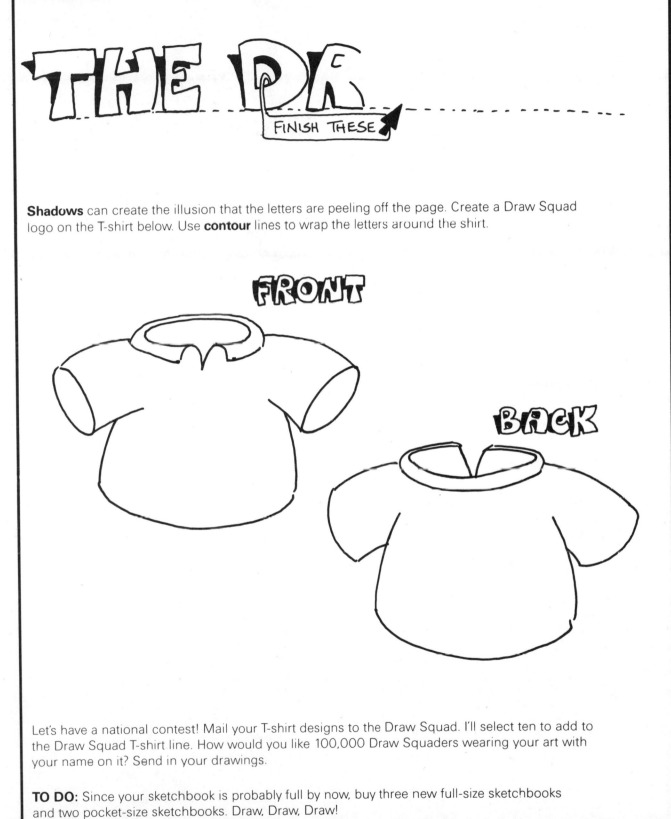

THE DR

FINISH THESE

Shadows can create the illusion that the letters are peeling off the page. Create a Draw Squad logo on the T-shirt below. Use **contour** lines to wrap the letters around the shirt.

FRONT

BACK

Let's have a national contest! Mail your T-shirt designs to the Draw Squad. I'll select ten to add to the Draw Squad T-shirt line. How would you like 100,000 Draw Squaders wearing your art with your name on it? Send in your drawings.

TO DO: Since your sketchbook is probably full by now, buy three new full-size sketchbooks and two pocket-size sketchbooks. Draw, Draw, Draw!

Drawing Contest #18: **The Ultimate Forest**

Draw a massive forest. Then add tons of extras, such as a squirrel, a secret tree city; or how about a monkey kingdom where the trees are really camouflaged appliances for the monkeys' luxurious lifestyles (like a microwave oven tree or a VCR tree and so on). It's important to use lots of **overlapping** and **shading** with trees. My brother, Karl, holds the record with 37 trees in this contest. Surely you can out-draw that! Draw, Draw, Draw!

Matt Carswell, age 11
New York, NY
"Ultimate Forest"

Daily Drawing Journal

Entry Date / /

LESSON 19

Warm-up

We're way over 100 drawings now...yeah! Great job! Loosen up with 120 seconds of Drawercize. Do you get embarassed and hide your hands under the table when you warm up while nonchalantly looking around to see if anyone is watching? C'mon you drawing maniac, wake up! You're an artist. You don't have to worry about what people think. We have a creative license to act as "artsy" as we want. If you feel an art attack bubbling to the surface, don't worry if your friends are watching. Get them to join you! Is this a great planet or what!

Key Drawing Word: **Intermediate Attitude**

ATTITUDE: To create any artistic endeavor the artist must have enough self-confidence to offer his work to others for their consideration. The ability to feel good about your work must be developed through personal awareness of your talent, technique and creativity. This comes with the daily practice of basic elements which make up the background the artist draws upon to create his work. When the person feels good about himself, the work flows freely. Creativity is enhanced and the fear of criticism diminishes.

Ken Kraintz, Fine Arts Supervisor, Everett School District/Everett, WA

The key word symbol for **attitude** is: ⬆

Art Attack: Drawing #109

A Fancy Flag For 15 Funny Friends

ADD THESE "PEEK-A-BOO" LINES!

PUSH THESE LINES UP!

Art Attack: Drawing #110

The Penalty For Missing a Day of Drawing

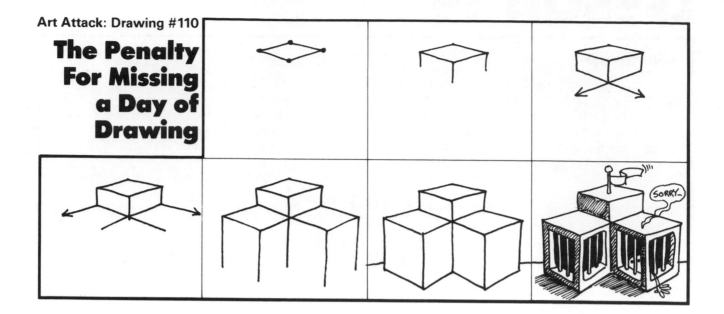

Art Attack: Drawing #111

The Great Pigasus

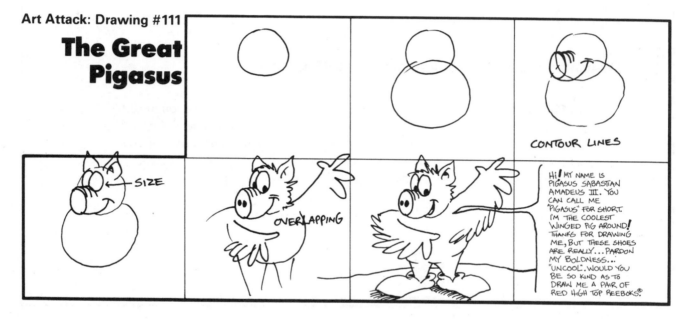

CONTOUR LINES

SIZE

OVERLAPPING

Hi! MY NAME IS PIGASUS SABASTIAN AMADEUS III. YOU CAN CALL ME "PIGASUS" FOR SHORT. I'M THE COOLEST WINGED PIG AROUND! THANKS FOR DRAWING ME, BUT THESE SHOES ARE REALLY...PARDON MY BOLDNESS... "UNCOOL". WOULD YOU BE SO KIND AS TO DRAW ME A PAIR OF RED HIGH TOP REEBOKS®

Motivator!

FAR-TECH corp.

Mandy Neill, age 14
College City, TX

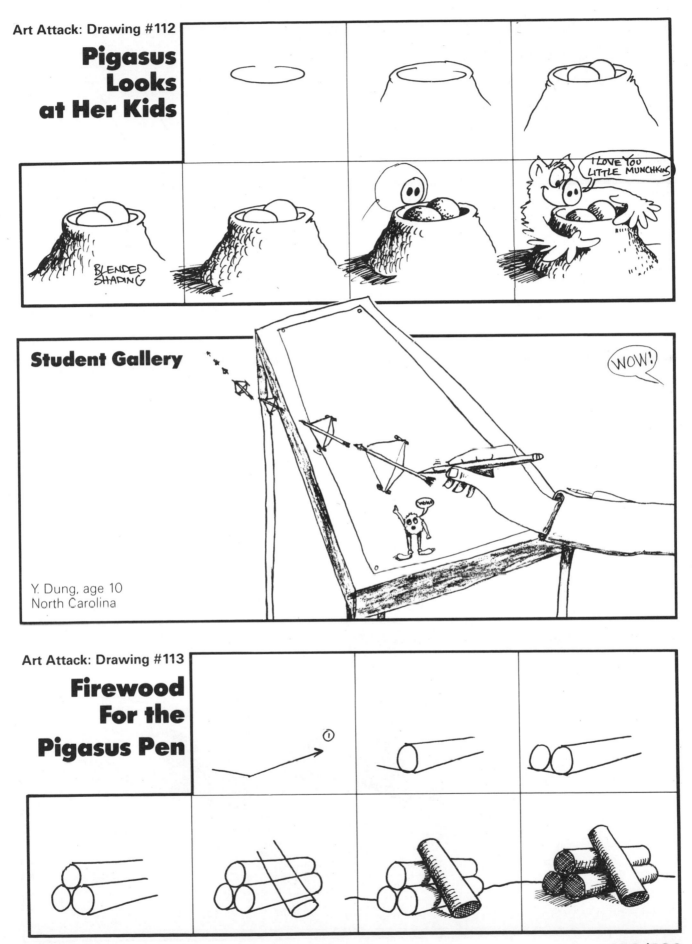

Cube with Inclined Planes

The Bruce McIntyre Achievement Scale
Level 19
The Window Club

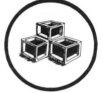

I know you can stack the Red Ant Club in one minute. Now I want you to draw the Red Ant Level and add a window to each surface. Complete the drawing with **density** (thickness) and **shading**. You've got three minutes. Here is the helpful window rule: if the window is on the right side, the thickness is on the right side; if the window is on the left side, the thickness is on the left side and if the window is on the top, the thickness is on the top. If you forget this rule, your window might become a giant button.

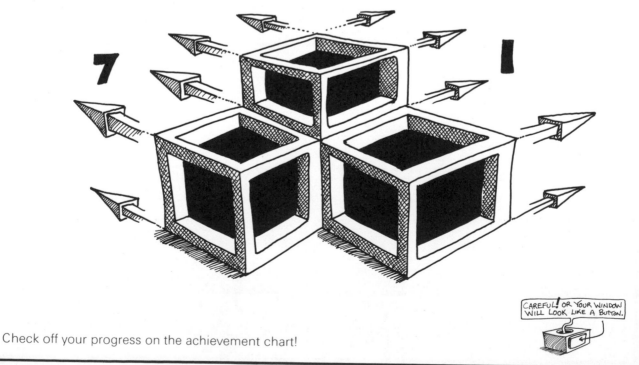

Check off your progress on the achievement chart!

Review

Have you sent for Earl Nightingale's audio cassette yet, the one I told you about back in Lesson 11? Aah…ha! Procrastinating, are you? Well, here is another elbow in the side. It's free and it's a totally "rad" **attitude** amplifier. I don't receive any commission for this. In fact, the company doesn't even know I'm mentioning them in this book. I do get a great feeling knowing a lot of people are going to turn their car travel time into "positive attitude" time.

Complete this flag.

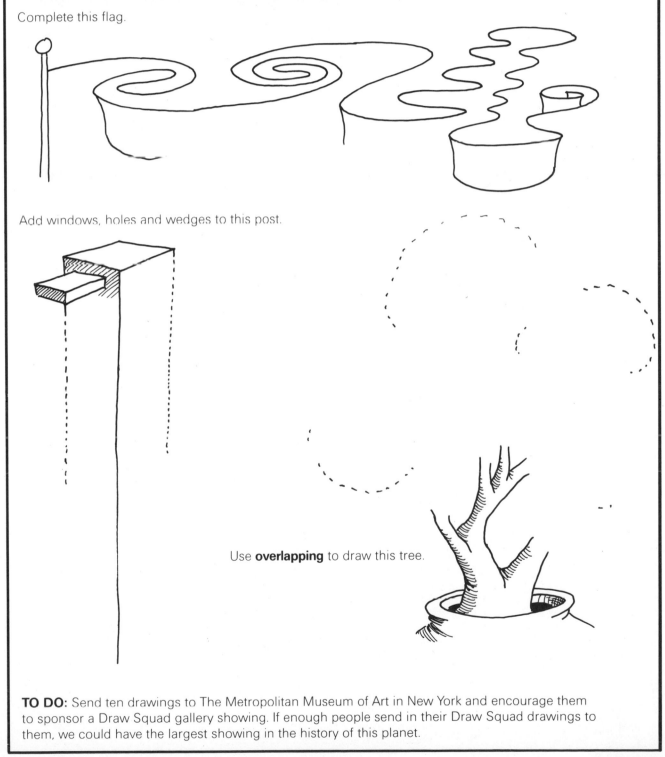

Add windows, holes and wedges to this post.

Use **overlapping** to draw this tree.

TO DO: Send ten drawings to The Metropolitan Museum of Art in New York and encourage them to sponsor a Draw Squad gallery showing. If enough people send in their Draw Squad drawings to them, we could have the largest showing in the history of this planet.

Drawing Contest #19: **Pigasus Fever**

Ideas are wonderful things. My good friend, Tom, Vice-President of the Draw Squad, was busy drawing Uni-Teds one fine afternoon, when he jumped up on the table and shouted "pigasus!" With practice, he let out the creative monster inside of him and out popped a terrific idea. When your ideas bubble out, be quick to snag them. Write them down and send them to the Draw Squad. (We just might use them in our next book.)

Tracy Stiffler, professional artist
Rochester, NY

Daily Drawing Journal

Entry Date / /

LESSON 20

Warm-up

We're now completing the intermediate level of your lessons. You're a better artist than I am now, so remember me when you're on the international lecture circuit of all the big museums. I expect postcards from every airport stop or I'll have to reclaim your Draw Squad Card.

Key Drawing Word: **Intermediate Daily**

DAILY PRACTICE: An artist, like an athelete, must train everyday in order to develop the proper muscles and mental capacity to do art. Repetition and review are essential for developing skills and determining progress. Practice requires a constant evaluation so that mistakes are not adopted and advancement can be achieved. While the process of practicing may be viewed as boring, the progress achieved can be exciting and can be inducement for further practice.

David Humphreys, Arts Educator/Washington, DC

The key word symbol for **daily** is:

Art Attack: Drawing #115

The Red Carpet Treatment

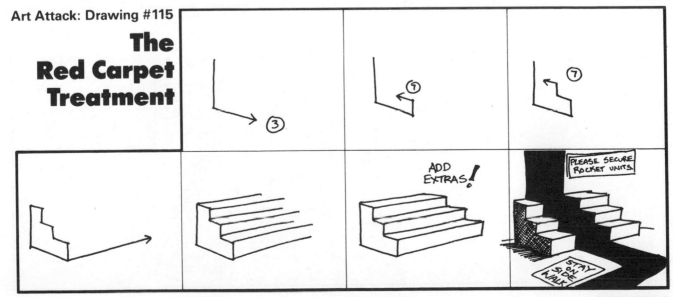

Art Attack: Drawing #116
The Secret Muffin Recipe Revealed

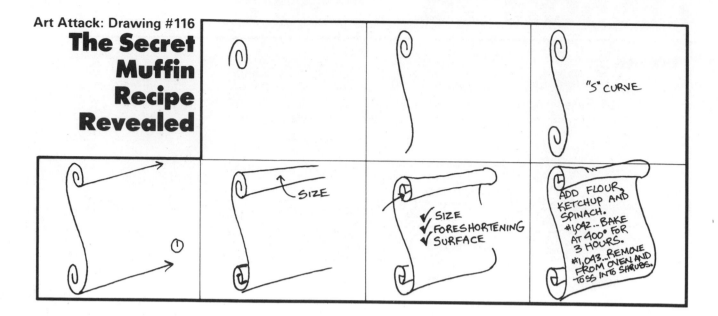

"S" CURVE

SIZE

✓ SIZE
✓ FORESHORTENING
✓ SURFACE

ADD FLOUR, KETCHUP AND SPINACH.
#1,042... BAKE AT 400° FOR 3 HOURS.
#1,043... REMOVE FROM OVEN AND TOSS INTO SHRUBS.

Art Attack: Drawing #117
Self-Storage Mania

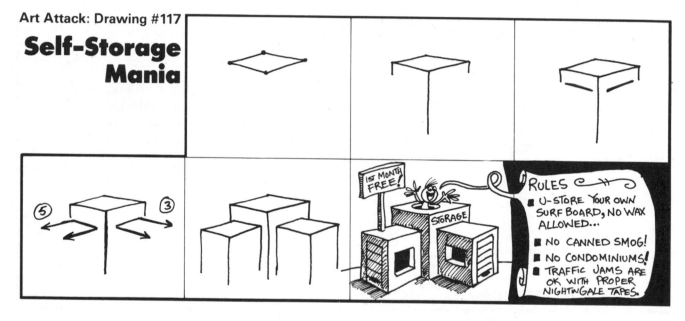

1ST MONTH FREE!

STORAGE

RULES
- U-STORE YOUR OWN SURF BOARD, NO WAX ALLOWED...
- NO CANNED SMOG!
- NO CONDOMINIUMS!
- TRAFFIC JAMS ARE OK WITH PROPER NIGHTINGALE TAPES.

Motivator!

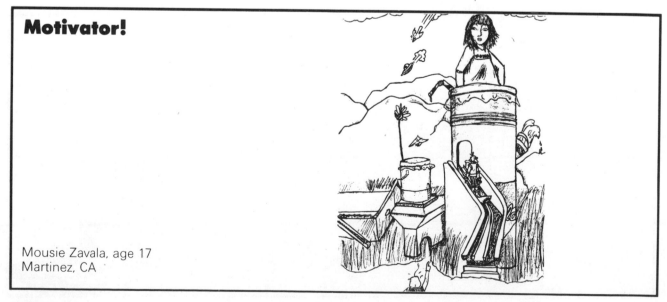

Mousie Zavala, age 17
Martinez, CA

Art Attack: Drawing #118

A Fuchsia For Grandma Helen

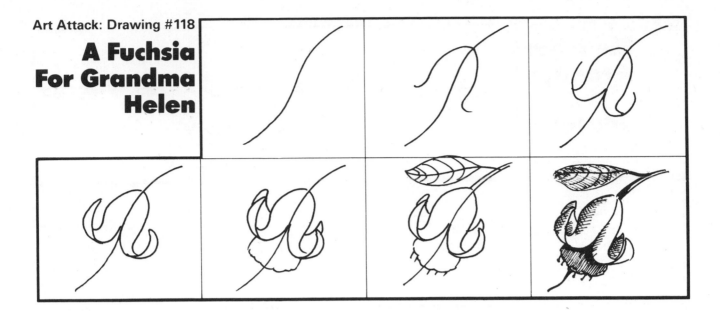

Student Gallery

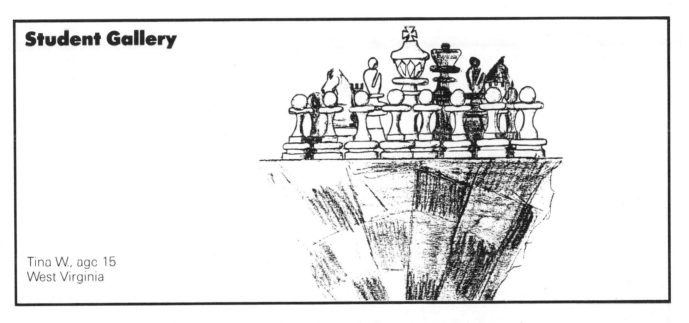

Tina W., age 15
West Virginia

Art Attack: Drawing #119

Grandpa Ralph's New House

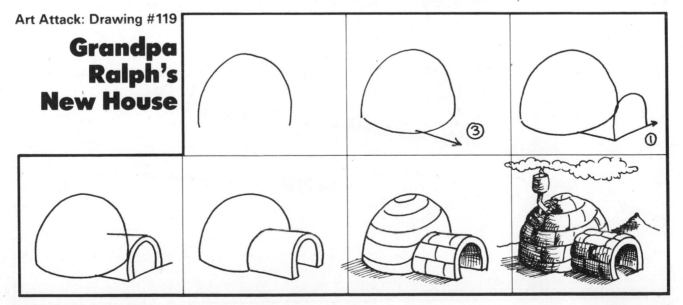

Me After Grandpa Saw His Igloo

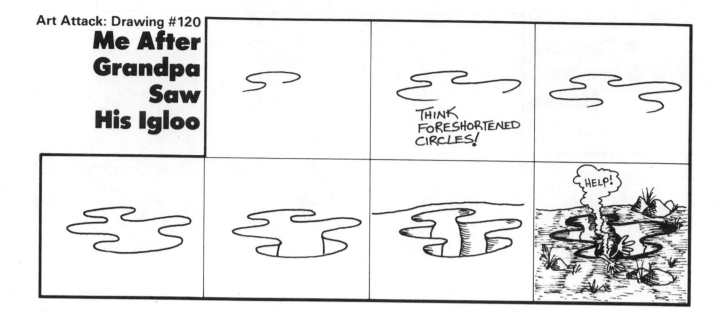

THINK FORESHORTENED CIRCLES!

HELP!

The Bruce McIntyre Achievement Scale
Level 20
The Pencil Launch

You want a really challenging club level? I bet you keep saying these are just too easy, and that they are too boring. All right, I hear you! Try this Pencil Plane for Achievement Level 20. You must draw four of these Direction 1 Pencil Planes in eight minutes. Use **contour, shading, shadow, foreshortening, size** and **surface**. Draw 317 of these on yellow stick-ems and write "Draw Squad Launch" on each of them. Stick them all over the kitchen. Oooooh, what fun we Draw Squaders have, eh?

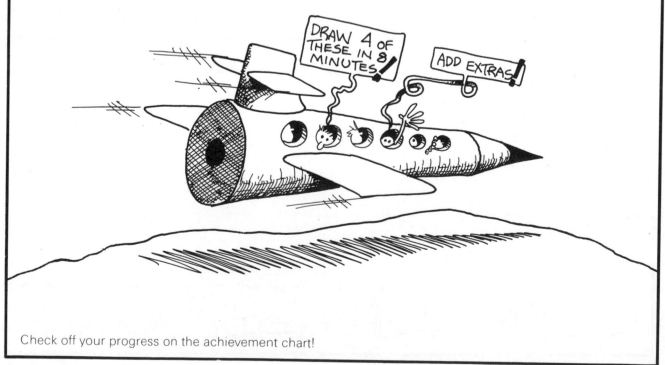

DRAW 4 OF THESE IN 8 MINUTES!

ADD EXTRAS!

Check off your progress on the achievement chart!

Review

Use **density** to draw a hamburger nightmare below.

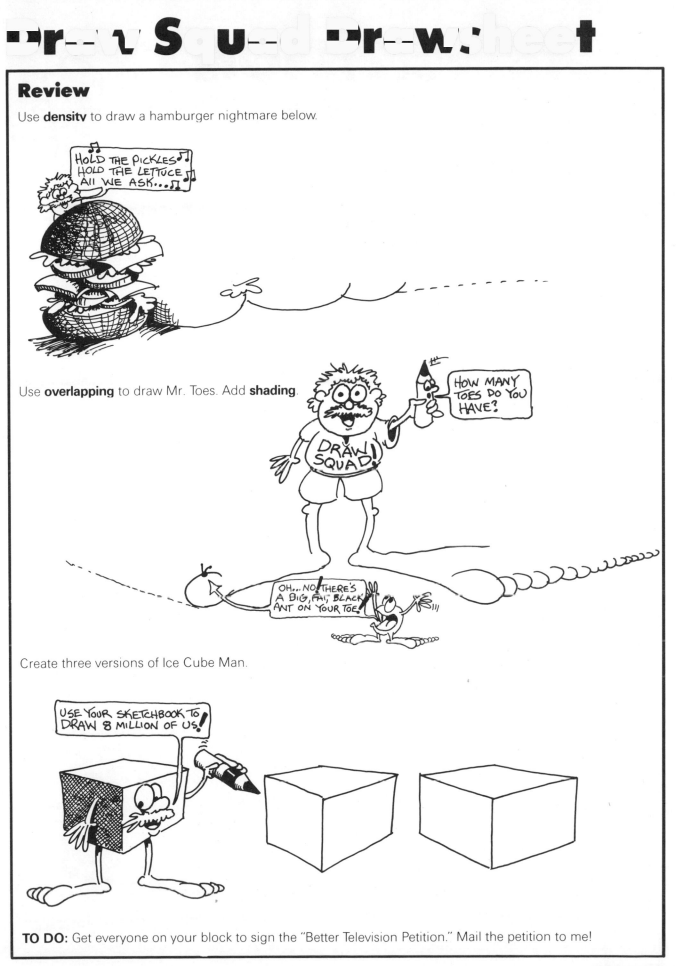

Use **overlapping** to draw Mr. Toes. Add **shading**.

Create three versions of Ice Cube Man.

TO DO: Get everyone on your block to sign the "Better Television Petition." Mail the petition to me!

PETITION

Drawing Contest #20: **Better Television Petition**

This is written for younger Draw Squad members. However, if you are a parent, teacher or just a concerned Draw Squad member, please participate in today's contest! How many people can you get to sign this petition?

Dear T.V. People,

We kids are getting very frustrated with the nonsense you've been program- ming for us on television. We are tired of having our brains turned into mush, while watching all that yucko stuff. Please don't shrug this off. Please help Mark Kistler and others like him program more responsible television. We feel that mindless violence is negative role modeling. In "real" life when we have a problem, we don't blow up the problem. We creatively solve it. You know why? Because we're in the DRAW SQUAD! That's it! Let's have a show about how fun and beneficial drawing is. Let's have shows like the Draw Squad T.V. Show!! We, the undersigned, vote for more shows like the Draw Squad, and for all-around better television.

_____ _____

_____ _____

_____ _____

_____ _____

_____ _____

_____ _____

Get millions of your friends to sign this and mail it to:

Draw Squad Petition
P.O. Box 478
Oceanside, CA 92054

LESSON 21

Warm-up

I've got it! Let's start a Draw Squad Newsletter. Yeah! "Artsy" reading for millions of Draw Squaders. Everyone can send in drawings and ideas. I'll include a Key Word Review and a fun new lesson every issue. Wow, this is going to be fun! I can see it now, Draw Squad will become the *Time* magazine of the 90's. It'll be translated into 19,000 languages. I love it when these brilliant ideas strike. Your warm-up for today is to mail ten ideas to me for the Draw Squad Newsletter.

Key Drawing Word: **Advanced Foreshortening**

FORESHORTENING: the closer a part of an image is to the viewer the larger it appears. **Foreshortening** establishes a view point for the observer and creates the illusion of depth. It allows the artist the opportunity of exaggeration and dramatic lighting effects. In television animation it is crucial in maintaining life-like movements and a sense of distance.

Tracy Stiffler, Professional Artist, WXXI T.V. 21/Rochester, NY

Create your own key word symbol for **foreshortening**:

Art Attack: Drawing #121

Pencil Launch in Direction 1

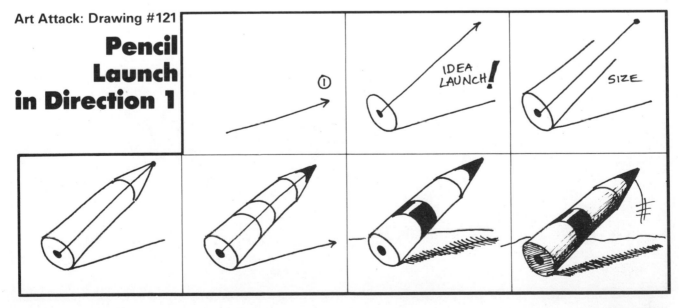

Pencil Launch in Direction 3

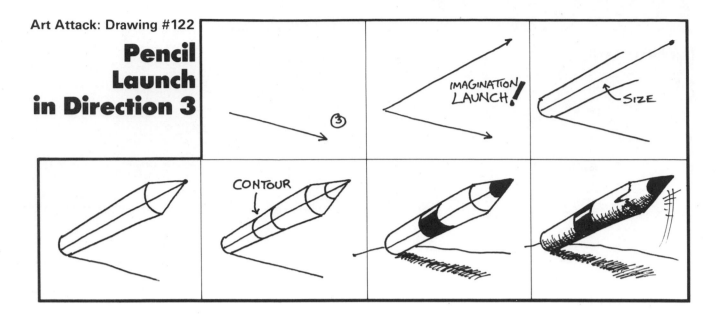

Draw Your Cake and Eat It Too!

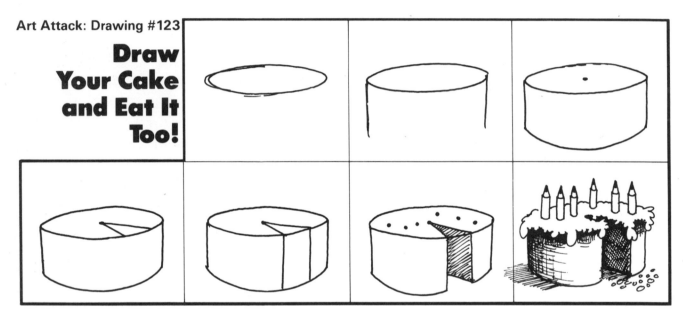

Motivator!

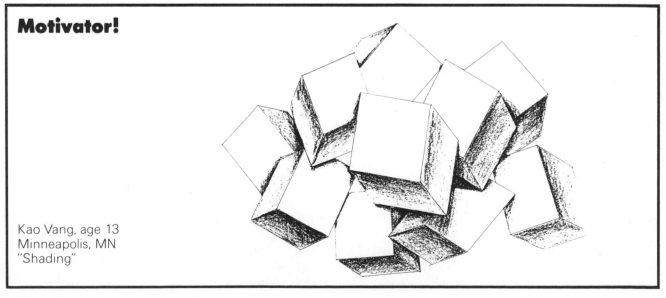

Kao Vang, age 13
Minneapolis, MN
"Shading"

Draw Squad Newsletter HQ

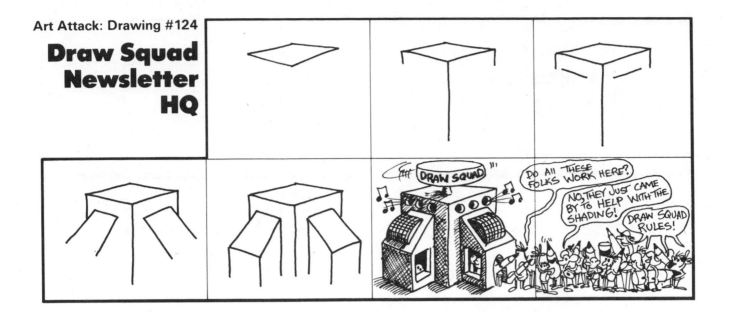

Student Gallery

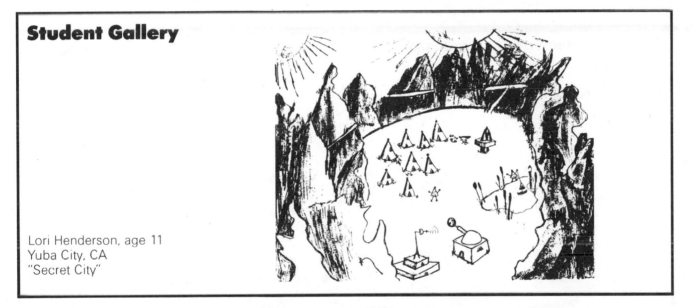

Lori Henderson, age 11
Yuba City, CA
"Secret City"

Skateboard Joe

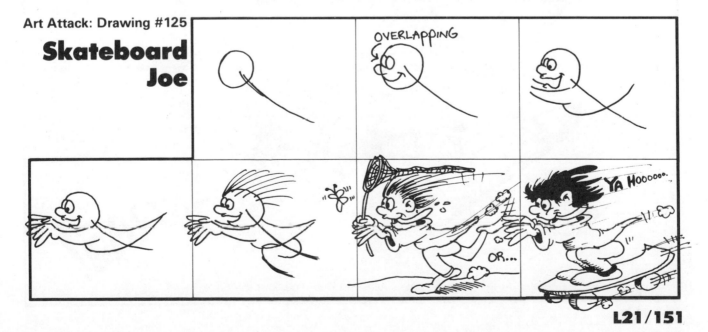

Two Poles Resting

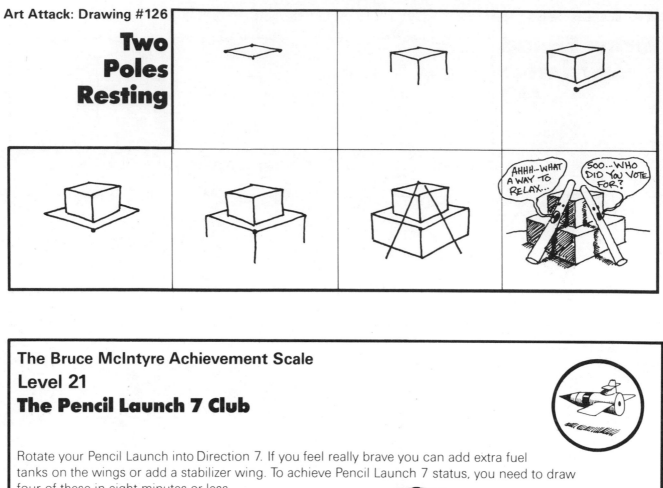

The Bruce McIntyre Achievement Scale
Level 21
The Pencil Launch 7 Club

Rotate your Pencil Launch into Direction 7. If you feel really brave you can add extra fuel tanks on the wings or add a stabilizer wing. To achieve Pencil Launch 7 status, you need to draw four of these in eight minutes or less.

Check off your progress on the Achievement Level Chart in the back of the book.

Draw Squad Drawsheet

Review

Use **foreshortening** and **density** to fill the sky with 30 hot air balloons.

Use **foreshortening, shading** and **alignment** to complete the "Draw Video" Center.

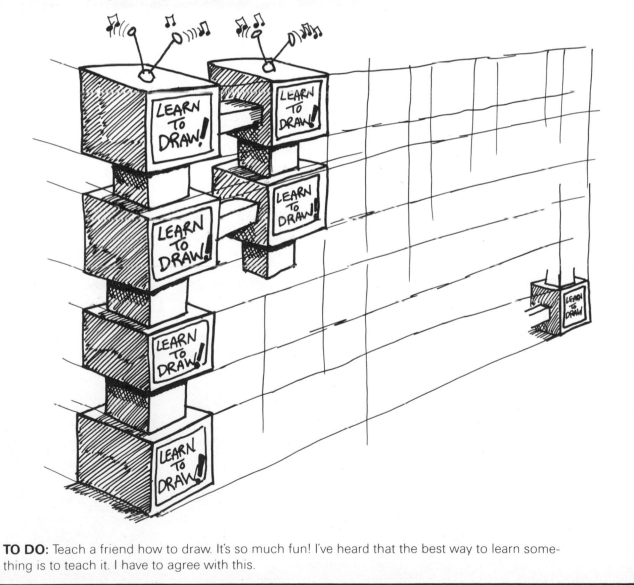

TO DO: Teach a friend how to draw. It's so much fun! I've heard that the best way to learn something is to teach it. I have to agree with this.

Drawing Contest #21: **Drawing Mania**

This drawing is an example of how friends can teach friends how to draw. Emery didn't learn how to draw from me but rather from a friend, who learned from a friend, who learned from me. Let's see how many people you can teach to **shade** in one day.

Emery C., age 11
Hawaii
"Tubed"

Daily Drawing Journal

Entry Date / /

LESSON 22

Warm-up

How are your friends' drawings coming along? How does it feel to be the Draw Squad boss of your town? Keep everyone drawing! It's important for the "world of creative thinkers" we're trying to create. Warm up with a few minutes of Drawercize. Do you ever read the backs of cereal boxes when you're munching your breakfast? Wouldn't that be a great place for Draw Squad lessons or better yet, a perfect place for a Draw Squad gallery? Today's warm-up is to send your drawing to a cereal company and get your drawings printed on the back of a box. Let's have the Draw Squad Olympics! The finalists get their drawings printed on cereal boxes. The companies can further our "art" cause by including a couple of Draw Squad pencils and a cool breakfast sketchbook in every box. We'll get a billion breakfast eaters drawing everyday.

Key Drawing Word: **Advanced Surface**

SURFACE: To create the illusion of depth in your drawing, put the object *lower* in your picture. This compositional idea of near and far will be enhanced when used with overlapping. Visual weight in a drawing also enhances that illusion by controlling the object's size, color and density. For a severe illusion of depth, trim or crop off insignificant parts of the foreground or less important objects in your sketch.

Thomas DiPierro, Art Instructor, The Three Village School District/Setauket, NY

Create your own key word symbol for **surface:**

Art Attack: Drawing #127

The Draw Squid

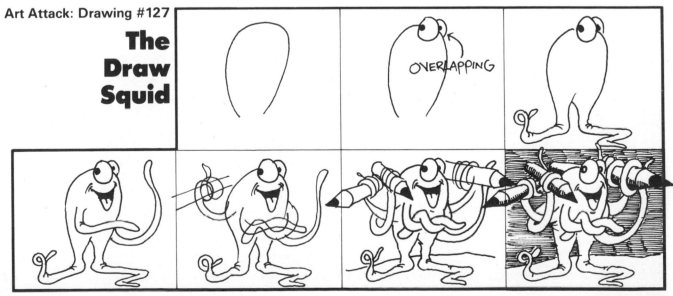

Art Attack: Drawing #128

Leaning Twinkies®

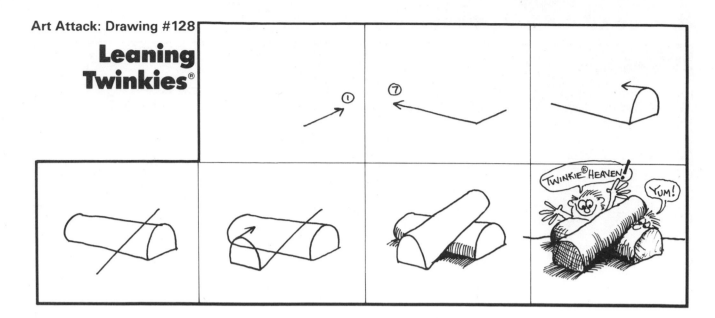

Art Attack: Drawing #129

Mrs. Twinkie® Goes Fishing

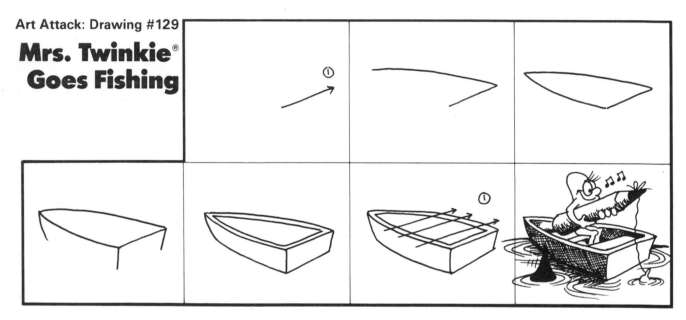

Motivator!

Brandy Becker, age 16
College City, TX

Art Attack: Drawing #130

Draw Squad Yacht in Direction 7

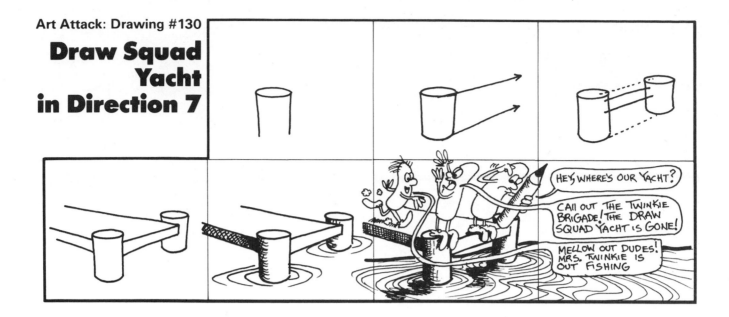

Student Gallery

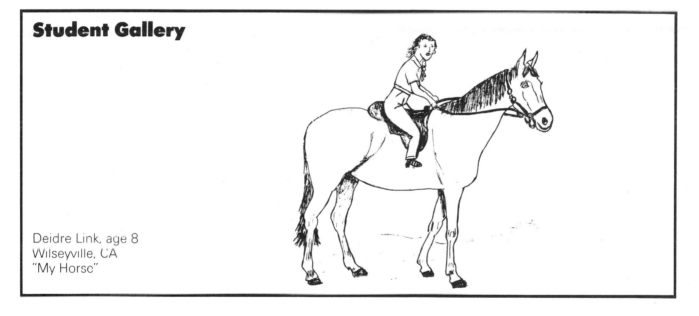

Deidre Link, age 8
Wilseyville, CA
"My Horse"

Art Attack: Drawing #131

Mr. Balloon's Nightmare

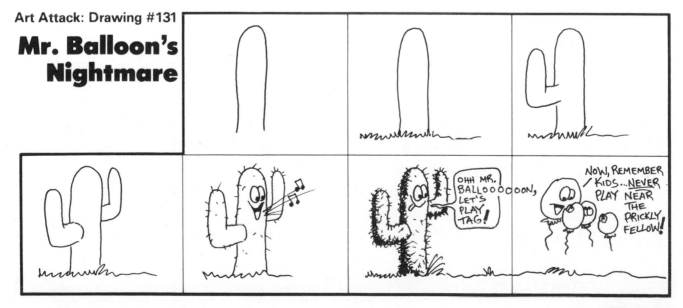

Pencil Launch in Direction 3

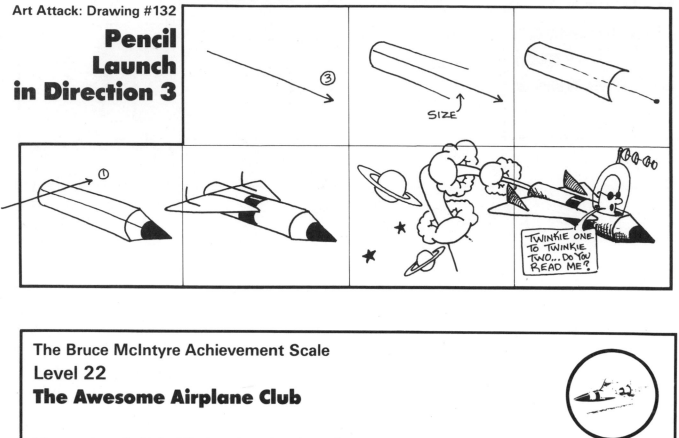

The Bruce McIntyre Achievement Scale
Level 22
The Awesome Airplane Club

Many students find it is difficult to draw the wings of an airplane. You need to rely on **foreshortening**. Follow the drawing exercise below. Be very careful to avoid the "droop syndrome." During my lecture tours, I ask the audience to draw an airplane. After they're finished with the "I can't even draw a straight line" routine, they draw me something very similar to the first drawing below. People from all over the world draw very, very flat. Use the key words to draw the plane in 3-D.

FLAT ➡ 3-D

To achieve the Awesome Airplane Level, you must sketch the plane in Direction 5 four times in eight minutes.

Check off your progress on the chart in the back of the book.

Review

Use **shading** and **contour** lines to add fluff to these 3-D clouds.

MY..OH MY! WHAT A LOVELY DAY TO DRAW.

Shade the French Fry Kingdom.

Shade the fuel tubes to the Pencil Shuttle.

FUEL ME UP WITH THE 10 KEY WORDS OF DRAWING AND PREPARE TO LAUNCH INTO THE WORLD OF ADVENTURE ART!

FUEL

TO DO: Send your drawings to cereal companies.

Drawing Contest #22: **The Draw Squid**

How creatively can you tie up the Draw Squid's arms? What does the Draw Squid look like when he is having an "Art Attack?" What does the Draw Squid's girlfriend look like? How about the Draw Squid's dog? How many Draw Squids can you draw on a single sheet of paper? The present record is 16, held by Abigail Diekatze, age 18, Vista, CA. Why stop at Draw Squids? What about Draw Dogs, Draw Hamsters, Draw Hedgehogs and Draw Sharks?

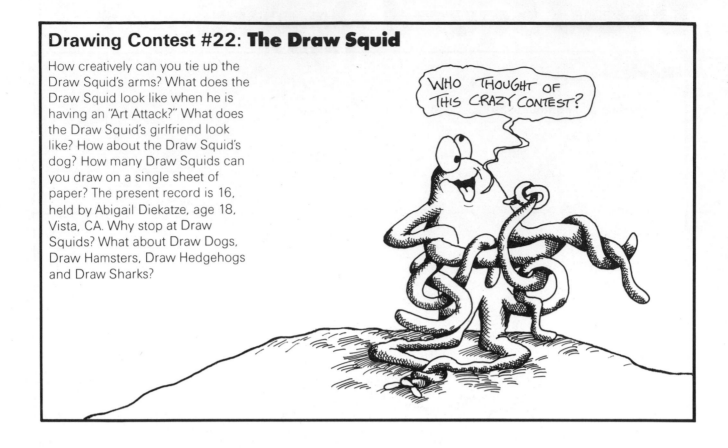

Daily Drawing Journal

Entry Date / / /

LESSON 23

Warm-up

You can teach your school buddies how to draw. It's fun! Be sure to follow the key words and the lessons outlined in this book. Remember that each component is important to the lesson as a whole. From the Warm-ups to the Drawsheets, each has a specific purpose in strengthening your drawing skills. Warm up with one minute of Drawercize, then flip through your sketchbooks to see your progress from Lesson 1 to Lesson 23.

Key Drawing Word: **Advanced Shading**

SHADING: The filling in of shadows (those dark areas away from light sources.) There are several different ways of representing shadows: by drawing lines around the edge of an object away from the light source, by increasing the concentration of lines, either parallel or perpendicular (as in crosshatching), or by increasing the density of dots as they recede from the light source (stippling).

Mike Schmid, Art Teacher, Haverhill Elementary School/Fort Wayne, IN

Create your own key word symbol for **shadow**: ☐

Art Attack: Drawing #133
The Doorknob in Direction 5

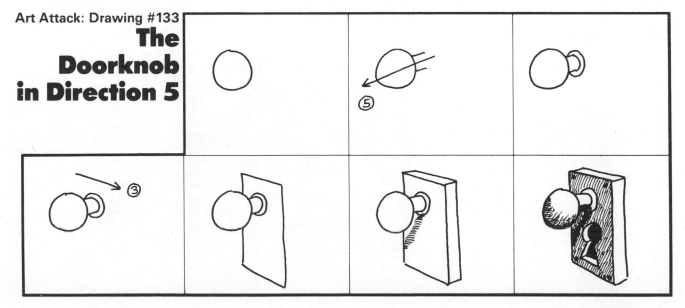

Art Attack: Drawing #134
The Official Draw Squad Lamp

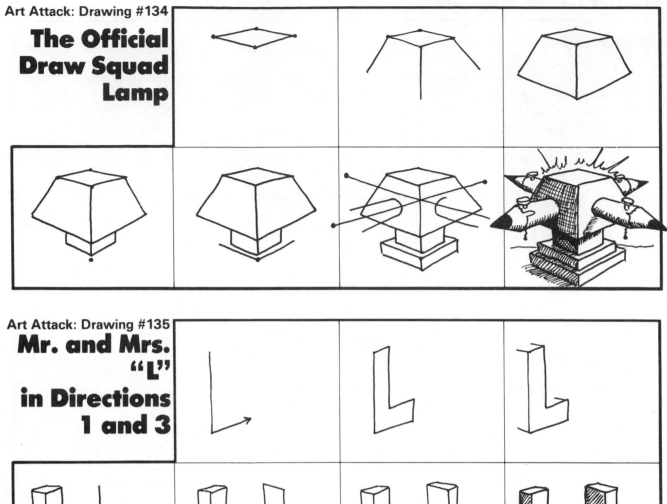

Art Attack: Drawing #135
Mr. and Mrs. "L" in Directions 1 and 3

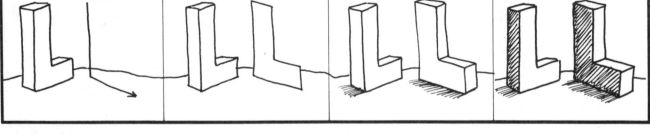

Motivator!

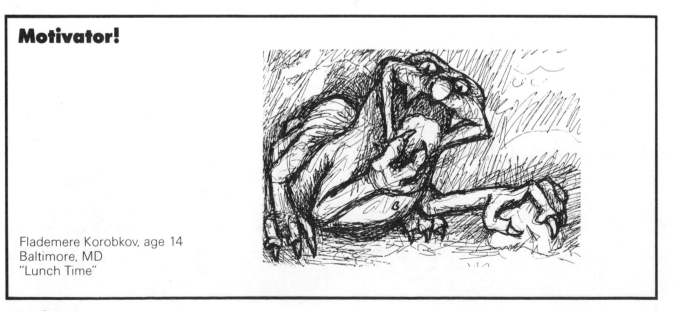

Flademere Korobkov, age 14
Baltimore, MD
"Lunch Time"

Art Attack: Drawing #136

What People Turn Into If They Don't Draw

TRY SHADING THE OTHER SIDE.

ADD EXTRA'S!

Student Gallery

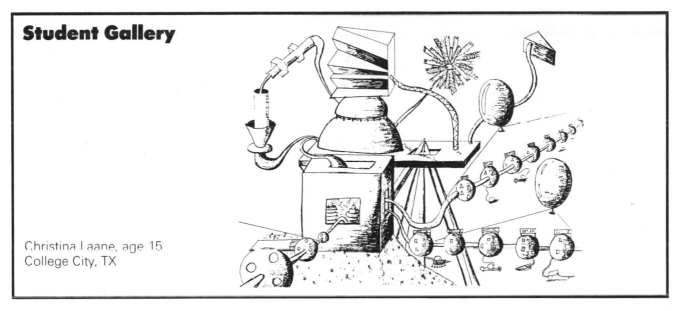

Christina Laane, age 15
College City, TX

Art Attack: Drawing #137

A Bag of Cheerios®

FORESHORTENED CIRCLES

MINE, ALL MINE!

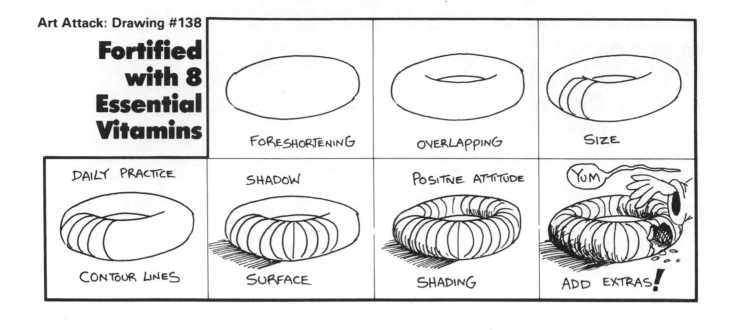

Fortified with 8 Essential Vitamins

FORESHORTENING

OVERLAPPING

SIZE

DAILY PRACTICE

CONTOUR LINES

SHADOW

SURFACE

POSITIVE ATTITUDE

SHADING

YUM

ADD EXTRAS!

The Bruce McIntyre Achievement Scale
Level 23
The Awesome Airplane 3

For this club level, turn the airplane to face Direction 3. For an "extra" challenge, try adding another wing to make it a biplane. To achieve the Awesome Airplane 3 Level, you need to draw this plane four times in less than eight minutes!

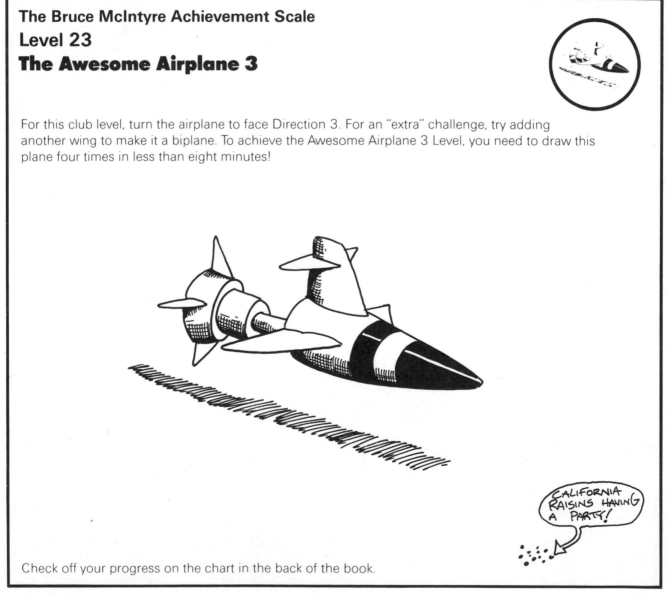

Check off your progress on the chart in the back of the book.

Review

Use **shading, overlapping** and **size** to draw the pillars.

Use **overlapping, density** and **shading** to complete this key ring.

TO DO: Pull out those handy dandy yellow stick-ems. Label every spot in your yard that's **shaded.**

Drawing Contest #23: "L"ville

Using all four important drawing positions, sketch a scene with millions of "L's." Who can draw the most unique 3-D "L"? Draw fat, tall, thick, short and giant ones for a really interesting study in **overlapping** and **surface**. The student record is 323 by Wendy H. of Albany, New York.

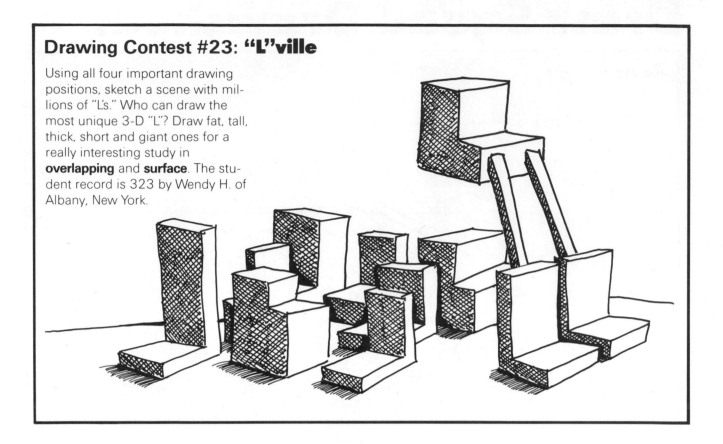

Daily Drawing Journal

Entry Date / /

LESSON 24

Warm-up

Twenty-three lessons down, seven to go! Let's review what we've accomplished so far. This is a great visual motivator. Start on the pre-test page of your sketchbook. Skim through the zillions of drawings you've done since then. Impressive! In the short time we've been drawing together, a lot has happened. You've learned the Ten Key Words. You've joined the Draw Squad. Your artwork is plastered all over cereal boxes. Need I go on?

But even after all of this, there is something missing, something that would enable the Draw Squaders of the World to stand apart from the rest of humankind. A Draw Squad Uniform! Or better yet, call it a Draw Squad "Artiform." For today's warm-up, go down to your local paint store and buy a few paper painter overalls. Draw all over them with markers. Be sure to put Draw Squad on them in big, bold 3-D letters! If you really go nuts, get a paper hat and shoe coverings as well. Art Attack! Imagine what your friends would think, seeing an animated color sculpture walking around with a sketchbook under one arm and this book under the other, singing, "Shade, Shade, Shade." This is going to be great! Send me some photos when you finish your Draw Squad suit. Wearable art! I love it!

Key Drawing Word: **Advanced Shadows**

SHADOWS AND VALUE GRADATION: Shadows are caused by directional light. **Shadows** help define form by making objects look more three-dimentional. To understand **shadows** you must understand which direction light is coming from. To help simplify drawings when using **shadows** always use only one light source. Either natural light, light from a window or artificial light. Light from a light bulb can be used. **Shadows** flow around objects that are curved. Drawing with **shadow** is similar to drawing with contour lines. Contour lines go from thick to thin and from dark to light. **Shadows** start as dark areas on the subject and flow across the subject getting lighter as they move toward the light source. **Shadows** on the subject start at the point farthest away from the light source. Doing a **shadowed** area is very similar to doing a value gradation chart. Gradations are made across the surface of the subject from dark to light.

Ron Adams, Professional Artist and Teacher/Seattle, WA

The key word symbol for **shadow** is:

Art Attack: Drawing #139

The Draw Squad "Artiform"

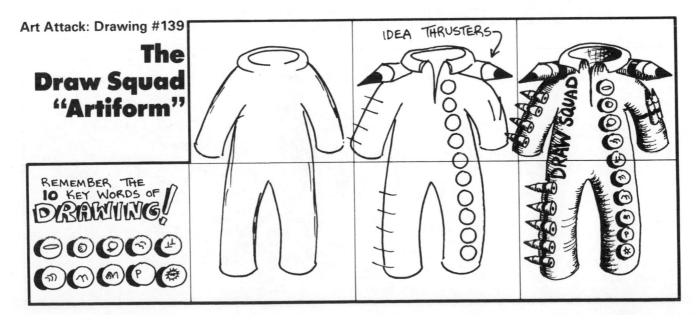

REMEMBER THE 10 KEY WORDS OF DRAWING!

IDEA THRUSTERS

Art Attack: Drawing #140

The Secret Muffin Recipe Sells Big!

Art Attack: Drawing #141

Direction 1 Mania

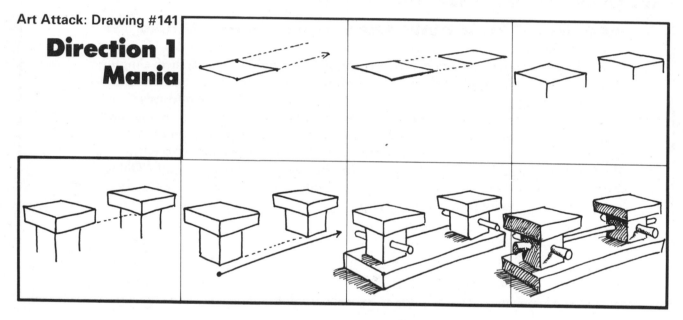

Motivator!

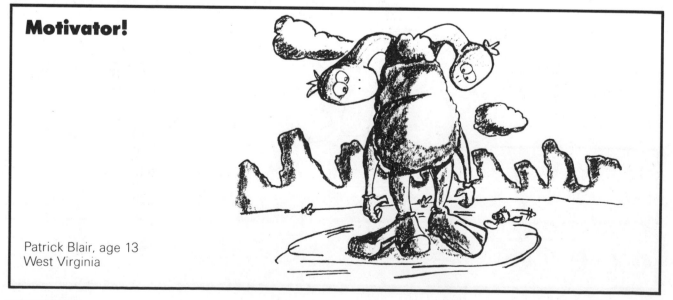

Patrick Blair, age 13
West Virginia

Art Attack: Drawing #142
The Big Career Decision

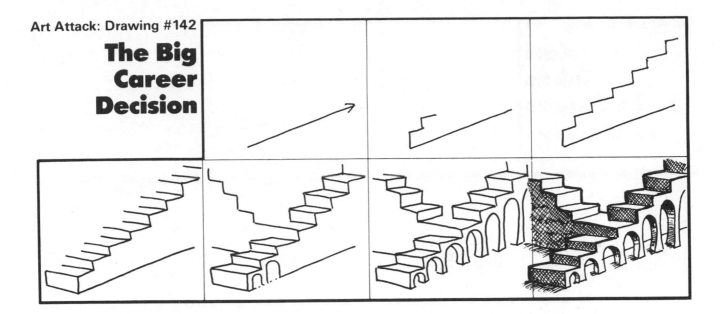

Student Gallery

John Miller, age 16
Canada
"Cloud City"

Art Attack: Drawing #143
Mr. & Mrs. L's Pencil Factory

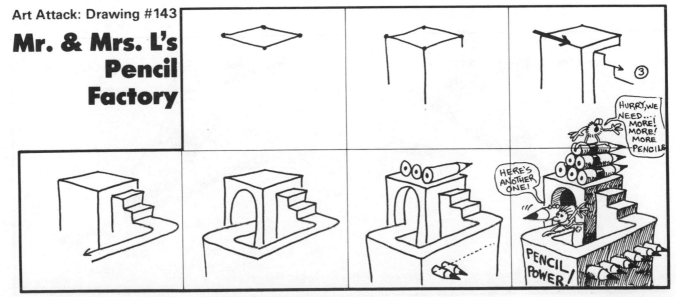

Karl Takes to the Slopes

in Directions 3 and 5

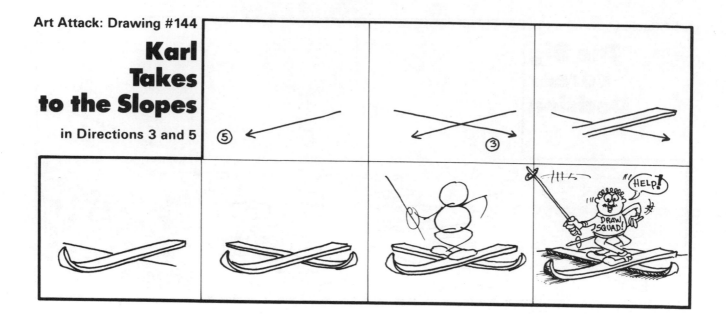

The Bruce McIntyre Achievement Scale
Level 24
The Pencil Tips Club

Shadows are emphasized in this club. Start with four guidelines (**shadows**) in each of the drawing positions. Angle the pencil so that the tip and **shadow** meet. To make it into the Pencil Tip Club, you must draw three sets of four raised pencils in ten minutes. Draw Attack!

Draw these all over your Draw Squad suit!

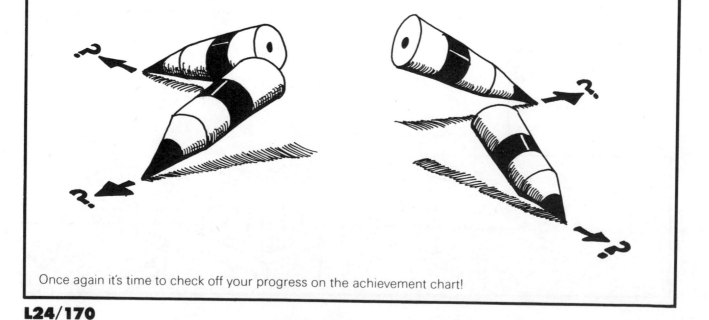

Once again it's time to check off your progress on the achievement chart!

Review

Add **shadows** and **contour** lines to the Draw Squaders.

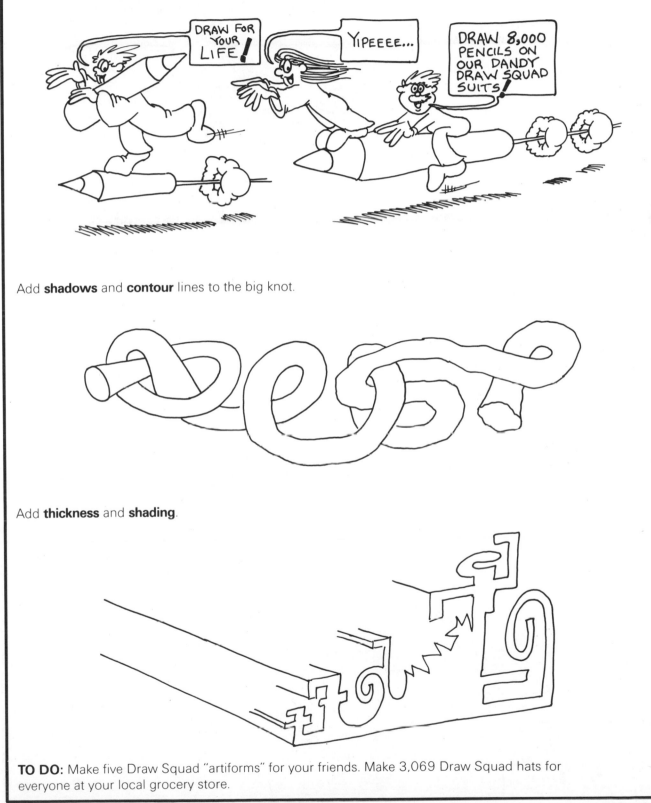

Add **shadows** and **contour** lines to the big knot.

Add **thickness** and **shading**.

TO DO: Make five Draw Squad "artiforms" for your friends. Make 3,069 Draw Squad hats for everyone at your local grocery store.

Drawing Contest #24: **Twenty-Four Steps to Success**

We've already practiced many of these steps in small doses. Now let's put them together and have an entire page covered with success symbols. Alignment is crucial to the visual success of this project. Choose an anchor, such as the lines of Directions 1 and 7. Before drawing a new chunk of steps, realign your 1 and 7 by retracing it a few times. The student record is by Michelle, age 11, of Texas. Her drawing is 3′ × 2′!

Daily Drawing Journal

Entry Date / /

I JUST LOVE TO "DROOP"!

LESSON 25

Warm-up

Are you wearing your Draw Squad suit? Cool, eh? We should have made these suits in Lesson 1! Now all we need is an "Art Launch." We need to get a Draw Squader chosen to be the first artist in space. Hmmmm. Who should it be? I've decided that because of the inherent risks, as your Draw Squad leader, it should be me. I'm glad we all agree. I was prepared to write 12 pages as to why it should be me. Since you didn't raise even a little fuss, I guess I'll be going. What a cool Draw Squader you are! Yahoo! I'm going into orbit! I promise I'll create another drawing book all about the experience! I'll be sure to launch you a postcard.

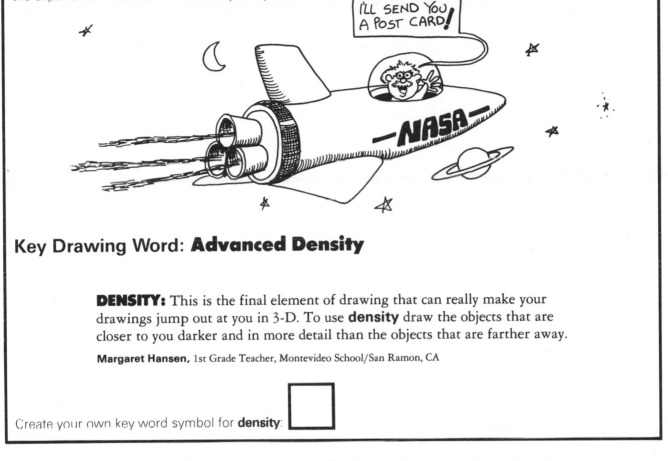

Key Drawing Word: **Advanced Density**

DENSITY: This is the final element of drawing that can really make your drawings jump out at you in 3-D. To use **density** draw the objects that are closer to you darker and in more detail than the objects that are farther away.

Margaret Hansen, 1st Grade Teacher, Montevideo School/San Ramon, CA

Create your own key word symbol for **density:**

Art Attack: Drawing #145

The Orbit Monster

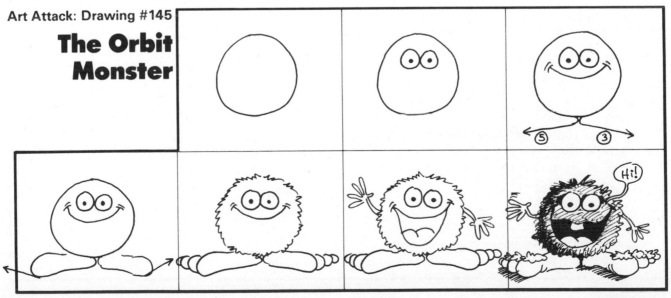

Art Attack: Drawing #146

Pre-Launch Shuttle Breakfast

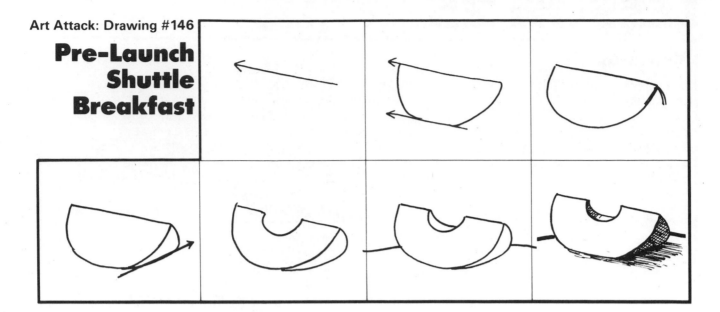

Art Attack: Drawing #147

A Gift for My Shuttle Buddies

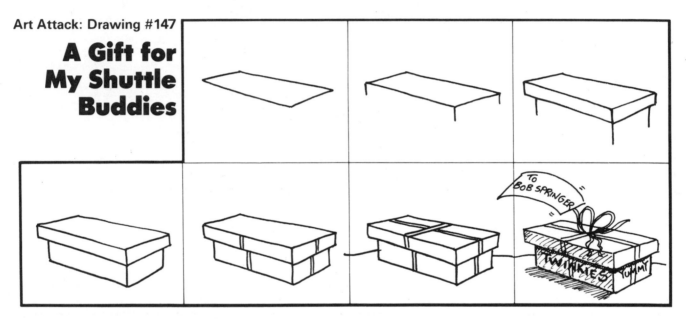

Motivator!

This is a fabulous drawing sent to me from a Draw Squader in New York. One thing is missing...It's missing the artist's name! Please, please, please always sign and date all of your drawings. This is very important even for your own records. (For our records, we also appreciate it if you would include your age, city and state).

Anonymous Draw Squader
"Cindy & Her Friends"

Art Attack: Drawing #148

Teaching the Shuttle Crew How to Draw

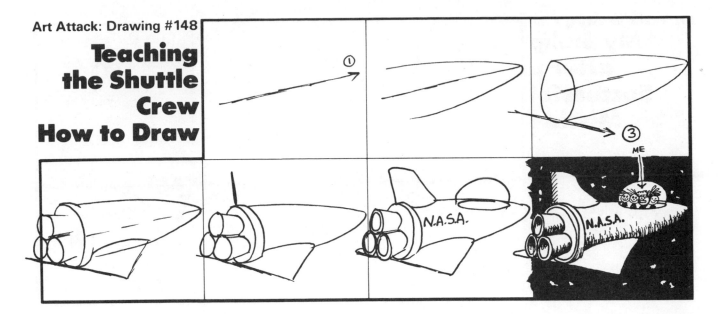

Student Gallery

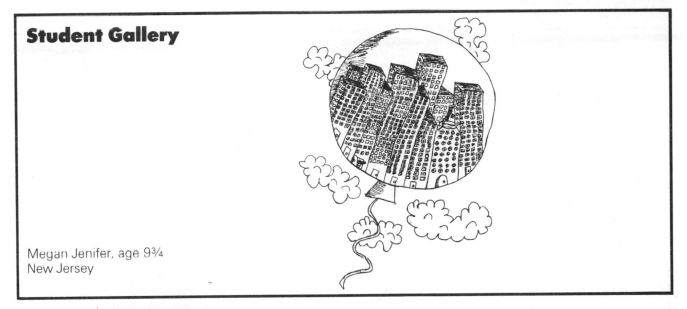

Megan Jenifer, age 9¾
New Jersey

Art Attack: Drawing #149

Looking at San Diego from Space

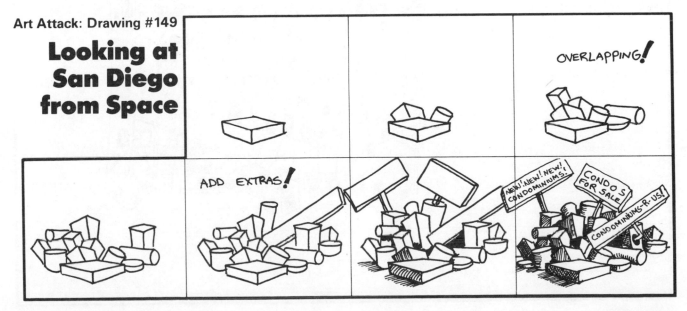

My Smile after a Successful Mission

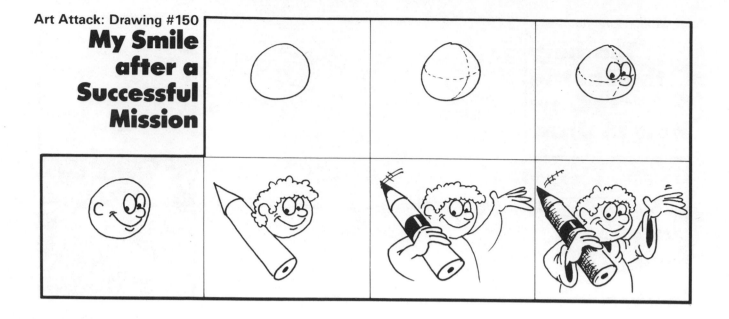

The Bruce McIntyre Achievement Scale
Level 25
The Super City Club

Spend 30 minutes creating your very own Super City.

Darren Cruise, age 9
Albany, NY

You may now check off your progress on the chart in the back of the book!

Review

Add archways and trees. Then add **shading** and **density**.

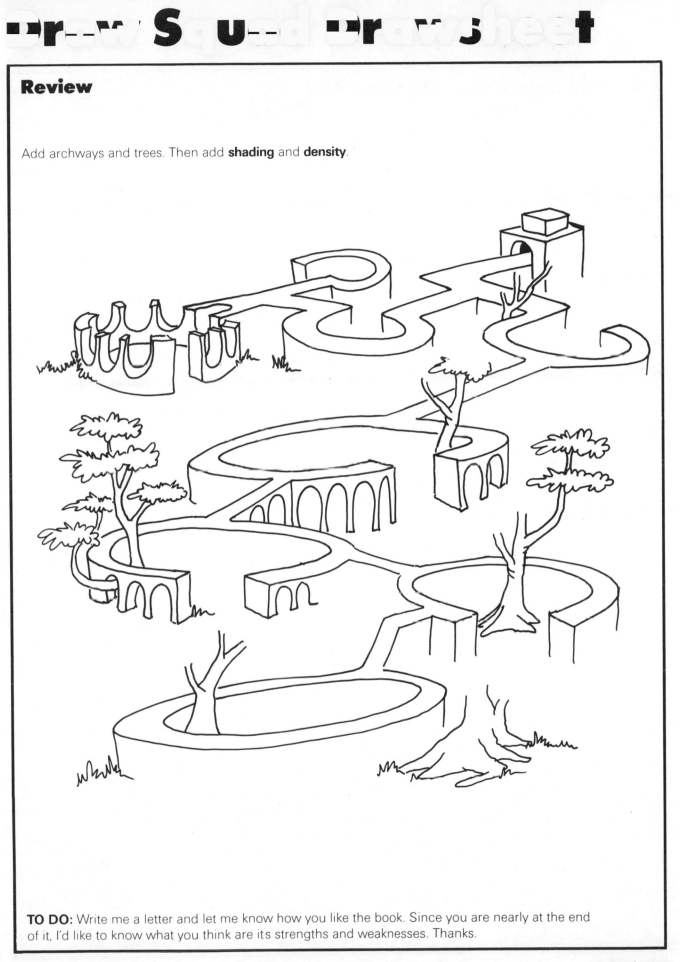

TO DO: Write me a letter and let me know how you like the book. Since you are nearly at the end of it, I'd like to know what you think are its strengths and weaknesses. Thanks.

Drawing Contest #25: The Super City

Today let's combine the club level and the contest. In 30 minutes draw the most amazing Super City. Sign and date it and mail it to me at the Draw Squad.

Michael Santiago, age 10
Washington, DC

Daily Drawing Journal

Entry Date / /

I WANT TO GO ON THE SPACE SHUTTLE TOO!

LESSON 26

Warm-up

I love sending art in the mail. Art letters are so much fun. Today let's send a letter to the White House urging the President to declare a National Drawing Day. This will be a day where everybody gets to draw for 12 hours. Send your drawings and letters to:

Mr. & Mrs. President
The White House
1600 Pennsylvania Ave.
Washington, DC 20500

Key Drawing Word: **Advanced Contour**

CONTOUR LINES: To make **contour** lines work at their maxium effectiveness you may have to draw lines that are only slightly visable. This is why artists learn to look very closely at their subject. Every detail must be observed. If you draw lines that are barely visible you will find that they add a great deal of depth and dimension to your drawings. Look closely at the knuckles on your hand and observe that most wrinkles start as very thin lines, get thicker as they move across the finger, and return again to thin lines. These transitional lines will add a great deal of depth and dimension. Remember that **contour** lines show transition as they flow around and across your subject. Look for transitional lines everywhere and exaggerate them as you draw the subject.

Ron Adams, Professional Artist and Teacher/Seattle, WA

Create your own key word symbol for **contour**:

Art Attack: Drawing #151

Sawhorse in Direction 1

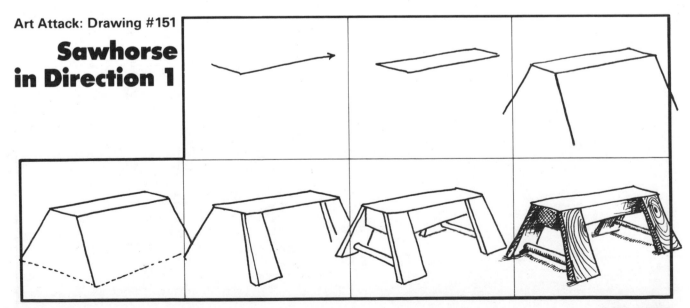

Art Attack: Drawing #152
Saturnbot's New Condominium

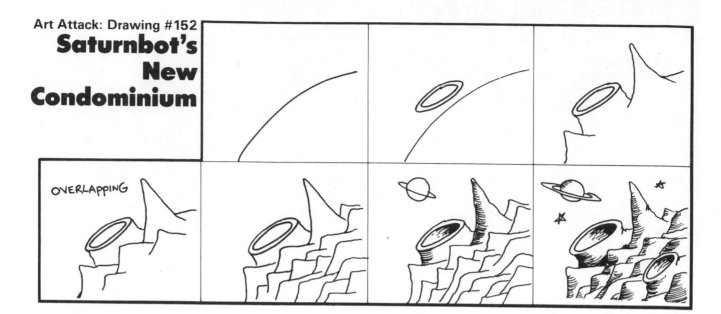

OVERLAPPING

Art Attack: Drawing #153
Flying Saucer Party

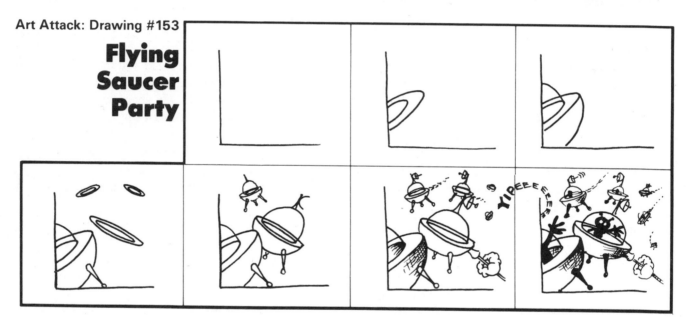

YIPEEEEEEEE

Motivator!

C. Brewington, age 11
Arkansas

Art Attack: Drawing #154
The Whoosh Cloud

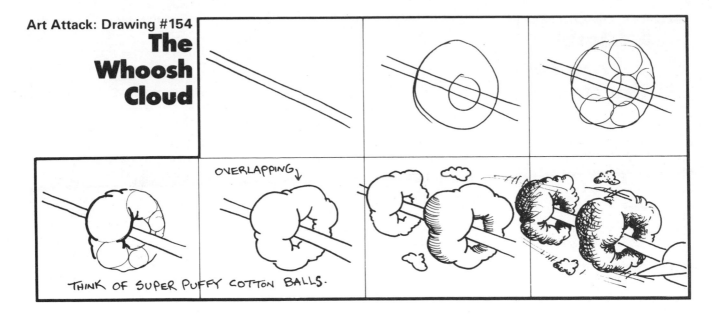

OVERLAPPING ↓

THINK OF SUPER PUFFY COTTON BALLS.

Student Gallery

Kevin Kennedy, age 11
Elkland, PA
"Transportation Device"

Art Attack: Drawing #155
Inside Furblett's Room

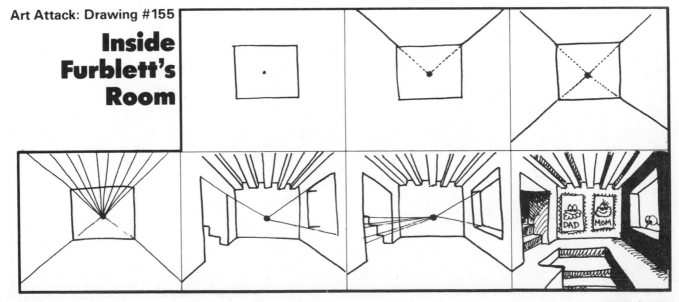

DAD MOM

A Climbing Tree For Baby Devon

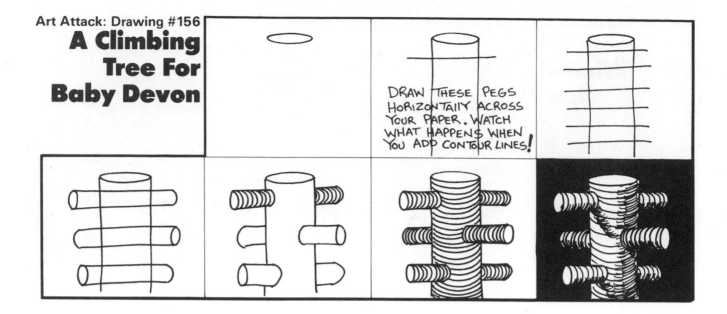

DRAW THESE PEGS HORIZONTALLY ACROSS YOUR PAPER. WATCH WHAT HAPPENS WHEN YOU ADD CONTOUR LINES!

The Bruce McIntyre Achievement Scale
Level 26
The Totally Tubed Club

To achieve this level, you need to concentrate on **contour** lines. There isn't a definite object to draw, just a few guidelines. In eight minutes, draw a tubular structure that consists of eight tubes. All four drawing positions, Directions 1, 3, 5 and 7, must be used. Each tube must have a minimum of five **contour** lines. Go for it!

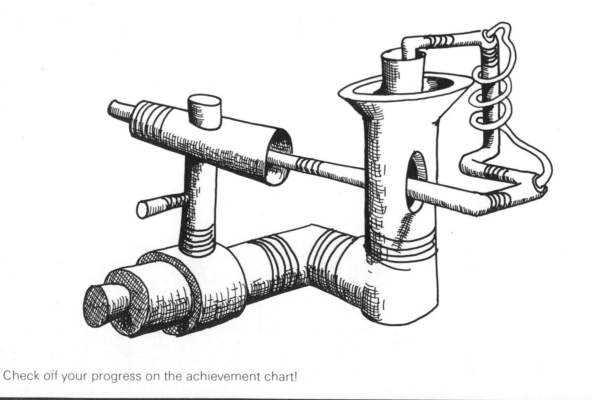

Check off your progress on the achievement chart!

Draw Squad Drawsheet

Review

Even though these pegs are horizontal on the drawing, they look 3-D. **Contour** lines push objects into the depths of your drawing!

Draw the windows and doors with thickness on the condominiums below. Make them look 3-D!

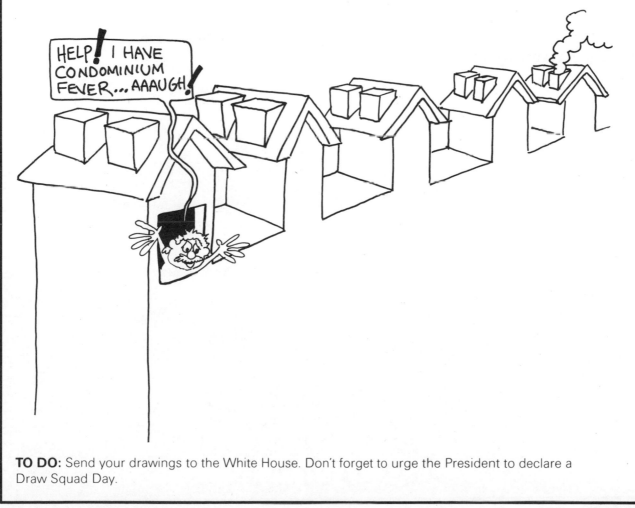

TO DO: Send your drawings to the White House. Don't forget to urge the President to declare a Draw Squad Day.

Drawing Contest #26: **Gingerbread Mania**

Create a galaxy of Gingerbread People. Draw them very thin, like they were just rolled out in a bakery. This is a great **density** exercise. I just made up this contest about ten minutes ago, so I don't have any student record. How many Gingerbread People can you draw?

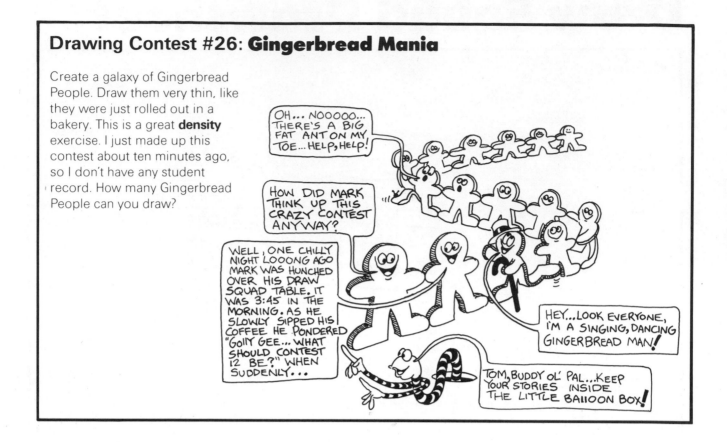

Daily Drawing Journal

Entry Date / /

LESSON 27

Warm-up

It's time to get your drawing talent introduced to the masses. Pick ten of your favorite drawings from your sketchbook. Send them to billboard companies in your area with a letter that reads:

Dear Billboard People,
 I'm donating the enclosed drawings to our city's art cause. Please consider allotting some of your space to display these and other local masterpieces. You will not only help advance creative thinking, you will also be ahead of the nation when the President declares the first National Draw Squad Day.

 Sincerely,

 DRAW SQUADER
 (YOUR NAME)

I'M GOING TO CREATE 856 "ART ATTACK" BILLBOARDS IN UNIBEARVILLE!

MR. DOYLE MADE GIANT BILLBOARDS FOR HOUSTON YOUTH ART MONTH! BOY, WHAT A COOL ART TEACHER!

The Key Drawing Word: **Advanced Overlapping**

OVERLAPPING: This occurs in drawing when an object in the composition appears to be in another object. **Overlapping** helps to create the appearance of depth in the drawing. When **overlapping** is combined with appropriate changes in size and detail (objects should be drawn smaller and less detailed if they are in the distance), a greater sense of depth is created.

Leslie Wingfield, Art Educator/Spring, TX

The key word symbol for **overlapping** is:

Art Attack: Drawing #157

An Apple For Dad

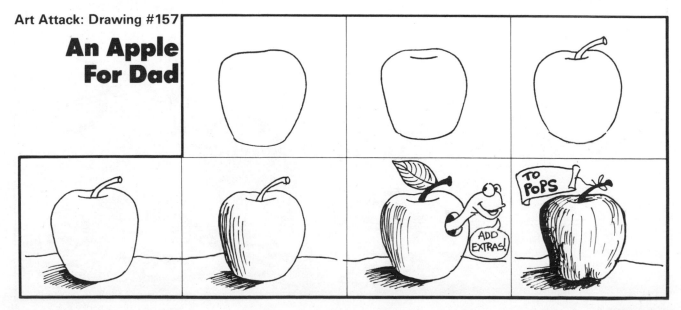

ADD EXTRAS!

TO POPS

Art Attack: Drawing #158

Fancy Archway

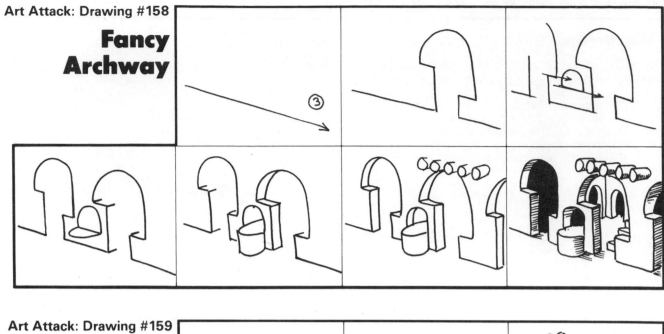

③

Art Attack: Drawing #159

Trasher

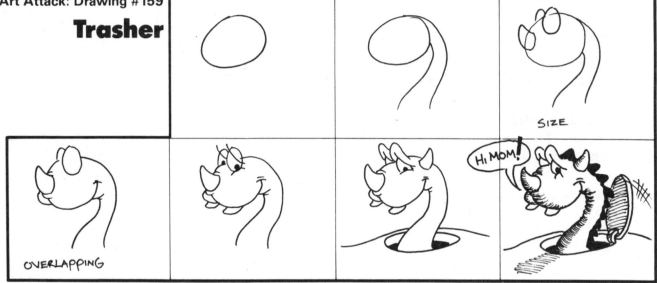

SIZE

OVERLAPPING

HI MOM!

Motivator!

Rob Santamaria, age 17
Boston, MA

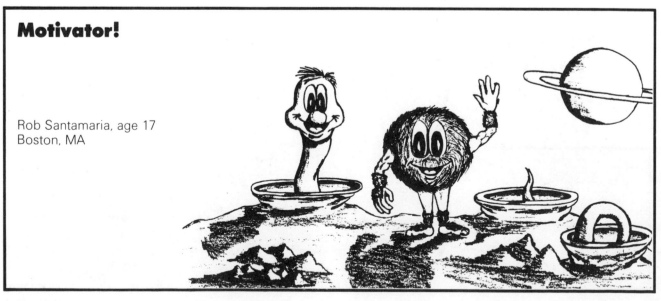

Art Attack: Drawing #160
Trasher's Home

Student Gallery

Wesley Pilley, age 11
Blackfoot, ID

Art Attack: Drawing #161
Boards in Directions 3 and 5

A Person Who Hasn't Learned to Draw

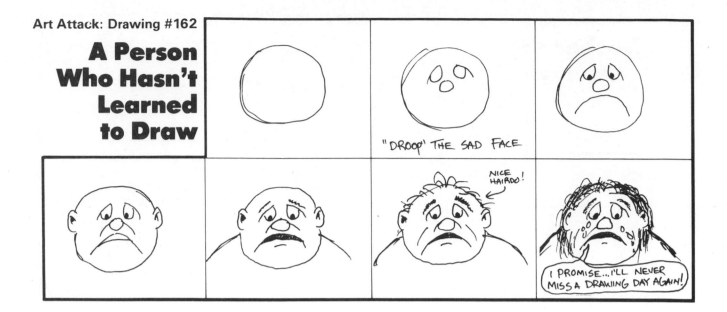

"DROOP" THE SAD FACE

NICE HAIRDO!

I PROMISE...I'LL NEVER MISS A DRAWING DAY AGAIN!

The Bruce McIntyre Achievement Scale

Level 27

The Super Planet Club

Let's launch from the Super City and draw a 60-minute Super Planet. Ready, Set...Draw!

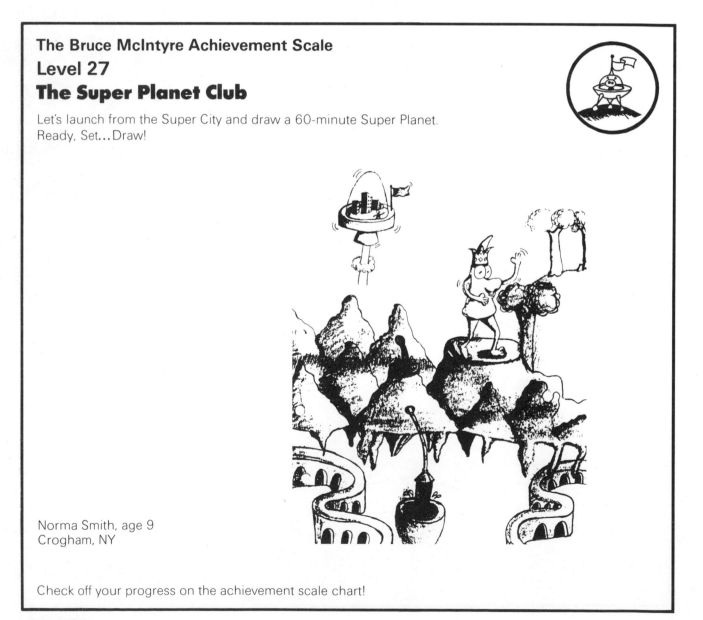

Norma Smith, age 9
Crogham, NY

Check off your progress on the achievement scale chart!

Review

Use **overlapping** and **shading** to complete the post below.
Add your drawings to the multi-level metropolitan billboard.

TO DO: Get your drawings displayed on at least one giant billboard in your town.
A mammoth Draw Squad Art Attack!

Drawing Contest #27: **The Big Droop**

I love to droop things in my drawings. Drooping creates such a wonderful visual effect. For Drawing Contest #27, let's see who can draw a picture with the most droops. The **undershadow** is important on this drawing. The student record is held by Michael L. with 87 droops.

Peter Pardoe, adult
Meriden, NH

Daily Drawing Journal

Entry Date / /

LESSON 28

Warm-up

Many people ask me if I ever run out of ideas. I tell them, "No way, I'm a member of the Draw Squad!" Here's another fun warm-up idea for these adult Draw Squaders. After two minutes of Drawercize, take a blank sheet of paper from one of your sketchbooks. Draw your favorite character, preferably one you've invented yourself. Reduce it to an inch in height. Take this to your bank the next time you need to order checks. Request that your drawing be included on your checks next to your name and address. Putting your drawing on your checks will cost you extra money, but think of how many people you'll be touching with your art! The phone company, the power company, the stores where you shop...For the younger Draw Squaders, ask the bank to hang your drawings all over the walls!

Key Drawing Word: **Advanced Size**

SIZE: Try this experiment. Get a rectangular piece of cardboard and cut a rectangular hole in the middle of it. Ask two friends who are the same size to walk away from you as you look through the hole. What happens as they walk away? Now ask one to come closer to you and one to walk farther away. What happens? (Remember they are the same size). Try this with people walking in malls or on sidewalks. Look at buildings that are all the same size but some are near and others are farther away. What happens as you look through your cardboard? That is the lesson of **size.** Does bigger look closer or farther than smaller?

Amy "Art" Krichko, Art Teacher/West Germany

Create your own key word symbol for **size**:

Art Attack: Drawing #163

Super Cool Tea Kettle

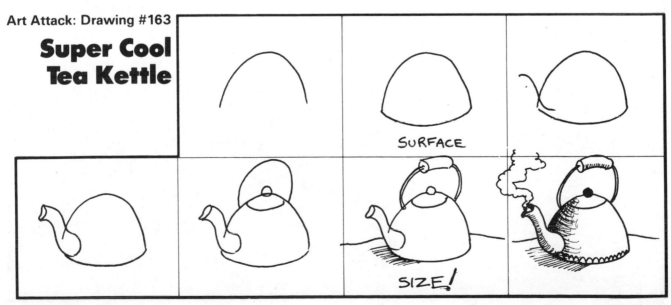

Saturnbot's Observatory

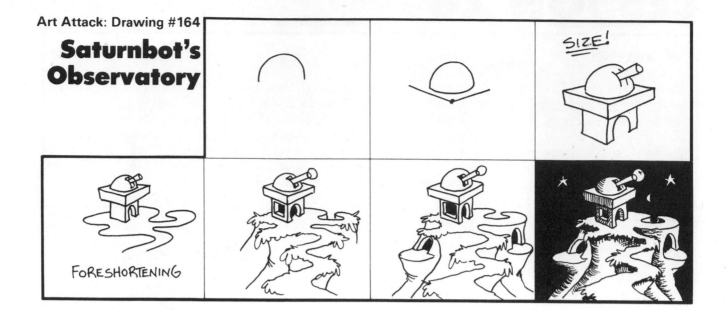

FORESHORTENING

SIZE!

Pigasus' Pig Trough

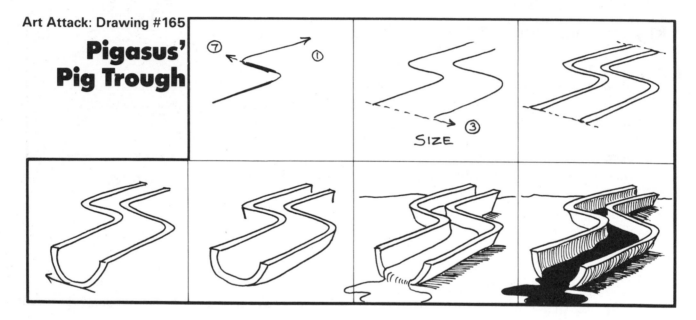

SIZE

Motivator!

Shawn Corbin, age 13
Atlanta, GA
"Secret Creature"

Uni-Ted Builds a Table

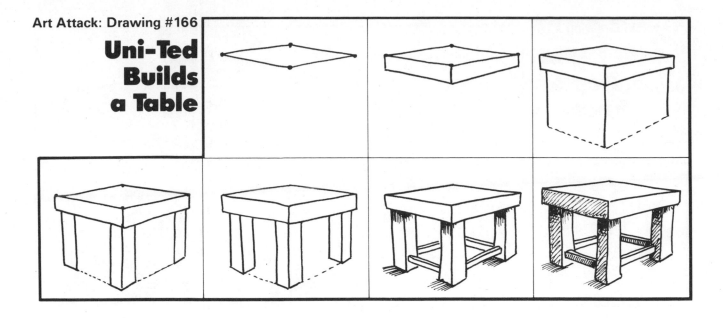

Student Gallery

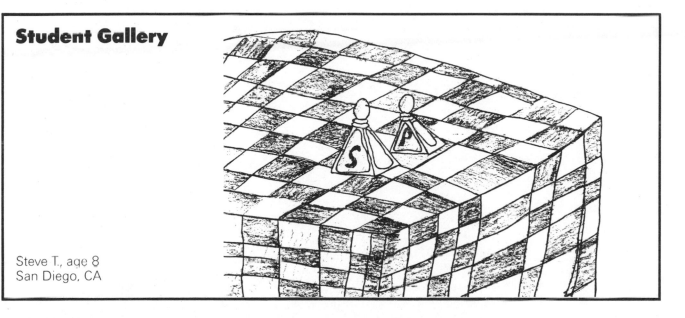

Steve T., age 8
San Diego, CA

Furblett & Furblina Tie the Knot

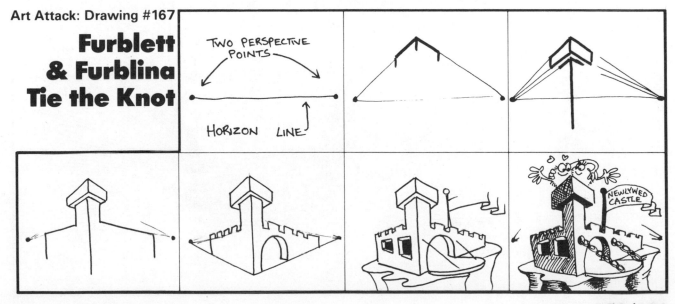

Art Attack: Drawing #168

Salt & Pepper Shakers

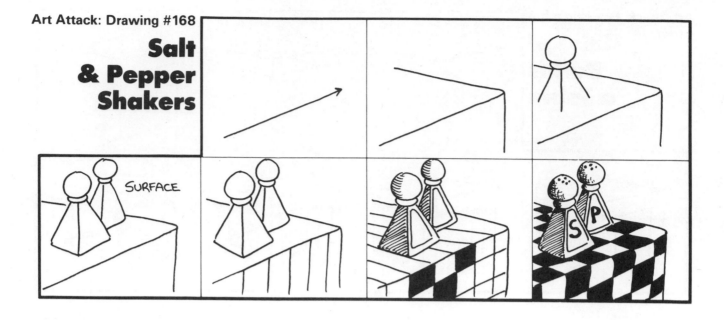

The Bruce McIntyre Achievement Scale

Level 28

The Super Galaxy Club

If you thought the Super City and the Super Planet were fun, try the Super Galaxy. A two-hour drawing marathon! This one must be at least 3' long by 2' high. Don't be surprised if you spend four days on this one. It's a really fun club to complete. Draw it, you Art Attack animal, you.

France Ringuett, age 15
Columbus, OH

Guess what? Why don't you check off Level 28 on the chart!

Review

Draw three sketches below. Select one to redraw in black ink. Take that final sketch to the bank and have it printed on your checks.

THESE WILL MAKE TERRIFIC STATIONERY!

Draw the poles using **density** and **size**.

TRUE/FALSE

☐ ☐ I'm rushing to the bank right now to order artsy checks.

☐ ☐ I'm going to wear my Draw Squad suit to the bank

☐ ☐ I'm going to send Mark a copy of the check, so he can see how it turned out.

☐ ☐ I've never seen so fine a moustache as Mark's.

☐ ☐ These questions are not about drawing.

"I can't even draw a straight line" is a _____ attitude.

"I can draw because I am a super-smart person" is an example of a _____ attitude.

Your _____ controls you _____ .

_____ is very fun.

Answers: 1. The symbols can be used as tools to learning; to recognize and label artwork wherever the Ten Key Words of Drawing are being used. 2. True 3. True 4. True 5. True 6. True

TO DO: Have new checks printed with your drawing on it. Have an Art Attack every time you write a check.

Drawing Contest #28: **Super Galaxy**

Since you're still consumed with Club Level "Super Galaxy," and you will be for another few days, it doesn't make sense to do anything other than a Super Galaxy Contest! Who can draw the most ingenious Super Galaxy on a 2' × 3' piece of paper?

Danny Starr, age 11
Alexandria, IN
"Super Galaxy"

Daily Drawing Journal

Entry Date / /

WOW! WHEN EVER I PICK UP A PENCIL TO DRAW, I FEEL LIKE I HAVE TO JUMP UP AND DANCE THE TEXAS TWO-STEP! C'MON YA'LLLL, DRAW'LL DRAW'LL, DRAW'LLLL!

LESSON 29

Warm-up

Are you getting tired of looking at those boring paper placemats in fast food restaurants? Let's turn them into another Art Attack! Next time you're caught in the claws of the fast food frenzy, pick up a few extra placemats. Later that evening, design a couple of Draw Squad Placemat Lessons. Mail them to the restaurant's headquarters with your vote to turn those boring placemats into exciting Draw Squad lessons. I can see it now. Fast food restaurants will be competing to see who can print the coolest "artsy" placemats. Just another example of our global Draw Squad influence.

Key Drawing Word: **Advanced Attitude**

POSITIVE ATTITUDE: Every artist needs a personal artistic vision in order to aspire to greater achievement. This vision enables the artist to maintain a **positive attitude** because the artist will not become entrapped with daily problems or set-backs, but will strive for personal artistic success and accomplishment. A **positive attitude** is essential for overcoming all obstacles and for discovering solutions.

David Humphreys, Arts Educator/Washington, DC

Create your own key word symbol for **attitude**:

Art Attack: Drawing #169

Furblett & Furblina Tie Another Knot

CONTOUR LINES

Art Attack: Drawing #170

Knarly Tree

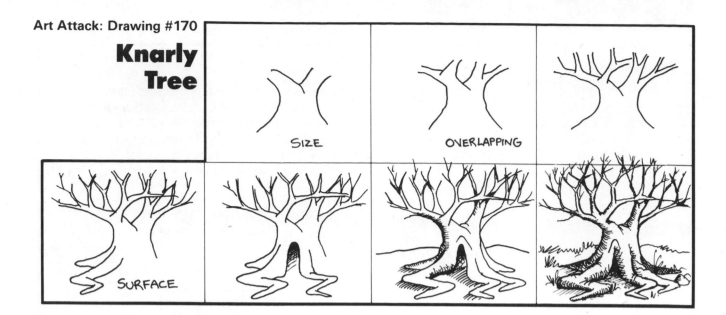

SIZE

OVERLAPPING

SURFACE

Art Attack: Drawing #171

The Draw Squad Empire

Motivator!

J. Quintero, college student
New York

Art Attack: Drawing #172
Wooden Clothespins

Student Gallery

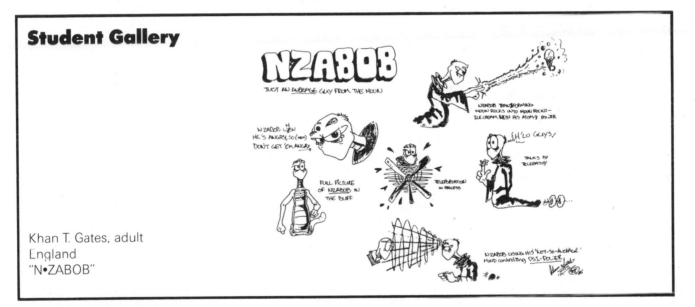

Khan T. Gates, adult
England
"N•ZABOB"

Art Attack: Drawing #173
Draw Squid Rocks Out

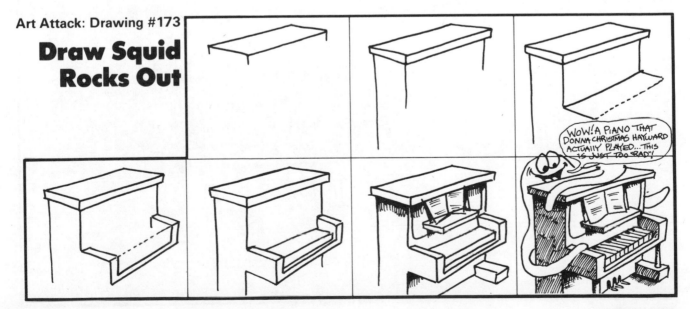

A Hatchet in a Stump

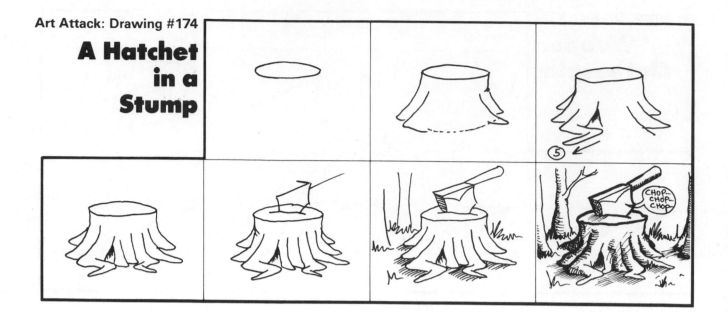

The Bruce McIntyre Achievement Scale
Level 29
The Super Universe Club

Time for the really big one. A giant Super Universe mural. Cover a wall in your house with butcher paper. In the bottom right-hand corner, keep a log of how much time you spend working on the Super Universe. To achieve this success level you should invest at least 40 hours into this project. Yahoo, what an achievement! When you finish it, please be sure to send me a photo. Here's another idea. If you want to make your Super Universe even bigger, get a full roll of butcher paper. As you draw, roll the loose end onto a pole (a broom handle works well). Now you can "scroll" it out and draw a never-ending Draw Squad Super Universe!

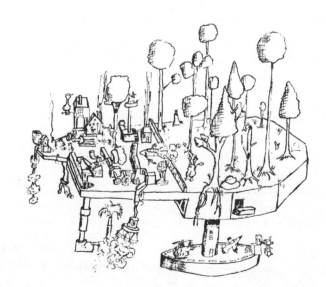

Mark Savell, age 13
Iowa

Check off your progress on the chart in the back of the book.

Review

Add **shading** and windows with thickness to this cloud city.

TO DO: Design three exciting new fast food restaurant placemats. Just think of how many people will be drawing while munching on their french fries.

Drawing Contest #29: **Super Universe**

Keep an accurate record of the hours you spend on this colossal project. The record is 200 hours. Actually, that's how long it took me to draw the mural in my public television show, "The Secret City." This Super Universe might take you an entire month to complete at about an hour a day, so don't get discouraged. Stick to it!

Brian Reynolds, age 17
College City, TX
"Super Universe"

Daily Drawing Journal

Entry Date / /

LESSON 30

Warm-up

You've made it! The last lesson. You are an official Draw Squad instructor. Now it's up to you. There's a wild jungle out there full of millions and millions of people who still think they "can't even draw a straight line." It's up to you to teach them how to draw Furblina and the Draw Squid. It's a heavy responsibility, I know, but you've got to carry the drawing torch forward. Please remember why drawing is so important:

1) Learning how to draw unleashes the imagination.
2) Drawing helps a person think in 3-D and to become a creative problem-solver.
3) Drawing is a global language. It crosses all political, religious, ethnic, economic and cultural barriers.

Key Drawing Word: **Advanced Daily**

"The arts are truly a universal language. To some, they are a vision...to others, an expression of creativity...to still others, sheer magic. To all — the artist and the participant in the arts — they are an experience that involves the discipline of creating or the discipline of learning to express one's self creatively. One thing is sure. The arts can transform our lives. Thus, they should be a vital part of everybody's everyday living.

Vivienne Anderson, President/New York State Alliance for Arts Education, Affiliate of the Kennedy Center

Create your own key word symbol for **daily**:

Art Attack: Drawing #175

Mr. Blob

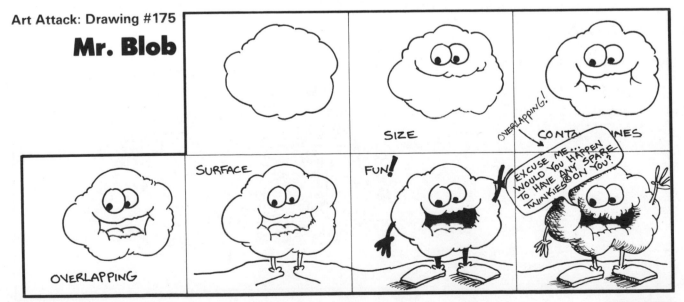

Fancy Volcano

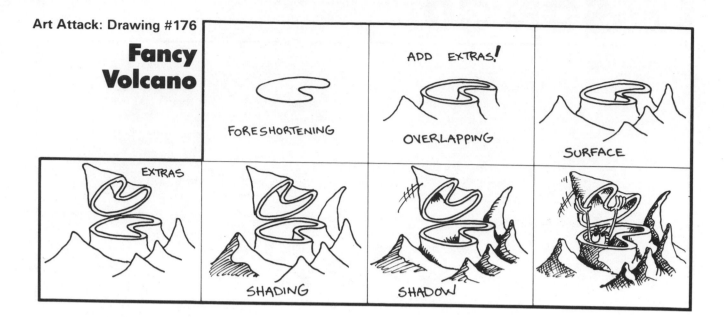

FORESHORTENING

ADD EXTRAS!

OVERLAPPING

SURFACE

EXTRAS

SHADING

SHADOW

Positive Mental Attitude (P.M.A.)

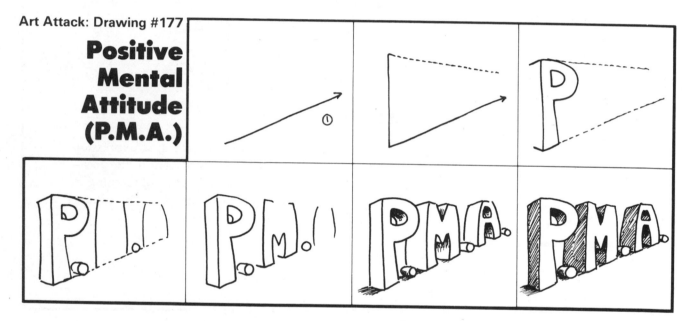

Motivator!

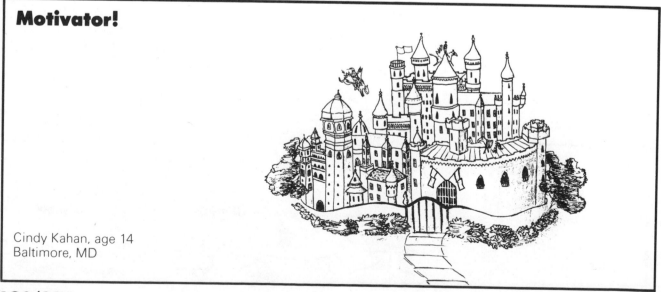

Cindy Kahan, age 14
Baltimore, MD

Art Attack: Drawing #178
Human Ear

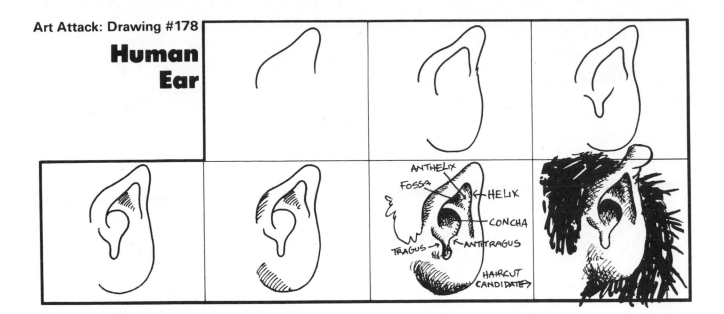

Student Gallery

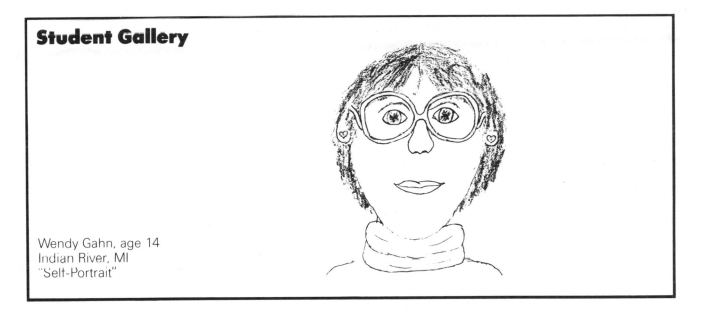

Wendy Gahn, age 14
Indian River, MI
"Self-Portrait"

Art Attack: Drawing #179
Wishing Well

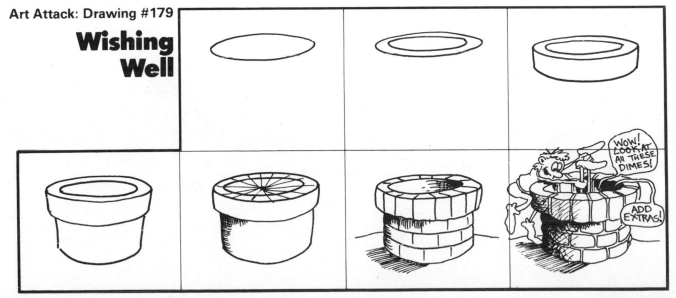

King Banana

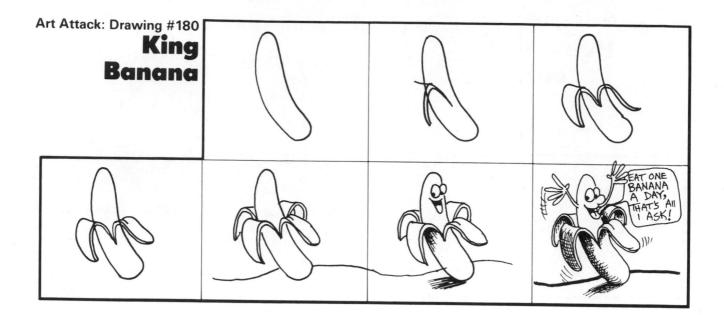

The Bruce McIntyre Achievement Scale
Level 30
The World Peace Club

Let's wrap up these drawing achievement levels with a World Peace Club. I see bumper stickers now and again with my favorite thought: VISUALIZE WORLD PEACE. Now that you're a superb three-dimensional sketcher, you can think in 3-D better than ever. Why don't you harness that powerful 3-D imagination machine to promote world peace? Imagine the impact if millions of Draw Squaders creatively "visualized" world peace. Think of the tremendous amount of creative ways international tensions could be released. To achieve the status of the World Peace Club, you have to visualize world peace, then draw two sketches from that mental image. Send these, along with a short note of encouragement to keep up world peace, to:

<div>

The President
The White House
1600 Pennsylvania Avenue
Washington, D.C. 20500

The Secretary-General
c/o The Soviet Embassy
1125 16th Street, NW
Washington, DC 20036

</div>

Noland Ligens, Jr., age 12
Florida
"Elkey & Katicy"

Get your entire Draw Squad Club to mail these in. Let's fill the White House and the Kremlin waist-deep in delightful images of VISUALIZED WORLD PEACE.

Check off your progress on the achievement chart!

Draw Squad Drawsheet

Review

Complete the Skycastle

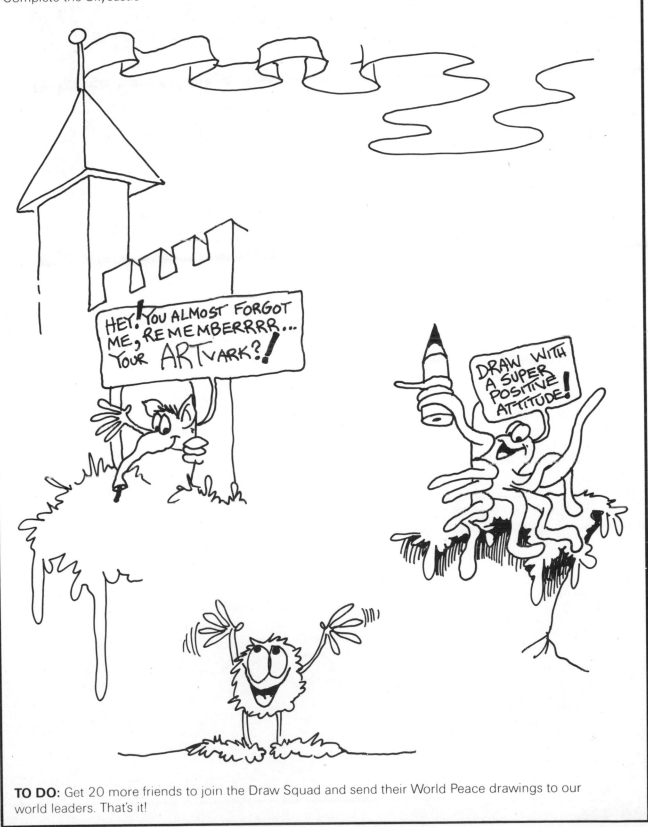

TO DO: Get 20 more friends to join the Draw Squad and send their World Peace drawings to our world leaders. That's it!

Contest #30: **World Peace**

Natalie Essay had a wonderful "World Peace" idea when she drew hundreds of Furbles holding hands. This reminded me of "Hands Across Furbleville." Today's contest theme is to get everyone in your class to draw their version of world peace, and encourage them to send these drawings to the President of the United States and to the Secretary-General of the Soviet Union. Draw Squaders will make a difference! Mail, Mail, Mail!

Natalie Essay, age 7
Magnolia, TX
"World Peace"

Daily Drawing Journal

Entry Date / /

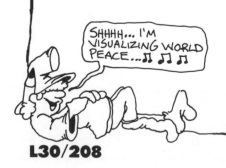

Farewell

I'm very proud of you! You've stuck to your dream of learning how to draw. Incredible! You've completed 30 lessons, over 200 drawing exercises. Where do you go from here? Okay, here's the plan. Are you ready? First, continue teaching at least one person a day how to draw. Secondly, keep your fellow Draw Squaders enthusiastic about drawing and about positive thinking. Then, and most importantly, use your visual brilliance to creatively promote world peace. There are over 600 organizations in the U.S. alone (thousands world-wide) striving to bring peace to the world. If you mailed one drawing to one organization everyday, you could personally support 600 organizations in less than two years. Go to it, you Draw Squad maniac! Keep up your super positive attitude until...Draw Squad II, The Next Generation...Draw, Draw, Draw!

Yours in Creative Success,

Mark Kistler

Mark Kistler

Eric E., age 14
Los Angeles, CA
"Sunset Blvd."

Chapter 3
Drawing Success in the Classroom
Special Ideas For Teachers

Drawing is the single most important skill that you can nurture in yourself and in your students. Every time I emphasize this idea in one of my lectures, I hear, "What about reading or writing?" "Gasp, what about eating Big Macs?" Controversy, controversy!

Okay, I suppose I am a bit biased toward drawing, you know, having been the "Commander" and all. I suppose wearing a red flight suit with 38 pens and pencils stuck all over me, in front of millions of kids, influences my priorities. However the results speak for themselves. Ten million students have proven my point: drawing is a vital communication skill that every student should have the chance to learn.

I truly mean it when I say that anyone *can* draw! Below is Wendy's drawing. She is a darling five-year-old kindergartner who was born without arms or legs. She practiced with all her "normal" classmates by holding the pencil in her mouth. When she couldn't keep the pencil in her mouth any longer (because she was laughing so much at my silly humor), she held the pencil between her chin and her shoulder. An inspiring story of the power of positive creative thinking.

Drawing with your students offers you valuable insight into your student's thoughts and feelings. The more you know your students, the better you can teach them.

Copy this page and leave it on your superintendent's desk (a subtle hint for a $250,000 budget increase for your visual arts program!). Reasons why your school district should hire a certified art educator for each elementary and junior high school:

Drawing is...
 ...an extraordinary window into your student's *imagination*
 ...a *crucial communication skill*
 ...a *powerful self-esteem* launcher!
 ...a conduit for *creative* enthusiasm
 ...the *perfect* alternative to commercial television
 ...the *foundation* for art
 ...an important slice in the *curricular* pie
 ...the *perfect* learning *tool* to teach every subject and it does it in a fun and enriching manner
 ...so completely *open-ended* that your students will surpass your expectations tenfold
 ...wonderful *therapy* (before you strangle your students out of frustration, draw with them!)
 ...a powerful deterrent, and an exciting alternative to drug abuse. "Just say yes to art and no to drugs!"
 ...incredibly fun!

Wendy P., age 5
Texas

Drawing...
 ...*balances* society's current left-brain biased thinking systems
 ...develops *patience* and *concentration*, and teaches students to follow
 directions
 ...builds fine motor skills and hand-eye coordination
 ...nourishes creative *problem-solving* skills
 ...promotes *creative risk-taking*
 ...dissolves the "I can't" syndrome, cultivating visual thinking and *visual goal-
 setting* skills
 ...nurtures *critical* thinking
 ...ability means visual literacy!

That about covers it! Drawing is one of the most important skills you can nurture in your kids. This learning vehicle guides them through every important development stage, from pre-school (dexterity skills), to elementary to advanced levels of concentration. Three-dimensional sketching creates enthusiasm and positive self-esteem. It produces repeated kinesthetic successes that reward your students every time they draw. I've had many shy, reserved and painfully insecure students (I call them sleeping geniuses) completely blossom *through* drawing. I've had brilliantly creative, confident, "miniature Einsteins" *launch* to advanced levels of drawing while in the 4th or 5th grade!

I challenge you to try this "chalkboard approach" to drawing for two weeks, only 20 minutes a day. It's easy to fit into your lesson plans. Ninety percent of what you're teaching is already visual information!

Drawing, when used as a teaching tool, is a powerful vehicle for conveying the critical concepts in every subject. Or, as I like to say, drawing is the hub of the curriculum. When children apply these communication and critical thinking abilities to classroom information, the learning process becomes a self-perpetuating wheel of success. The more adept students become with "pencil power" drawing ability, the higher their creative thinking skills will become. Success breeds success! With each successful solution classroom self-esteem will soar.

Imagine: you won't need to teach the basics over and over. Your kids will absorb and retain visual information at an accelerated rate. Since they can *see* the solutions, the learned concepts will be much easier to retain. This ability to teach a variety of subjects through a vehicle as wonderful as drawing can be the answer to a new and stimulating approach to teaching.

As you use drawing to convey concepts in the classroom, you make learning even more fun. For example:

READING: Have your students illustrate book reports.

WRITING: Create a story from your childrens' drawings.

MATHEMATICS: Have your students think about *visual* problems. For example, how many drawings would it take to animate a two-minute cartoon if each second requires 24 drawings?

SCIENCE: Sketch the human body, the skeleton, the muscular system and the organs. By drawing the parts of the human body your students will understand it better.

GEOGRAPHY: Instead of talking about volcanos, draw a few with your students. While you're shading, explain how volcanos are created and why they erupt.

SOCIAL STUDIES: Don't just read your students the description of an igloo, or a teepee...Draw one!

This is a very tiny scratch on the tip of the information iceberg. For every idea you teach via drawing, three more uses will pop into your mind. This idea cultivation will snowball until your entire day will be spent joyfully drawing with your kids.

When students are excited about their potential and when they are enthusiastic about learning, they will absorb everything much faster. Sketching nurtures their self-image by offering them remarkable visual rewards. (Leading educators who have assisted me with the definitions for the Ten Key Words in this book, as well as thousands of other teachers, can verify the wonderful effect this program has on the self-confidence of students.)

How do you start? You guide your kids through each lesson, step-by-step, via your chalkboard, video-tape or giant-sized bulletin board paper. Each of these 30 lessons are sequentially structured and formatted into 10 segments. The format and structure have proven successful for me in thousands of classrooms with millions of students, at levels ranging from kindergarten through college. I'm excited that you're considering giving it a whirl in your classroom.

You're in for a major art attack! Your kids will thrive in this world of drawing because of the strong *structure*, the sequential *tangible goals*, and the high level of *expectations* you have for them. (The higher my expectancy level is of a class, the more determined they are to surpass it.)

So often school districts haven't had the resources to hire full-time, certified art educators for each school. Crafts are often substituted for art education in our classrooms. This "crafts" approach actually squelches the students' creative drive through sheer frustration because kids experience a temporary, limited success. While I recognize that crafts are enjoyable and build manual coordination skills, it is only a tiny percent of a comprehensive art program, leading the kids into the "creativity crunching" funnel...

Let's approach art education with the same diligence and determination that we pursue math, reading and writing (not to mention computer literacy). Let's re-vamp society's old, archaic acronym for education. Remember the old "back to basics" with the three R's...reading, writing and arithmetic? Visual communication, visual arts, visual literacy, and structured visual development should, without question, be a vital part of the basics. I propose that we channel the enormous resource of energy that is now consumed by "computer mania"

213

into a national campaign promoting a "D.R.A.W. curriculum" (D=Drawing, R=Reading, A=Arithmetic, W=Writing). This is a whole-brain synthesized approach to education, balancing out our current tremendously lopsided, left-brained, rote memory educational system.

Drawing is the foundation, not only for a successful art curriculum, but as I've illustrated, for every subject in your classroom. I'd love to see ten million parents and teachers walking around with D.R.A.W. buttons on...In fact, forget the 10 million, think big, right? Let's get 30 million parents and teachers wearing D.R.A.W. buttons promoting visual thinking and creative problem-solving.

I'd love to see your support. Send me a letter, tell me how these lessons have affected your children's: artistic skills, creative thinking skills, problem-solving abilities, hand-eye coordination, self-confidence, information transferring skills (tying together math, science, reading, writing, language arts, social studies, etc.).

I will use your classroom applications from this program to enrich other books in this series of drawing lessons. (Be sure to specify permission for me to quote your ideas and re-print your students' drawings.)

Integrate Drawing Into Your Classroom

Drawing is a perfect class activity. You can assure 100% success for every child by utilizing all three learning modes...the auditory, the visual and the kinesthetic. See it, say it, do it and know it.

As you sketch each drawing step-by-step on the board, talk about the application of the "warm-ups," the "key words," and the "art attitude boosters." Your support and persistence reassures the students of their brilliance and "awesome creative potential." Talking will soothe any "I can't" fears and enthuse the kids to "launch" with their pencils. The goal is 100% hands-on participation.

Each student has his or her own confident learning mode. By talking we pull in the auditory learners; now let's grab the visual learners. Use your chalkboard, your overhead projector and the video machine. Use giant rolls of paper, and do whatever your imagination can come up with to reach those visual learners who have to "see it" to understand. Finally, pull in the "kinesthetic" learners by encouraging all the kids to pick up a pencil and blast off into the drawing lesson.

Motivating Students (From an idea mailed to me from my friend Amy "Art" Krichko from West Germany)

"I grab kids who are dressed in exciting ways — hair, designs on clothes, etc. ...And point out how creative they are. Each art class, a few more kids join in the creative look routine. I tell them, express your craziness in your dress, your artwork, etc. ...It's fun!

I encourage kids to make art out of stuff they find while outside playing. I'm a cheerleader for art!"

Student Warm-up (Another wonderful idea by Amy Krichko)

I have students close their eyes "... relax ... your arms and legs are melting into energy ... feel that energy ... everything around you is art ... keep relaxing your arms ... now your hands ... fingers ... fill your fingers with art energy ..."

Finger Aerobics

Athletes stretch their muscles, musicians warm-up their instruments, singers warm-up their voices; Draw squad members loosen up with their fingers. Follow the directions in the Lesson 1 Warm-Up.

Classroom Pencil "Tips"

All of you classroom teachers amaze me with your never-ending enthusiasm. You are always so willing to share cream-of-the-crop ideas from decades of teaching. In many industries, ideas are selfishly hoarded and used for personal gain. I have never found this to be the case with teachers. Many of my classroom projects can be directly attributed to this generous sharing of ideas.

As you read in my "Special Thanks" introductory pages, you will see the names of dozens of teachers whose generosity has helped mold my classroom system. Writing this book has motivated me to formulate a new book project, a classroom idea resource catalog. Can you imagine how helpful this book would be if 500 teachers contributed ideas like the ones listed? Just think how grateful those first-year teachers would be, being able to choose any of thousands of "hot" ideas from leading educators around the country!

The Draw Squad

Here are some Draw Squad Tips I've enjoyed applying in my classrooms. Use them as often as you like. Should you look at these ideas and think, "I've been using that technique for over 10 years!" or "I've got even more ideas those first-year teachers would absolutely *love* to use," pleeeeease, write them down and mail them to me and I'll quote you in the catalog.

Mickey Mouse had a club. Football has clubs. Scouts have clubs. Everyone has clubs except artists! Let's remedy this today.

Form a Draw Squad Club in your classroom. I have over 130,000 members from my public television series, and I have thousands of kids mailing in for Draw Squad club cards. Kids love the idea of joining a drawing club. It's a powerful motivator! I mention the club card briefly during my school assemblies and the mail pours in — I know it will work in your classroom too! Here's an outline of how the Draw Squad works. (Use ideas freely.)

STEP 1 (Club Card): After the first drawing lesson when the excitement is high, I ask how many kids want to join the Draw Squad. I give them my address and they mail in for club cards. This is a slick little I.D. card that both the student and I sign. An instant self-esteem booster. The students carry the cards around as a constant reminder that they're in the Draw Squad. ("The Draw Squad Card — don't leave home without it.")

STEP 2 (The No T.V. Contract): Upon receiving the card the kids and their parents need to sign the "Just Say Yes to Art and No to T.V." contract. This is an agreement stating that the Draw Squad member will draw instead of watch T.V. for one week. Kids gasp at the No-T.V.-for-a-week challenge. It's a scary idea for them, yet they really get into it by the second day. Needless to say, parents love the idea immediately. The key to having a successful week is having an overwhelming volume of drawing projects for the kids to complete. (See page 218 for details.)

STEP 3 (Daily Lesson): You've got to keep the kids fueled up with new ideas. One drawing lesson a day with a club level wrap-up will do the trick.

STEP 4 (Daily Club Level): Spend at least ten minutes a day checking off the students' successes on the Bruce McIntyre success scale.

STEP 5 (The Daily Contest): As the kids complete their club levels, write out the contest theme of the day. Each of these are explained in the "Idea Launch" section. Every student who turns in a contest drawing is "a winner."

I made the mistake one summer of issuing a Draw Squad T-shirt to one "winner." This had a disastrous effect on the other kids. Some even thought I didn't like their drawings because they didn't win. I quickly changed my strategy. I was trying to promote practice, not tears! Now each child who turns in a drawing participates in the "Yahoo" ceremony at the beginning of class. The "Yahoo" ceremony is a validation reward for a drawing well done! Each "winner" stands on his chair holding his artwork above his head. On the count of three, everyone yells, "Yahoo," acknowledging and supporting the creative effort. This motivates the kids who forgot and those who slipped and watched T.V. This will also strengthen the winners' desire to repeat the success and try even harder on the next contest.

An ideal visual reward is to cover the ceiling with these contest and club level drawings. I call mine the "Sistine Classroom." The kids swarm in at recess and lunch to show their friends their art success. I also cover all four walls around the chalkboards with drawings and with classroom club charts.

STEP 6 (Motivate): When your kids are leaving the class, you can stick a pencil through a roll of cash register tape and as each student walks out of your room, hand him or her the loose end of the roll. The other kids love to wach their peers walking down the hall with an armful of drawings and drawing equipment trailing a 50-foot ribbon of club paper. After 50 feet or more, rip the edge and hand it to the next student. This register tape can be used for "looooooong contest" entries. These are great to hang in bunches on the wall.This ceremonial "paper pulling" is a great way to say, "Draw tonight, see you tomorrow."

Before, during, or after class, whenever the kids seem to need a little boost, I ask "who needs some art genius juice?" The hands shoot up and I take out my trusty "art genius juice dispenser" (a house plant squirter filled with water) and lightly douse the kids. If the kids get too wired from this you can tone it down and just issue ½ a squirt on the back of their necks. To get the class back on track simply say, "Draw Squad position number one" (both hands on your head). Then position two (both hands on your shoulders), then three (both hands in the air). When I jump to position 96 (both hands on my nose), the kids always laugh.

There are a few dozen hand signals I use to pull the kids back into the drawing lesson. I also use the shade song. I start singing "shade, shade, shade we love to shade." (Adults are terribly offended by my singing voice, but it seems to work with the kids!) The kids join in harmony as we begin the next drawing. I use the overhead projector most of the time and break up the lessons by switching between the chalkboard and a large pad of paper.

The Draw Squad Journal

I make each student an individual Draw Squad drawing journal. I take a manila folder, staple 30 sheets of white 20# bond paper (copy machine paper) on the inside right half of the folder. Two staples along the top is sufficient.

This will save you the big bucks of buying each student a separate sketchbook. As the kids need more paper, you simply staple more in or issue a new folder. Make certain your kids *date* each drawing page. On the other half of the manila folder you can staple a copy of the club chart and contest results.

Draw Squad Sketch Books

Have each member of the Draw Squad design the cover for a Draw Squad sketchbook. Duplicate a dozen of each design. Staple 15 blank sheets behind each drawing and you have wonderful sketchbooks that build self-esteem. These can be shrunk to ¼ size practice pads, too. It's inexpensive, yet it yields high attitude results.

Draw Squad Desk Covers

Cover your students' desks with white butcher paper. Have them draw a Secret City on their desks. Change the paper every couple of weeks. Use this idea with all their bookcovers, too!

Draw Squad Calendar

Another use for the contest entries, besides covering the ceiling, is to make a calendar. Twelve designs takes care of the year. A great fund-raiser! Forget about selling candy, sell *art*. This applies to book markers, folders and book covers.

Draw Squad Songs

I've been singing the same "shade, shade, shade" song for eons, and I thought it was about time for some new songs. So I've decided that *you* should come up with some fresh material.

Why have songs with drawings? It makes the Draw Squad more of a club. Songs also enhance the fun element in each lesson. The singing is an effective attention-pulling device when you want to steer the kids' focus back to the lesson. So, good luck in your new songwriting pursuit!

A Draw Squad Party

The kids bring paper plates, cups, napkins -- all unprinted. When I say "party!" the kids attack the white surfaces with drawings. You can't eat off this party set, but it sure is fun to create!

Draw Squad Cool Down

Experiencing a hot and muggy May in your classroom? Artistic motivation is melting? Henric Post, a teacher in New York, shared this idea with me. Instead of air conditioners, how about using "art conditioners" to cool off the kids! A wet paper towel placed on the back of each student's neck relieves the entire class from heat exhaustion and sparks that great imagination machine once again. I've seen this work in his classes and have tried it in mine. It's wonderful!

Say "Yes to Art and No to T.V." Contest

This is the most difficult, yet the most fulfilling contest of all. The first day of the contest is the toughest; so, I give the students a major drawing art attack list.

1. Signing "Yes to Art and No to T.V." contract. (See page 253.)
2. Draw 25 simple tables stacked on a long strip of paper.
3. A name tag (I buy plastic covered convention name pins) then I let the kids draw their names in 3-D! Instant Draw Squad Name Tags.
4. The "No T.V." Button - There is no size limit. Imagination rules on this project. The point is to constantly remind the kids throughout the week that they have pledged to draw while the T.V.'s stay off. One class of 30 kids will start this project and by week's end you will have half the school wearing the buttons! Once I had three kids make a gigantic button out of a refrigerator box that all three wore at once!
5. Daily contest sample: Simple Table Mania - Today's contest I begin with the sentence "Who can stack the most simple tables?" I count the hands and then show them a few examples such as:

The "Yes to Art and No to T.V." Party

A celebration for making it through an entire week without T.V.! I have each student bring a treat. I bring paper plates, utensils, napkins, and something to drink. At the end of class on Friday we consume sugar and other nutritionally sound munchies. Yes, I should bring carrot sticks and apple chunks, but I figure you can only change the world one step at a time. Let's recondition our kids' T.V. habits first, then we'll have a "Just Say No to Junk Food, Yes to Art" Week next year! Besides, all those moms make the ultimate cookies!

Drawing Displays

Display your students' drawings on all the walls, the ceiling, and on their desks. This will motivate the kids to spend more time drawing. The result? More enthusiasm in *your* classroom.

And don't stop with your classroom display. Contact the managers of banks, insurance agencies, real estate offices, libraries, grocery stores, art galleries, city and government offices, fire and police stations, shopping malls, museums, community centers, ice cream and doughnut shops, barber shops and hair salons, etc. Children's art looks great in all these places.

Another great way to get your kids' drawings displayed is to mail them to me. I'll publish their successes in future books. Better yet, have your class publish their own art books. Your kids can take them home for their parents' coffee tables.

Matthew T., age 9
Carlsbad, CA

The McIntyre Success Scale

The lessons in this book follow the Bruce McIntyre success scale. I find that keeping track of the students' progress is a great motivator. I prepare a chart showing the kids' progress from level to level. I staple a chart inside each kid's drawing folder. Your children will take pride in their continued success.

A giant bulletin board size club level chart with the students' names down the side and the club names across the top is a fine visual tool for your class room.

During the final five minutes of each drawing lesson I establish "club" time. The kids use this time to complete club drawings. You then check off their "homework" club levels on their success chart. (You can use the success chart in the back of this book.)

Often the kids get so excited about achieving the levels that they'll submit sloppy work. The remedy for this is simple. "You say, this is a wonderful attempt, Sarah, but I've seen you draw much more carefully. Tell you what, go back to your desk and redraw this three more times *neatly* then I'll check you off."

You might think Sarah would be discouraged with your "draw three more" reply. Just the opposite is true. Sarah is motivated to try harder to surpass your expectations. Sarah will take more time to practice the challenge levels, and really learn how to draw them neatly. She's anxious to move on to the next success level! Insist on neat, thoughtful work, loaded with "extras."

Success Level Validation Cards

Another fun idea is to make individual I.D. cards for each level of the Bruce McIntyre success scale. The kids love this.

Idea Starter Sentences

During the last few moments of my classroom day I always try to toss out a few idea starters.

"I'm on the chocolate river, what does my boat look like?"

"In Furbleville, where do furbles work? What do they wear? What do their vehicles look like? Do they live under water, in caves or on a starbase?"

Are moonbots furry or metal? What do the moonbots' shoes look like? Is there a McDonald's on the moon?"

I offer one idea-starter a day tying it in with the contest drawings. Notice how the students' interpretations of the contest guidelines (described in "Weekly Contests") will vary when mixed with these idea thrusters.

Weekly Contests

I have already mentioned drawing contests as sure-fire classroom motivators. In this section, I will explain how they work.

Use a different contest each week. Just base each contest on one lesson from this book.

Remind the kids that when you draw, *nobody loses*. Everyone shares in the success of the "winner."

Each week, draw a lesson with your kids. Have each student try out for the next club level, then give them the description of this week's contest.

In general, the rules are as follows: students must draw neatly to the best of their ability. Each object in the picture must use one or more of the Ten Key Words. There is no limit to the size of the paper. Any medium may be used. More than one student may work on the same drawing, forming little Draw Squads. Example: a 9' x 3' mural was turned in by three students last summer — wonderful teamwork. Create idea-sharing!

To start the contest, give the students an "idea-thruster." (See below). As the contest entries come in, display each piece of art on the walls, the door, even on the ceiling! On Friday, *every* child who turned in a drawing is a winner. The award ceremony consists of all the "winners" standing on their chairs and getting squirted with "genius juice" (a squirt bottle of water), one squirt per drawing. If it's too cold for this, try "Yahoo Applause." As you move around the room, put your hands on the head of one student at a time while the class "yahoos" (five seconds each).

Here are two samples of how you might run a contest:

Contest #1: Flying Saucers. "Who can draw the most flying saucers on a single piece of paper?" "Who can draw the three most creative flying saucers using the most extras?" "Let's see who draws the craziest, coolest, cutest, furriest creatures inside their flying saucers?" You see how one contest can build into three! Give the kids a tangible goal and they'll surpass your expectations every time!

Week #2 - The Radical Termite Tower (This activity can be duplicated with any of the 30 levels).

Have the students fill up any size piece of paper with an enormous termite stack.

Encourage the kids to add their own "extras." Make the termite stack twist and turn, tie it in knots, and so on.

Make sure that the students use **shading, surface** and **foreshortening.**

Clone Yourself on Video

I have produced 30-minute video lessons of each lesson in this book. This is a very effective way for me to "clone" myself for everyone's classroom. Rent a video camera and clone yourself drawing on the chalkboard so your kids can review at the push of a button. If you want information on obtaining my video series, write to me care of The Draw Squad.

Classroom Drawing Relays

Separate the kids into four standing rows (teams). The head of each row gets a piece of chalk. When you say "Draw," the head of the row walks quickly to the chalkboard to draw a simple table (Lesson One). Upon completion, he rushes back to his line and hands the chalk to the next team member, etc. The team that finishes first is "Yahoo'd."

Variation: Have a drawing relay for each club success level. Have the kids walk quickly through their lines two or three times; this really forces productive practicing!

Another variation: Before each team member hands over the chalk, he has to walk to the door, run to the swing set and back, walk through the class and hand-off the chalk. This is a great art/P.E. tie-in! Think of your own motivating variations. Creative classroom application is your treat!

Chalkboard Artist

When I'm using the chalkboard or the overhead projector, I often ask two or three students to be today's "da Vinci-etts." They draw along with me on the chalkboard. The whole class watches these spotlighted students succeed. And, as they watch me draw they participate with the lesson at their own desks. This is a nice student involvement activity.

If you line the chalkboard with butcher paper first and have the spotlighted student artists draw with thick, colored chalk, you can cut the giant drawings apart after the lesson for the kids to bring home. Be sure to take turns so that each kid gets a chance to be under the spotlight.

Classroom "Super" Mural

Make a classroom Super City that all the kids participate in. Stretch a long sheet of butcher paper across the room and hang pencils every three feet. The kids learn how to share and blend ideas together to create a Super City with forests, buildings, oceans and mountains. This nourishes that Draw Squad team spirit. You can also suggest a theme for each mural such as "Furbleville," the land of furry creatures, or "Moonbotville," a moon where moonbots live. Let the kids color the mural with markers and crayons.

Gigantic "Super School" Mural

Think big! Apply the same idea as the classroom mural to include the entire school, a school Super City drawing. Stretch the white butcher paper all around the cafeteria walls. Hang pencils every few feet and let the kids go at it!

Drawing Mobiles

Draw Furbles, Moonbots, Secret Cities on paper plates. Cut them out, string them together, and hang them from the ceiling -- instant mobiles!

Art Attack Buttons

The project is to design your own art attack slogan and button and make at least 3,000 for friends to wear.

Super Stationery

Each one of your students' drawings is a prime piece of stationery art. Talk to your local copy center about printing up stationery based on student drawings. When your kids see their artwork reproduced on colored paper and envelopes, they'll go wild! Why? Because they're published artists!

Cool Cards

Seasonal greeting cards are fun to draw and easy to print. Grandma and Grandpa "hello" cards—art to warm the heart.

Drawing Newsletter

Create a special newsletter that spotlights the students as artists. Include a picture of each student, copies of their drawings and brief biographies. This will make them "cool," matching even the "coolness" of the football stars and the computer geniuses!

The Label Game

This exercise is an effective way to teach your students the importance of the key words. Copy a three-dimensional illustration from a magazine or newspaper. Distribute one copy of the drawing along with a list of the Ten Key Words, and a small red high-lighter. Ask your students to highlight every spot where the artist has successfully used **foreshortening.** After a few minutes, repeat the challenge using another key word. Continue the exercise until the students have gone through the entire list.

Variation: The students can positively reinforce the understanding of the Ten Key Words by using yellow sticker pads and labeling one another's drawings. The stick 'ems peel off without harming the drawing, yet the students are able to see their own drawings covered with success labels.

Art Cadet Spotlight

Spotlight four students a week as the "Artists of the Week." Have them turn in their favorite drawing successes to you. Reduce these drawings to fit on an 8 ½ " x 11 " sheet of white paper. Make 30 copies and distribute them to your class. Take ten minutes and have the four artists autograph their drawings on each of the copies. This is really a treat to watch, the four kids strutting from desk to desk amid congratulatory comments from the viewing masses. A delightful, positive experience enriching every art student during the year.

37 Seconds of Recess Bonus

Running out of verbal rewards for contest winners and students who turn in club achievement levels? I've had fun with this one. I declare the kids who turn in their club drawings and contest entries to be Draw Squad leaders and they are awarded an extra 37 seconds at afternoon recess. This sounds ridiculous, but it's really fun and it works if you present it with the same seriousness and drama as you would a million dollar award.

Imagination Launch

An addition to the Draw Squad calendar idea was devised by Margaret Hansen from San Ramon, California. She had all of her kids draw self-portraits emphasizing the Ten Key Words of Drawing. These first graders really turned out some great stuff! She reduced the size of these drawings and put them in the calendar. Each child had his or her own picture in the class calendar.

Never-Ending Roll

Hang up a roll of butcher paper horizontally from the ceiling like a large roll of paper towels. Make sure the paper is fastened (with light rope and eye hooks) so that when you stretch it down to the floor the kids have plenty of draw space.

Write an idea starter sentence such as "I'm a green furry marshmallow muncher. What do I look like?" You will be delighted with the wide variety of sketches. When the space is full, simply pull down a new idea area.

Repeat the process over and over while rolling the paper up at the bottom. At the end of the roll you can flip it over and have the entire backside to cover. Just think, months of drawing enthusiasm captured on one roll of paper for your classroom archives! A great project display during parent-teacher conferences.

Free or Almost Free Drawing Paper

If your school is running out of drawing paper, here are some great spots to find lots of extra paper:

Most companies use computers, and computers use those wonderful never-ending sheets of paper. Ask companies to donate a box of this paper or ask them to recycle their computer paper for your kids.

Ask local copy shops and print shops to save their scrap jobs and recycled paper. Often, for a minimum charge, they'll make pads out of it for your kids.

Get your local grocery store to donate a roll of butcher paper.

Administrative offices ... The list goes on and on. Just ask for what you need, then back your car into the loading zone. Most people who donate will even load your car for you!

Practice Booklets

Another great motivator to keep your kids drawing is to cut a stack of paper in quarters. Draw some nice small covers: "My Drawing Book," "Art Attack Book," "My Draw Squad Sketches," etc. Staple the cover on 30 sheets of blank paper, a really fun yet inexpensive sketchbook. The miniature size adds to the excitement. Because it's pocket-size, it's a portable reminder to Draw! Draw! Draw!

Art Pads

Have each student select their favorite drawings. Reduce them to fit four drawings per 8 ½ " by 11 " page. Bring these masters to your printer. Print up 120 note pads with a light colored ink. Each pad will have 25 assorted pages filled with students' drawings. For some spare change, your kids will see their art "in print." Each one will take home four cool note pads for their families to use for phone notes, grocery lists, refrigerator notes, grandparents' gifts, and so on. The kids absolutely love these!

Wrap It In A Drawing

White butcher paper with pictures drawn on it becomes wonderful wrapping paper for gifts. Art wrap!

Button Bulletin Board

After the "Yes to Art and No to T.V." Week, I collect all the Draw Squad name tags and "No T.V." buttons and hang them on the bulletin board and collect them over the years. It's an impressive display, plus it's a great way to keep a little of the magic of each student.

Create Passports

Create Draw Squad passports into the land of imagination. Have the kids draw "visa stamps" for special events.

Drawing Molecules

Explain to your students that any successful three-dimensional drawing can be broken down into "molecules." Just as water can be broken down into molecules made up of hydrogen atoms and oxygen atoms, drawings can be broken down into 10 key elements. Show the kids how even the biggest most elaborate drawings can be broken down into small manageable parts — a real confidence-builder!

Wear Your Art

Have the kids bring a white T-shirt from home. Tack cardboard inside the shirt and let the kids draw on it with permanent ink. This exercise can keep the kids busy for hours. Besides T-shirts, you can also use white hats, aprons, sheets and so on.

Imagination Chairs

Besides just wearing the T-shirts that the kids have drawn on, you can staple them around the back of their chairs.

Creative Self-Portraits

Another activity which gets kids participating enthusiastically is to have each student lie down in any position on white butcher paper. Have them outline one another's figures and cut their outlines out of the paper. Then have your kids draw in the details using **contour lines, overlapping, shading,** etc.

Variation: Turn your figure into a hairy marshmallow-eating alien or draw your figure as the King or Queen of Chocolateville! Paint and colored markers make this project even more wild!

Draw Sculptures

Here's a great project from Tina Farrel of Houston, Texas. She has the kids cut thick white mat board into creative shapes. She then instructs the students to make a paper sculpture by cutting slots and using a little glue. When the sculptures dry, the kids get to cover the outside white surfaces with 3-D drawings! I even jumped in with this project, and let me tell you, it's really a blast. The end result is a colorful paper sculpture covered with three-dimensional drawings.

Shoe Box Drawings

Shoe boxes are great drawing surfaces. Have the kids draw pictures that wrap around on all four sides. Your classroom will look really great with 30 colored boxes hanging on the wall. Or, if you really want to go nuts over this project, rig up a shoe box "Super City" sculpture to lift off the counter whenever the door is opened. Nifty idea, eh? Animated art action!

Genius Juice the Teacher

Following the Draw Squad No T.V. celebration on Friday, I slip into my bright yellow rain gear and step outside. The kids line up and get to dowse me good with genius juice, one squirt a piece. After 30 squirts I'm completely drenched. Often I rub my head and say "Oh, No ...Genius overdose, my brain hurts ... Aauugh!" This is fun but I recommend it only for the daredevil teachers because the kids are straddling that fine line between fun and total chaos!

Classroom D-P Attack!

Here's how I cultivate a little cross-campus art rivalry. I have my class spend a week drawing miles of sketches on long rolls of cash register paper. On Friday, I tell the students to wait quietly for three minutes. (I'll usually have a parent volunteer help watch the kids.)

I then walk over to my cross-campus classroom rival, and innocently invite this unsuspecting class to a special visual treat that my class has prepared. The kids and their teacher will follow me on a very long walk around the campus, through the main office to shake hands with the principal, through the nurse's office, down to the library and then out onto the playground. Then, I declare "I just can't seem to find where my class has put the visual treat." By this time, the kids are mumbling "What's going on? This is *very* strange; something's up!"

I apologize about losing the treat and the class goes back to their classroom. Of course, during our little campus walk, my class has carefully invaded the "rival" classroom. My kids completely tie the room, desks, chairs, walls ... everything ... with their delightful drawing paper (D-P) rolls. Instead of toilet-papering a house, we have D-P'd a classroom! Everyone laughs hysterically and the kids all experience one more fun adventure in drawing.

Art Bags

A principal in Northern California gave me a great idea years ago. He gathered paper bags from nearby grocery stores. Then he had an art attack week and each child had five bags to draw and color on. When the kids completed their bags he had each of them sign their artwork with bold, red pens. Talk about a self-esteem booster! The kids' attitudes soared when the bags were given back to the stores for the customers to carry home their groceries. Instant art in the community. You know, most of those bags ended up on the walls of homes instead of lining trash cans.

Art-Air Balloons

Mark Soldano in New York shared a fun project with me. He had his kids draw Super City drawings, and write "will-you-be-my-penpal" letters. The letters and drawings were stuffed into helium balloons, along with the school address, during "art week." A large county map was placed on the wall. As the balloons were discovered, people would send back letters and drawings. Colored yarn and pins were used to visually locate the floating distance of the art. I call this a true art launch!

Mozart

I've found that by softly playing music by Mozart in the background, it helps the kids stay on track. The music also lends a magic, creative atmosphere to the class. I tie it in with the theme "Drawing is music to your eyes! Listen, enjoy and draw!"

Lunch Bag Puppets

Have each of your students bring a few empty lunch bags to school. Have them stick their hands in the bags. By moving their hands they have talking bags. Ask the kids to design a "drawing dragon" or "art animal." Draw a bag along with your students. Stress **undershadow** in the mouth and **shading** with the fur.

Seasonal Drawing Projects

Emphasize the Ten Key Words as the starting point for all these activities. In order to get away from the old stand-bys (like making a turkey out of a hand print), I anchor all my projects with a drawing lesson.

HALLOWEEN

- Help your kids draw 3-D faces and monsters on illustration board. With scissors and string, the kids have halloween masks! Instead of buying pre-fab costumes, buy white paper painter suits and have your kids draw their own. Emphasize draw, draw, draw!
- Have a pumpkin face drawing contest. Draw on the pumpkins! Emphasize **shading, overlapping** and **contour.**

CHRISTMAS

- Draw Christmas tree ornaments in 3-D to cut out. Hang them everywhere, not just on Christmas Trees!
- Help your kids matt their drawings and wrap them as gifts.
- The stationery and greeting card ideas I've outlined earlier are wonderful as gifts.
- Drawing all over white butcher paper creates wonderful wrapping paper! Art wrap!
- Drawing on T-shirts make great gifts. Illustrating Christmas songs, cutting out the drawings and taping them in windows make incredible window displays!
- Frosty the Snowman, Santa, reindeer, Christmas trees are all perfect drawing lesson subjects. Use the Ten Key Words and it's easy!

THANKSGIVING

- Have your kids list everyone who will be attending Thanksgiving dinner. Have the kids make 3-D place cards for each guest! After they add color to every place card on their list, they can begin to work on individual name mats. **Variation:** Make name cards out of silverware paper rings, or paper aprons for grandma and grandpa. The Thanksgiving turkey, cornucopia, pilgrims, Indians, family gatherings are all wonderful subjects to be drawn in 3-D. Again, emphasize and validate where the Ten Key Words are being used skillfully.

VALENTINE'S DAY

- This is one of my favorite days. Each student sculptures a 3-D mailbox out of a shoe box. Then they draw 3-D valentine scenes all over the mailbox. After color is added, staple the mailboxes up on the bulletin board. Now the kids are busy for weeks drawing 30 valentine cards each, not to mention the envelopes! On Valentine's Day, the kids put valentines in one another's "mailboxes."

A Drawing Kingdom

Imagine this: You walk into your classroom after looking at all the Draw Squad posters covering the windows. As you open the door, you notice a shoe box drawing sculpture lifting off of your desk. The inside of the door is covered with strips of Bruce McIntyre success level drawings...the ceiling is completely covered with contest drawings. The far wall is a gigantic theme mural, with pencils hanging from tape every few feet. One wall has a large club check-off chart along with a hundred or so 3-D name tags, "No T.V." buttons, and an overflow of contest drawings. Another wall is covered with life-size self-portraits, modified as furry aliens.

The visual achievement and drawing success your students display is overwhelming. Their work gleams with art confidence. Their desktops, wrapped in white butcher paper, are smothered in drawings. More drawings are proudly displayed on T-shirts stapled to the backs of their chairs. Even more drawings are displayed on old shoes that had first been dipped in white paint and are now fastened to the legs of each desk. You fill the chalkboard with drawing exercises. The kids come pouring in wearing paper painter suits, white painter hats, white paper Draw Squad capes, and white paper hospital shoes (of course, they've already covered themselves in drawings). Now they're working on their art mobiles which will soon hang on the already over-crowded ceiling.

Art enthusiasm is in the air! The kids love coming to school! This is the ultimate creative classroom, and you can make it happen. One drawing lesson a day is all it takes. DRAW, DRAW, DRAW!

Sharon Kim, age 14
Baltimore, MD

Chapter 4
How Mark Kistler's Drawing Program Launched My First Grade Classroom
(by Margaret Hansen, Montevideo School, San Ramon, CA)

You do not have to be an artist or even artistic to implement or incorporate Mark's lessons into your curriculum. Personally, my reasons for starting were not based on any artistic ability or lofty educational goals or ideals. Rather they stemmed from my own desire to learn how to draw.

After watching Mark's program a few times, I found it so easy and fun that I decided to try some of the lessons with my students. I didn't want them to have to wait 35 years to discover the joys of drawing.

We started with five-minute drawing lessons a couple of times a week. One thing just sort of led to another and then another, with benefits far greater than anyone would have ever anticipated. These drawing lessons can add a lot of meat and magic to your teaching, curriculum and classroom.

Now, I know you might be wondering how one justifies the adoption of such a program to parents and administrators. Or, what is more likely, you're wondering why you should even bother. Let me quickly list for you the advantages for your students and benefits for you.

Student Skill Development Benefits

1. The program can enhance all essential academic areas of study, including math, science, social studies, language arts, handwriting, and reading.
2. The program stimulates and promotes independent thinking, study skills and work habits, structured and creative.
3. The lessons help develop sequential learning skills.
4. Drawing is an excellent means to promote right-brain use for more equal and total brain development.
5. Drawing is an excellent way to help teach very young children, when English is their second language. The kids will learn about concepts such as: right and left, up and down, geometric shapes, in front and behind, in and out, size, surface, density and shape.
6. Mark's art program helps develop fine motor, visual motor and visual-spatial skills. These skills can help students in handwriting, reading and math.
7. The Draw Squad gives children the means to express themselves artistically.
 This benefits both their emotional and educational growth.
8. Art is great for science instruction. Drawing helps make the children better bservers of the world around them and gives them the means to record their observations.
9. There is a high level of success among all students from all ability levels. The Bruce McIntyre success scale builds self-confidence and self-esteem.
10. Success is an incredible motivator. The motivation and positive attitude that the children gain from this program spills over into other areas of their academic endeavors. It is a great "hook" for non-achievers.

Benefits For You, The Classroom Teacher

1. There are no papers to correct.
2. The program requires very little teacher prep time.
3. The program demands very little expense for supplies.
4. The program does not require large blocks of instructional time.
5. The program can be incorporated easily into existing programs, curriculum and schedules.
6. The program keeps children quiet and occupied between required task work.
 This can give you valuable time to work with students one-to-one or in small groups.
7. The program provides excellent alternative activities for those students who always finish early.
8. The program makes students active participants in the learning process.
9. Success with the program can lead to increased parent support.
10. You will not be required to prepare and run off smelly and messy dittos.

Starting A Draw Squad Program In Your Classroom

Starting your own Draw Squad program is far easier than you might imagine. Here is an outline of the activities that I use and have found highly successful. The first five are for fast and easy implementation of the program. The rest are projects that grew out of our other areas of study and interest.

Five-Minute Drawing Lesson for the Day

About ten minutes before your students leave at the end of the day, or at any other time of day that there is a lull in the action, pass out a piece of paper to each student. (It can be scratch paper.) Now, teach the children just ONE drawing from one of the lessons. Go slowly, giving them one line at a time. Then go over it one more time but allowing them to tell you the sequence of instruction. Then give the children an UN-HOMEWORK ASSIGNMENT.

Un-Homework Assignments

Drawing practice is an un-homework assignment. In other words, it is not required and it is only to be worked on when they have completed their regular homework assignments. The un-homework assignment is to take what they have learned from the five-minute lesson of the day (or from the video lessons) and do as Mark says, *"Explore, discover and create."*

I think you will be amazed, as I was, at the amount of un-homework the children bring into class. There has also been a lot of positive response from the parents because the children get their regular assignments completed without the normal homework hassle. Parents also appreciate that their children will spend so much effort on their drawings and will demonstrate an incredible increase in skills in a short period of time.

The Un-Homework Bulletin Board

This is an area where the children can come in and pin up their un-homework creations. Our board is kid-high. From the floor to the top is about 4½′ and it's about 5′ in length. If you leave an ample supply of pushpins along one side of this board, your students can take care of this bulletin board all by themselves. When it gets full you may have to limit the number of drawings that each student may pin up. To make it really easy, have your students be responsible for putting up and regulating the number of drawings.

The "Yes I Can Learn To Draw In 3-D" Folders

Give each child a folder. It doesn't have to be fancy — a manila folder or a piece of 18″ x 24″ construction paper folded in half does quite nicely. Students should label the outside of their folder with the phrase "YES, I CAN LEARN TO DRAW" and their name. Have your students keep these folders in their desks. Here they will keep any drawing lessons, guide sheets, practice sheets and un-homework creations. Whenever a child has "free time" (this is anytime a student has completed his classroom assignments and thinks he has nothing to do), he has the option of taking out his folder and practicing any of the lessons covered to date.

This is a teacher-directed task with purpose and value that does not require any prep time; nor will it add to the number of papers you'll have to correct. The children think it's play, but you know that it's play with a *purpose.*

These folders are great to have out on the students' desks for Open House.

Adding Machine Tape Practice Strips

This is an idea I got from Mark's special school assembly. Rolls of adding machine tape are great for drawing practice strips. If you watch for sales, you'll find that several rolls can be purchased for very cheap. I've also received several boxes of donated tapes from parents and companies.

Give each child a strip of paper about a yard long. You don't have to be exact...just pull some out and tear it off.

The children can use these strips to practice the stacking of square tables, round tables, round and square tables, flags, unibears, furbles or whatever. When the child finishes with the front, they can flip the strip over and practice down the back. Students can keep these strips rolled up in their desks and take them out to work on whenever they have "free time." These strips take a lot of concentrated effort to complete. They are a great way to keep your class quiet. You might also enjoy decorating your classroom by hanging up the completed strips.

Creative Writing — Story Starters

With most creative writing assignments, students first write the story and then illustrate. Instead, have the children draw a picture first and then write a story.

You can identify specific lessons, give them several choices from the lessons, or let them take it from their un-homework assignments. Personally, I have found that children really love to write "Once upon a time..." stories from their pictures. If you give your students drawing lessons that coincide with your science or social studies units, these creative writing assignments can be used as enhancements.

You can also make this an oral language project by having each child record his or her story on a cassette tape. Staple all the pictures together in the order of the stories and you have a great listening station for your students and for the parents for Open House.

Computer Paper Murals For Science and Social Studies Units

Computer paper is great for murals because it is divided into squares. Moreover, it is usually possible to get parents and businesses to donate all the paper you will need.

Lay long sections of computer paper on the floor, give each child a section, then let them "go to it." If you have carpeted floors, you will have to bring in newspapers to put under the computer paper.

Some ideas for murals are: Dinosaurs, Space, the Fifty States, Mammals — Land and Sea, Animals, Seasons and Time Lines. These are a great way for the children to apply and demonstrate what they have learned, and once again, they are great to have for Open House.

"Published" Calendars

This is a project that can be done by all grade levels even though the study of the months, days of the week, and seasons are usually thought of as primary subjects.

Divide your class into twelve teams. Each team works (in pencil) on a drawing for its month and on filling in the day, date and month information on a calendar sheet.

After you check over the work to see if it's okay for print, the kids trace over the pencil lines with a thin line black marker. You may also want to make front and back covers and an inside title sheet for your calendar. Some school districts have facilities to duplicate these calendars and spiral bind them for you. If you aren't that fortunate check on the cost of having them done at your local printers.

These calendars make great gifts. I've found that parents usually want to purchase more than one. You can either charge just enough to cover the printing costs or make the project a fund-raiser for your class or for the school. The children love seeing their work "in print," and it is a useful gift that the parents can use all year long.

Face Painting

This is a great fund-raising activity that has been made even more lucrative by Mark's drawing lessons. It used to be difficult to get parents to help because they said they weren't artistic and that they couldn't draw. So many of my students went home and taught their parents the drawing lessons, that I had twice as many parent volunteers as before. In one afternoon, at the school carnival, we painted hundreds of furbles, unibears and the like on the hands and cheeks of hundreds of children. In the process we raised a lot of money for the school; money that the school PTA was able to use to bring in special assemblies (like the ones that Mark puts on.)

The face painting, by the way, is done with fine line brushes and non-toxic acrylic paints. There is an initial cost for the supplies but you only use small amounts. If the brushes are cleaned properly and the supplies carefully stored, they'll last for years.

"When I Grow Up" Booklets

This is a book that I have the children make at the end of the school year but you can adapt the project to other study units.

First take photo copies of your students' school photographs. (Like the ones that you put into their class folders.)

Next, take standard 8 ½ " x 11 " paper and fold it so it has eight squares. You will need enough of these sheets so that each of your students will have a square to draw in.

Now take the photocopied picture, cut out the student's heads and glue one child's head in each of the squares. Then let each child draw, in pencil first, what he wants to be when he grows up. Be sure to stress detail such as the items that the person will be using and surrounded by in his or her profession.

After you check over the work, have your students go over their drawings in fine line ink marker. Depending on the size of your class, you will have a book three to five pages in length. Make enough copies for a class set and then give the booklets to your students as an end-of-the-year gift. If you give the children time to sign one another's booklets on the last day of school, it will give the children a memory book that they will always treasure.

Time Capsule

As part of a science unit in the fall, we weigh and measure each of the students and have them record the information on individual fact sheets. These sheets are then put into a time capsule of sorts. (It is a box wrapped in paper and then stored in a cabinet.) At the end of the year, we open the capsule and record the new vital statistics.

In September, we now have the children take Mark's pre-test and then place them into the time capsule along with the general information sheets. Before opening the time capsule in June, we have the children take the same test again. The children are astonished by their "before and after" skills. The growth of *every* student demonstrated in this simple activity has been all the justification needed for the continuation of the program.

Teach Your Parents and Older Brothers and Sisters How to Draw

This activity is a great way to reinforce the lessons and build self-confidence. I always stress to the children that I'm teaching them something that most of their parents and older siblings never learned how to do (which is why 98% of the population draws at about a fifth grade level). The funny thing is, most children start teaching their parents, siblings and other friends before I even give the assignment. The children always have wonderful stories to share about their teaching experiences.

I hope that you will find this information helpful. I know that you can use the program at any level because I have had the pleasure of teaching Mark's drawing lessons to children in grades K thru 12, to adult education classes and to senior citizen groups. Please remember that you do NOT need any background in art to start this program, you only need the desire to learn. I honestly believe that if you try the lessons, your own success will be your motivation to give the joy of drawing to others. Good luck and happy drawing!

Tina Farell, cool art teacher
Houston, TX

Chapter 5
More Ideas For Teachers (by Mike Schmid)

When I was touring the elementary schools in Fort Wayne, Indiana, I had the pleasure of meeting the art teacher for Haverhill Elementary School, Mike Schmid. I was so impressed with his strong art program, which emphasizes drawing as the launching base, that I invited him to share his ideas with you. Not only did he send several great classroom ideas, he also included supporting tie-ins to the "art is the hub of the curriculum" philosophy. Thanks Mike, for all the great ideas, and for teaching me how to become an "origami maniac."

Here they are:

Centers

One of the greatest problems facing elementary school art teachers is what to do with the child who can finish any given project in half the time it takes the other students to finish. My solution is to set up Independent Work Centers. Here are my guidelines:

1- The instructions for the Center must be clear and concise.
2- There should be plenty of visual examples of the sequential steps to achieve each desired product.
3- There should be examples of the finished product.
4- There should be specific rules as to the care of the Center and how it should look when they are finished.
5- The project must be simple enough for the student to do on his own, but complex enough to retain his interest.

Some of the Centers I have used successfully are:

1- Bonsai Tree Drawing - set up by the window on a table
2- Drawing Fish in an Aquarium - set up at a 55-gallon fresh water tank
3- Mural Drawing - set up on a 4' x 6' drafting table
4- Reading Center - art books and magazines
5- Drawing Animals - set up with "how to" drawing books
6- Origami (a favorite) - different sizes of paper and several different sets of directions for simple to complex forms
7- Paper Weaving Center - set up with very specific, sequential directions
8- Papier-Maché Mountain - a table set up with cardboard to make a single mountain in miniature
9- Various painting Centers
10- Drawing on cash register tape and towers of boxes

Many of the Centers are introduced first as a class project before they are opened up to individual students. This ensures that the students have a firm understanding of what to do.

Cross-Curricular Tie-Ins

1ST GRADE

- Usually the kids are very interested in dinosaurs, so when they cover them in class, I have them make their own out of clay or papier-maché (lots of time required) or draw them. They are at an age where they are spending so much time doing things like learning to read and write, that it is difficult to relate to their curriculum in very many ways, so we have illustrated stories, poems and other simple projects.

2ND GRADE
- making puppets in Art
- writing and performing puppet plays
- illustrating creative writing exercises
- introducing Native American arts, such as belt and headband weaving

3RD GRADE
- primitive masks of Native Americans, Eskimos and Africans
- illustrations of writing
- haiku
- Japanese painting and illustrating
- origami
- constellations

4TH GRADE
- primitive masks
- totem poles
- space stations
- book making, binding and illustration
- color studies in paint while studying light in science

5TH GRADE
- totem poles
- introduction to Art History, relating artists historically to what they are
 studying in social science; incredible origami projects to work for peace by
 making a chain of 1000 cranes
- relate linoleum block printing to their history studies
- drawings of inventions by Leonardo da Vinci with their science studies

In all grade levels we spend about three art periods painting to classical
music. The music teacher then works with them on the history and
composition of the music and its composer.

Chapter 6
Drawing Self-Esteem

Ideas for Parents

Your kids are the most precious resource this country has. These little minds will develop into the geniuses who will teach and lead us into the future. It's our responsibility to equip them with creative thinking tools to help them build their future.

Everyday, kids are challenged by dozens, if not hundreds, of problems that require quick creative solutions. I've added this chapter to give you some practical ideas that will help develop your child's imagination. I'd like to give you a tool that, when applied, will produce such dramatic and positive results in your child's life that you'll be motivated to use it everyday in your own home. I'm sure you've already figured out that I'm talking about drawing.

My fellow art educator and friend, James Clarke, is a teacher from Houston, Texas. His list of credits includes: school administrator; member of the Board of Directors, National Art Education Association; and former President of the Texas Art Education Association.

James Clarke is involved with a team researching the positive effects that the visual arts have on a child's thinking and problem-solving skills. The findings so far have been very encouraging.

Kids who've been exposed to a rich visual arts program have demonstrated remarkable improvements in all areas of their curriculums. By the time my next book is published, I'm sure the final results of the research will prove that your kids will benefit considerably in all areas of their lives from exposure to the visual arts. Until then, you'll have to trust in my experience along with the experience of millions of parents whose children have benefitted from participating in my public television drawing show, "The Secret City."

Now that I've thoroughly convinced you that learning how to draw will enrich your child's life, allow me to share some ideas to help you set up a healthy *Art Launch* attitude in your home.

Art Attack Hour

Go through the 30 drawing lessons in this book, one a day, with your kids. Set aside an evening each week for an Art Attack Hour. By participating alongside your kids, you let them know that you think art is important. Your enthusiasm will be contagious (as will theirs).

Say Yes to Art and No to T.V.!

Have a family "Say-Yes-to-Art-and-No-to-T.V." Week. Most American kids spend an average of two years sitting in front of a T.V. by the time they turn 18. Considering the miserable state of children's programming, think of the vast amount of time your little ones are wasting. I often tell them that watching most commercial television is like voluntarily turning your brain into a mushy marshmallow!

Seriously, I'd like to see you sit through one Saturday morning of children's television without feeling shocked. Most of it is a mindless void of negative role-modeling and extensive violence. When your kids watch Rambo or Masters of the Universe solve problems by blowing up one another, how do you think they're going to choose to solve problems in their own lives?

I have all my students sign a "Say-Yes-to-Art-and-No-to-T.V." contract. (You will find a sample contract on page 253). I emphasize creative problem-solving and productive use of otherwise wasted television time. Your kids, like my students, will complain that it's impossible to go an entire week without watching T.V.

Don't take them too seriously. Once you start drawing one lesson a day with them, it'll be a cinch. The kids get so consumed by this exciting new world of imagination, they forget entirely about watching T.V.

Having a little trouble believing me? Try it! You'll be absolutely amazed. Once you and your kids have signed the "Yes to Drawing and No to T.V." contract, hang it on the refrigerator as a week-long reminder. You might want to plan a special activity like a trip to the local art museum as a motivating success reward.

Another idea is to have them draw and mount buttons to wear. I've even had kids go so far as making T-shirts, hats, and aprons, all with the "Yes-to-Art" theme drawn all over them. It's fun. Go ahead and give it a whirl!

I've included a petition for more responsible children's television programming in Lesson 20. By copying it, signing it, and mailing it in, you could be helping your children on an even greater scale. Many people question me about this "No-to-T.V." campaign. The usual question is, "Hey, Mark, aren't you cutting your own T.V. show's throat in doing this?"

On the contrary, when parents and teachers help kids survive a week without television, the kids remember the week as a positive experience. They remember how much fun they had pursuing creative endeavors rather than becoming giant marshmallow-brains. They remember how much time was added onto every day by staying away from the tube. But, more importantly, they become *selective* as to what they watch, choosing stimulating participatory drawing shows instead of all the other nonsense. So, the result of this campaign will increase the number of kids who'll demand better television.

There are dozens of organizations that are fighting for this same cause. I've listed my two favorite ones below. Send them letters of support and inquiries on how to get more involved.

Action for Children's Televison
20 University Road
Cambridge, MA 02138

National Coalition on Television
P.O. Box 2157
Champagne, IL 61820

Draw Squad Clubs

Use the drawing club levels and contests in the lessons. In the Introduction and in Chapter 1, I've explained why the nine lesson components are important to the success of a student learning how to draw with this book.

As a parent, you can capitalize on the enthusiasm the lessons create in your kids. In each lesson, I've outlined the club achievement levels and the drawing contests for the day. All you need to do to really hook your kids' creativity is to display the charts found in the back of the book next to the "No-to-T.V." contract on your refrigerator. To make this even more fun, participate with your kids. For example, you time their club entry drawings and they'll time yours. Another rule you can add is that only your kids can sign you off on the charts, and only you can sign them off.

Art Center

Assign a specific spot, a table or a special corner in the house, to be used as the "art center." This will be the family's designated art attack area. Hang white butcher paper rolls on the walls so there'll be plenty of space to draw on. When the unrolled section is full of wonderful drawings, unroll more paper. When the entire roll is used up, turn it over and you have a new "draw mania" roll of paper. You can also cover the chairs, floor and table with paper. This way when your kids get an art attack they can draw all over the room.

When I was growing up, my mother gave up an entire storage closet so I could build my own art studio. You might not have a spare storage closet, but coming up with a Draw Squad spot shouldn't be too hard to do. It'll really spark your kids' enthusiasm. With enthusiasm comes practice which results in improvement which results in greater self-esteem! Drawing really does build one's confidence. I see it everyday. So, promote your kids' development by making an art corner.

Art Supplies

Start an art-supplies-don't-count rule. My family had this rule when we were kids, that books didn't count. What I mean is that books were considered a staple of life just like water and air. Books were always available; one just needed to ask. They didn't count as gifts (water and air aren't given as gifts). We always had zillions of them around. After I had converted the storage closet into my art studio, my mother declared a new rule: art supplies don't count. They wouldn't count as gifts. They'd be as available to me as books were. I'm not sure how my mother afforded all my paints, pencils and art books on a school nurse's salary, but she did. Establish an art-supplies-don't-count policy in your home!

The Draw Squad

Make sure your kids join the Draw Squad. You can join, too! The Draw Squad is a very important part of the drawing student's enthusiasm. As I've said before, enthusiasm is the supporting pillar to success.

My strategy is simple. I want to get a million people so excited about learning how to draw that they take the time to commit themselves to joining the club. The thousands of kids who've already joined the club proudly carry around their Draw Squad Club Cards while enthusiastically drawing more than they ever had before.

I want this to be the Mickey Mouse Club of the 90's because it's a unifying, positive attitude, art attack, team spirited kids' club. Your kids don't have to spend money to join, just a self-addressed stamped envelope.

Because of the interest generated by my lecture tours and by my television series, I do have a product catalog of T-shirts and supplies, but these aren't necessary to be in the club, they're extras. The best products are the ones you and your kids create together!

Establish a Draw Squad evening (perhaps during the "No-to-T.V." week). Each member of the family could make another member a Draw Squad T-shirt, button, hat, book cover, sketchbook, etc.

A helpful hint: there's this paint on the market called Puff Paint. It's a fabric paint that actually puffs up when applied to fabric. Kids love it, and it makes great wearable art! You can find it and several other brands of permanent fabric markers at most art supply stores.

Have each member of your family mail me one of their drawings and a self-addressed, stamped envelope and I'll send you a Draw Squad Club Card.

Mark Kistler's Draw Squad
P.O. Box 478
Oceanside, CA 92054
United States
Western Hemisphere
Planet Earth
Solar System
The Milky Way
Universe

Draw Squad Imagination Center Franchise

Have you enjoyed the ideas I've presented in this book? Would you like to help 50,000 kids in your local area become Draw Squad maniacs? Are you looking for a new, thrilling, adventuresome career? One that would promote positive, creative thinking and build childrens' self-esteem? Consider starting a Draw Squad Imagination Center in your local area. Just drop me a letter c/o the Draw Squad and I'll send you the "Super Cool" franchise information.

Suggested Reading List

After you and your kids fully understand the Ten Key Words of Drawing, you can use other "How to draw" books to further their drawing vocabularies. Starting a collection of drawing books will build an "idea library" for your kids to enjoy. In the back of the book I've listed a set of excellent books and articles that will make for great art conversations and drawing activities.

Chapter 7
Drawing Goals
A Special Note to High School Students

Learning how to draw will help you achieve any goal to which you set your mind. Achieving your ultimate goal is simply a process of establishing the goal, illustrating it on an index card, and visualizing the goal five times a day! Sounds simple? It is.

Drawing is a daily work out for your imagination. As your drawing skill improves, your ability to creatively visualize your goal will also improve. The stronger you can picture your goal, the faster it will become reality. This sounds really wild to some of you, I know, but your success is limited only by your imagination.

Let me take a minute here to define what "success" means to me. It's not the accumulation of money. It's the achievement of a goal. One of my heroes, Earl Nightingale, says it better: "Success is the progressive realization of a worthy ideal."

So, remember, use that powerful mind of yours to visualize your goal, be it a goal for a particular class in school or a goal for life! Don't worry about the money. I believe if you're working diligently and faithfully toward your dream, you'll always get what you need. This brings to mind another great quote from Earl, "Your rewards in life will be in direct proportion to your contribution and service to others." So, draw your goal everyday, work harder to achieve that goal than you ever have before, and constantly remind yourself that service to others should take as much priority as service to yourself.

The best way for me to prove to you that visual goal-setting will change your life is by sharing my own experience with you.

When I was 16 years old, I listened to a cassette by Earl Nightingale entitled "The Strangest Secret." This 20-minute talk on goal-setting changed my life. For the first time, I set my dream goal: to teach a million kids how to draw before my 21st birthday! Over the next five years, I traveled to hundreds of elementary schools throughout the United States.

On my 21st birthday, I was still 480,000 short of my goal. I was devastated! Five years of diligent work only to miss my goal. Then I realized that the real excitement was in the *attempt* to achieve a goal not just in the final achievement. So, I gave myself a pep talk, and extended my goal of reaching one million kids up to my 22nd birthday. Everyday I visualized, in 3-D, a million kids filling the New Orleans Superdome, all of them drawing along with me while singing "Shade, Shade, Shade...we love to shade!"

When you imagine your goal in a clear, visual picture, and you visualize it daily, you become more aware of opportunities you might have missed along the way had you not defined your goal so clearly. You see, someone who's thinking about the end result of a goal will easily recognize opportunities that will help in the realization of that goal.

In my case, I had cloned myself on a video series for elementary classrooms. While I was searching for a national distributor for these video cassettes, I met John Price and Lee Soloman, two successful T.V. producers who just happened to be looking for a host for their children's art series. I sure heard opportunity knocking at my door, loud and clear, and only because I had a precise picture of what my goal was: to reach one million kids. What better way to do it than through T.V.!

I sent them letters and videograms. I called them almost everyday for months. Much later I learned that my age (21 at the time) initially kept me off the list of 38 serious contenders. I was up against professionals who had ten times the experience and education. But I had the clear visual goal and was more persistent than all the rest.

Finally, John and Lee chose me to host the show! I missed my extended goal of teaching one million kids how to draw, but one week after my 22nd birthday, the show began airing across the country to an estimated 10 million kids! Now I'm producing an exciting children's series called "Mark Kistler's Draw Squad." These days I visualize my series airing on Saturday mornings with the stiffest of competition. So, learn how to draw and then set up a strategy for success through visual goal-setting. It's worked wonderfully for me and thousands of others. It'll work for you!

One last and very important point I'd like to bring up about drawing and success: drugs. I know drugs are all around and I understand that curiosity is never far behind. BUT, I hope you'll understand that the temporary rush you might get from drugs can only be microscopic compared to the ultimate rush you'll feel when you focus on your goals, draw them out on index cards, and plant them in your imagination everyday. Drugs change the lives of those who abuse them; it's *never* for the better. Visualizing and reaching your goals will change your life, too. But you'll be a happier, more confident person for it. I guess you could say drawing is an ultimate drug since it can help you reach your dreams. Just say, "No to drugs!" and "Yes to drawing!"

Tim Flynn, age 12
Baltimore, MD

Kids Drawing for World Peace

Drawing is a powerful visual communicator. Drawing not only crosses language barriers as an ideal international language, it crosses ALL barriers, including political and economic ones. Just imagine the positive impact the following would have on our world leaders. Millions of positive, creative thoughts piled waist-high in the White House and in the Kremlin.

This would send a strong message to the decision-makers from the most important citizens on this planet...our kids! Join the 20,000 kids who've already mailed in their drawings. Get the drawings you and your children have done, and mail them in! Show your kids that they can make a difference!

Mr./Mrs. President
The White House
1600 Pennsylvania Ave.
Washington, DC 20500
United States

Mr./Mrs. Secretary-General
Soviet Embassy
1125 16th Street
Washington, DC 20036
United States

While I was speaking at the Texas Art Teachers' Conference in Houston, I was able to visit the Peace Child Art Exhibition. This was an incredible display of American and Soviet childrens' art. After talking with coordinator, Anne Smith, I really got excited about the project. Art from both countries was exchanged in a mutual children-for-peace campaign. The exhibition is touring the States and then the Soviet Union. If you would like to see your children exchange art with Soviet children, or if you would like to help further the cause of kids drawing for world peace, write:

Peace Child Art Exhibition
Peace Child Productions
P.O. Box 604
Cypress, Texas 77429
ATTN: Anne Smith, Coordinator

Please send copies of your drawings and letters to the Draw Squad!

The Bruce McIntyre's
Achievement Scale
Progress Club Chart

Lesson Level	CLUB	Time Limit	Completed
1	Termite	30 secs.	
2	Super Termite	3 mins.	
3	Hippo	30 secs.	
4	Paradise	8 mins.	
5	Aardvark	30 secs.	
6	Positive Mental Attitude	30 secs.	
7	Rhino	30 secs.	
8	Super Rhino	3 mins.	
9	Super Aardvark	3 mins.	
10	Super Positive Attitude	3 mins.	
11	Red Ant	60 secs.	
12	Super Ant	5 mins.	
13	Giant Ant	8 mins.	
14	"L"	8 mins.	
15	Red Pencil	60 secs.	

Lesson Level	CLUB	Time Limit	Completed
16	Pencil Power	8 mins.	
17	Radical Rowboat	8 mins.	
18	Radical Rowboat II	8 mins.	
19	Window	3 mins.	
20	Pencil Launch (1)	8 mins.	
21	Pencil Launch (7)	8 mins.	
22	Awesome Airplane (5)	8 mins.	
23	Awesome Airplane (3)	8 mins.	
24	Pencil Tips	10 mins.	
25	Super City	30 mins.	
26	Totally Tubed	8 mins.	
27	Super Planet	1 hour	
28	Super Galaxy	4 days	
29	Super Universe	1 month	
30	World Peace	Your Lifetime	

Draw Squad Contest
Progress Chart

Lesson Contest	CONTEST	Student Record	Your Record
1	Termite Opera	300	
2	Super Termite Tower	Lots	
3	Hyper Hippo	65 ft.	
4	Furblett Invasion	3,042	
5	Land of Doors	118	
6	Uni-Tedville	A whole lot	
7	Ultimate Flag	96 ft.	
8	Draw Button	132	
9	Tube City	Too many to count	
10	Furblettville	172	
11	Saturnbot Mania	1,100	
12	Moonscape	286	
13	Super City Saucers	137	
14	Art Attack	2,000	

Lesson Contest	CONTEST	Student Record	Your Record
15	Cubeland	1,047	
16	Road to Happiness	1	
17	Name Game	137	
18	Ultimate Forest	37	
19	Pigasus Fever	It's up to you	
20	Better Kids' T.V.!	42	
21	Drawing Mania	600	
22	Draw Squid	16	
23	"L" Ville	323	
24	Steps to Success	6 ft.	
25	Super City	30 mins.	
26	Gingerbread Mania	13 Billion Zillion	
27	Big Droop	87	
28	Super Galaxy	6 sq. ft	
29	Super Universe	200 Hours	
30	World Peace	4 5 Billion	

Suggested Reading

Mona Brookes. *Drawing with Children.* Los Angeles: J.P. Tarcher, 1986.

California State Department of Education. *Technology in the Curriculum-Visual and Performing Arts.* Sacramento: California State Department of Education, 1986.

W. Curr. *The Art of Leonardo daVinci.* Alhambra, California: Boren Publishing Co., 1962.

Betty Edwards. *Drawing on the Right Side of the Brain.* Los Angeles: J.P. Tarcher, 1979.

Bruno Ernst. *The Magic Mirror of M.C. Escher.* Toronto: Random House, 1976.

Joy Evans & Jo Ellen Moore. *Art Moves the Basics.* California: Evan-Moor, 1980.

Jack Hamm. *How to Draw Animals.* New York: Perigee Books, 1982.

Mark Kistler. *Learn to Draw with Commander Mark.* New York: Children's Video Associates, 1985.

Lee A. Iacocca. *Iacocca: An Autobiography.* Boston: G.K. Hall, 1984.

Bruce McIntyre. *Big Easel III: Best Book on Drawing People.* Santa Ana: McIntyre Audio-Visual Drawing Program, 1977.

Bruce McIntyre. *The Drawing Textbook.* Santa Ana: McIntyre Audio-Visual Program, 1961.

Bruce McIntyre. *Free Hand Sketching.* Santa Ana: McIntyre Audio-Visual Program, 1974.

Gary Larson. *The Farside: Gallery 2.* Kansas City: Andrews, McMeel & Parker, 1986.

Hans-Georg Rauch. *The Lines Are Coming.* New York: Charles Scribner's Sons, 1978.

Susan Rodriquez, *Art Smart.* Prentice Hall, Inc., 1988

Lee Savage. *Aldo's Doghouse.* New York: Coward, McCann & Geoghegan, Inc., 1978.

Susan Stryker & Edward Kimmel. *The Anti-Coloring Book.* New York: Holt, Rinehart and Winston, 1978.

Garry Trudeau. *Doonesbury's Greatest Hits.* New York: Holt, Rinehart and Winston, 1978.

Bill Watterson. *Calvin and Hobbes.* New York: Andrews, McMeel & Parker, 1987.

Hey Drawing Maniacs!

JOIN
MARK KISTLER'S

DRAW SQUAD

How much does it cost? No, not $100.00, not $10.00, not even $5.00. It costs something much more valuable than money. To join, it will cost you one original drawing. Can you afford to spend some creativity? Fantastic! Mail your drawings to Mark and he will send you a super cool **Draw Squad Club Card**.

Mark Kistler's
Draw Squad
Oceanside, CA 92054
United States
Western Hemisphere
Planet Earth
Solar System
The Milky Way
The Universe

Please include a self-addressed stamped envelope!

247

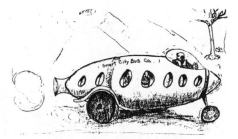

Fay Gasperlin, age 9
Florida
"Zebtron's Bus"

Mark Kistler's
DRAW SQUAD

Classroom Videotape Series

Each of the 30 lessons in this book are available on video cassette. These tapes utilize all the important drawing components while following Mark Kistler's proven sequential format. They are perfect for use in any classroom.

For further information write to:

Mark Kistler Productions

P.O. Box 478
Oceanside, CA 92054
ATTN: Kristopher Jeter

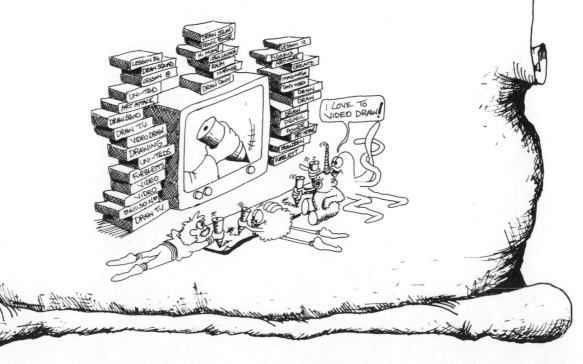

Anton W. Braswell, age 11
Houston, TX

The Draw Squad
"Yes to Drawing and No to T.V."
Contract

I, _____ , do hereby solemnly promise to just say "Yes to Drawing and No to T.V." for a period of two weeks from the date of ____/____/____

I fully understand that I am a brilliant genius and that I am brave enough to attempt this two-week drawing challenge.

During the next two weeks I will have tons of free time because I won't be glued to the television. I promise to devote this free non-T.V. time to drawing, drawing, and more drawing. Instead of watching violent and negative stuff on T.V., I will create super cool, creative, positive "pencil power" adventures in the world of my imagination.

Courageously Signed: _____

Date : _____

Witness: _____

Witness: _____

Paw print of family pet:_____

Display this contract on your refrigerator!